(o b) 14 day

JOHN HEDGECOE'S

Complete Guide to

PHOTOGRAPHY

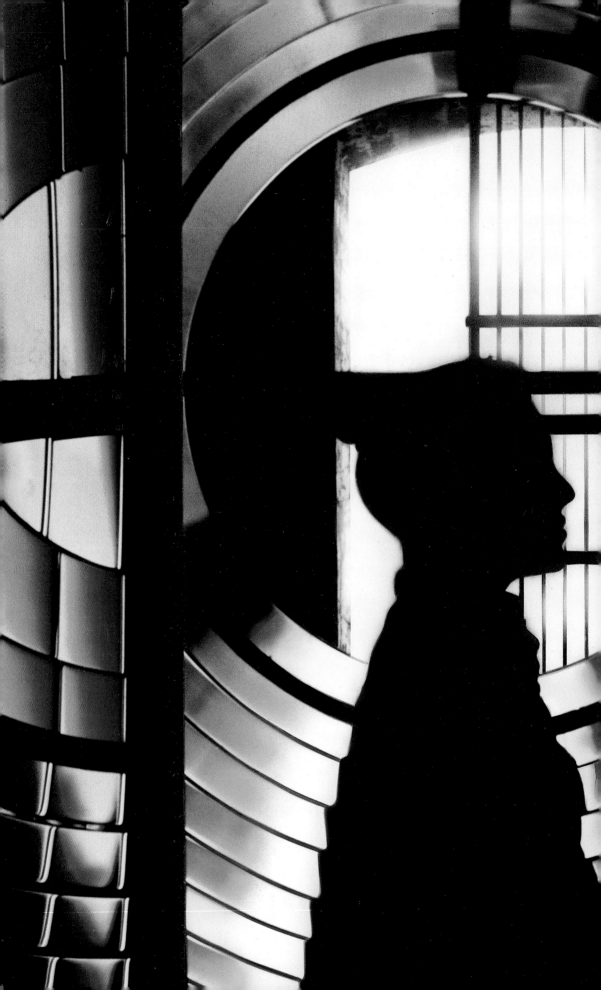

JOHN HEDGECOE'S

Complete Guide to
PHOTOGRAPHY

Sterling Publishing Co., Inc. New York

Library of Congress Cataloging-in-Publication Data

Hedgecoe, John.
　　[Complete guide to photography]
　　John Hedgecoe's Complete guide to photography.
　　　　p.　　cm.
　　Includes index.
　　ISBN 0–8069–8426–0
　　ɪ. Photography.　　I. Title.
　TR145.H416 1991
　771—dc20

Conceived, edited and designed by Collins & Brown

Associate Writer: Jonathan Hilton

General Editor: Gabrielle Townsend

Editors: Jennifer Chilvers
　　　　Susan George

Art Director: Roger Bristow

Designers: Bob Gordon
　　　　Ruth Hope
　　　　Steven Wooster

10　9　8　7　6　5　4　3　2　1

Published in 1991 by Sterling Publishing Company, Inc.
387 Park Avenue South, New York, N.Y. 10016
Originally published in Great Britain by Collins & Brown Ltd
© 1990 by Collins & Brown
Text © by Collins & Brown and John Hedgecoe
Photographs © 1990 by John Hedgecoe
Printed and bound in Hong Kong
All rights reserved

Sterling ISBN 0–8069–8426–0

Contents

Introduction

Photography is about making informed choices; there is no one way to take a picture. Almost any picture as it is first seen, whether it is a landscape view, group of people, still-life or historic monument could perhaps be improved upon by investigating a different camera position, a more suitable aperture or shutter speed combination, or a different choice of lens. But above and beyond these considerations, it is the quality of the light illuminating the subject – affected by the time of day and even the time of year – that has the potential to make an ordinary shot exceptional. Get the lighting right, and you are on to a winner.

The word 'photography' means drawing with light, and as you might appreciate the ability of a painter to communicate the atmosphere of a scene, no matter what the subject matter, so it is with photography. Many enduring, masterly photographs are not the result of chance. Certainly it is a matter of being in the right place at the right time, but in order to have captured that special moment, the photographer may have visited that spot at different times of day on many, many occasions over a period of days or even weeks, waiting for the light to enrich the scene.

The age of 'point-and shoot' photography has well and truly arrived, with the advent of the high-quality compact 35mm camera. This provides a range of sophisticated exposure options, automatic film transport and focusing, and often a very extensive zoom range and built-in flash. At the same time the single lens reflex camera, offering many of the automated features of the compact, but with the undoubted advantage of being able to accept a range of lenses from ultra-wide-angle to super-telephoto, is becoming even more affordable. So, the photographic medium is now freely available, but being able to produce a well-exposed, correctly focused image does not in itself make for good photography.

With photography it is not learning how the camera works, important as that is, that is paramount; it is learning to see and understand rather than simply looking. The best way to develop this ability is by adopting a firm, thematic approach. With this objective in mind, the bulk of this book is devoted to project work, with set assignments and goals to be achieved. All of the important camera controls and accessories, what they do and how they affect the final image, are comprehensively explained and illustrated.

Above all, photography is a fun activity. It is about recording memories and communicating your ideas and thoughts, and is unique in its ability to freeze forever a single instant of time. It is this, perhaps, that accounts for its universal appeal.

A trick of the light Even in the least promising of situations, you need to have the camera ready. This picture (right) was taken above the Arctic Circle in Norway. The weather had been overcast for the best part of the day. Just for a minute or two, however, the clouds parted to allow a flood of daylight to wash over a group of cottages clinging to the rocky foreshore.

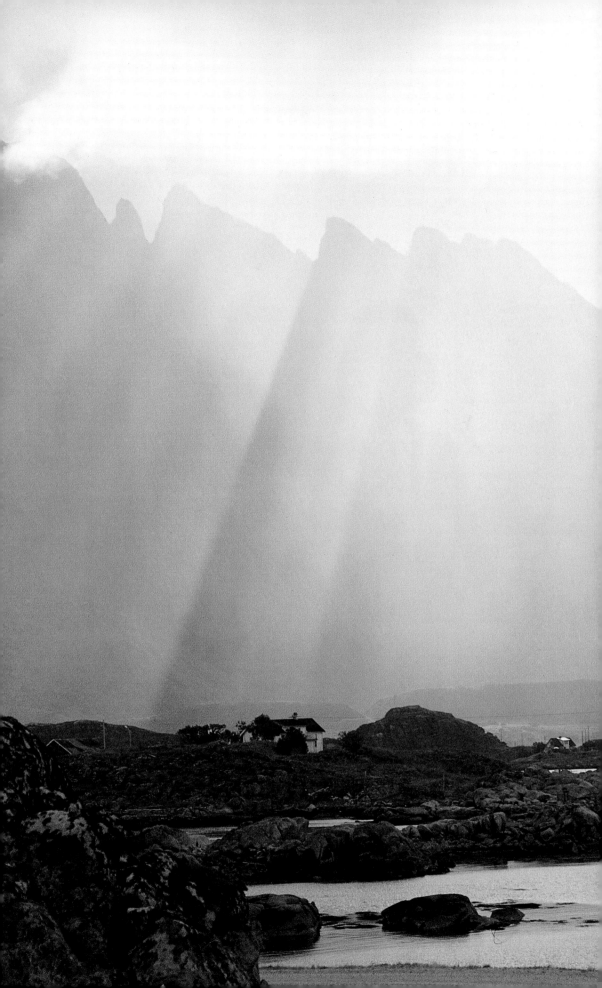

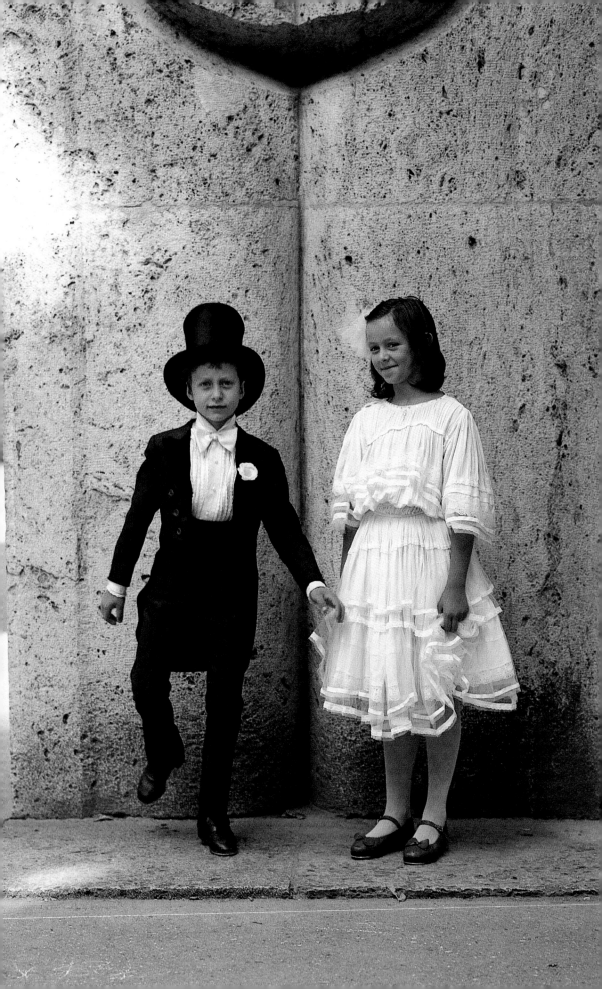

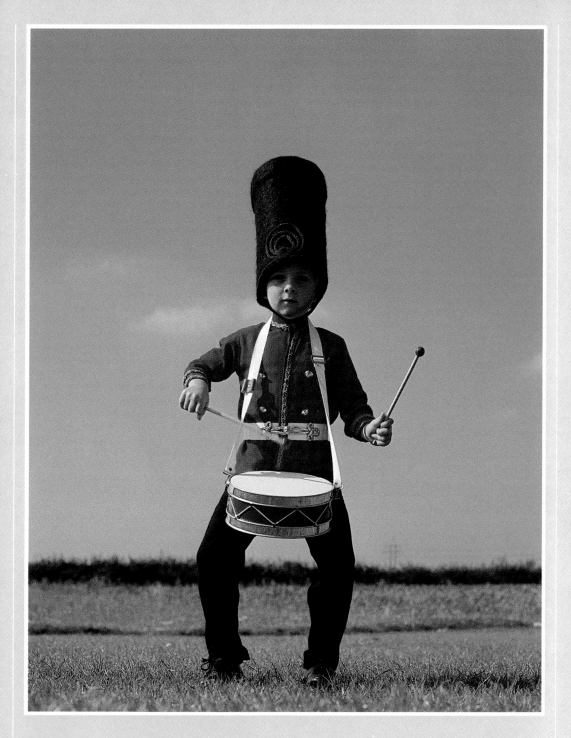

Fancy dress Children make endearing subjects for the camera, especially when they are in fancy dress and obviously enjoying themselves (above). A low camera angle was important to show this junior drummer against a plain, contrasting sky.

On assignment I was in Bucharest on an architecture assignment when I came across these young tap-dancing champions (left) giving a public performance. The chance was too good to miss. After all, the buildings would still be there tomorrow.

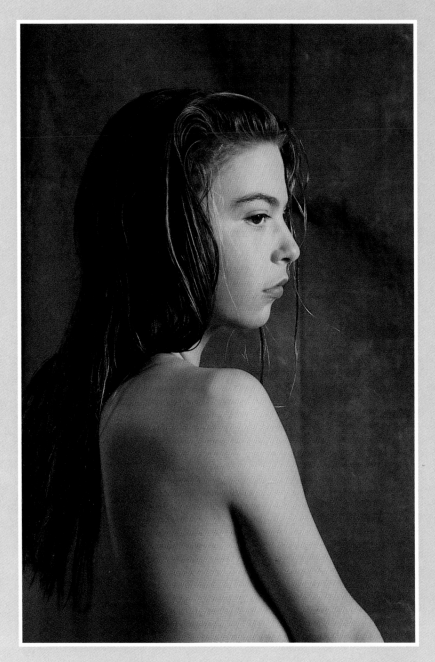

Two moods Although very different in mood, these
two pictures are of the same model. For the first shot
(above) I wanted the utmost simplicity, both of
composition and background, and of lighting. I chose a
plain tarpaulin for a backcloth and used a single
floodlight and reflector. The next picture (right) shows
her looking much more sophisticated. Her hair, now
teased out and fuller, makes an ideal frame for the face,
and two frontally placed floods, one to each side of the
camera position, ensured near shadowless lighting.

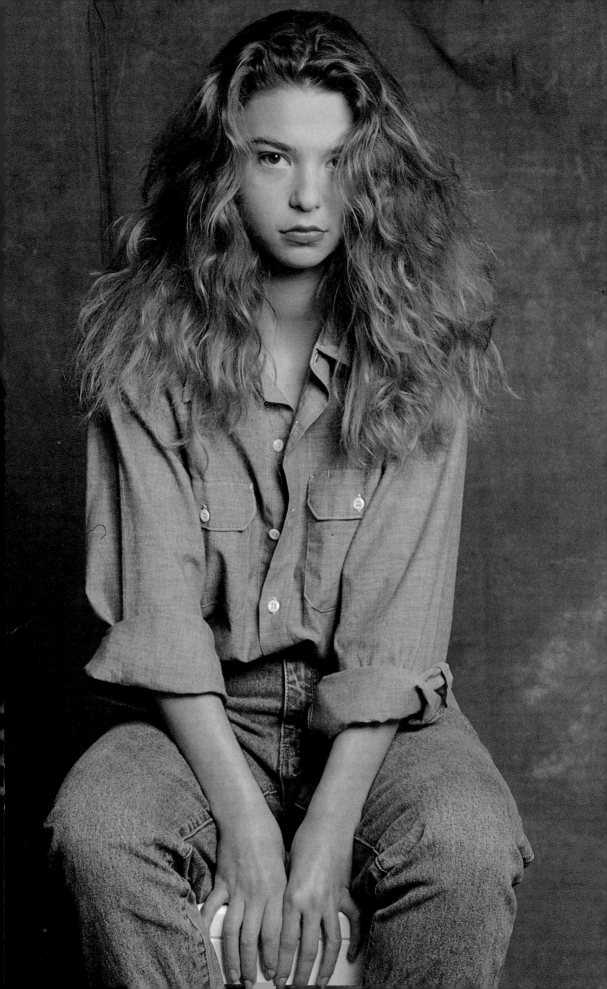

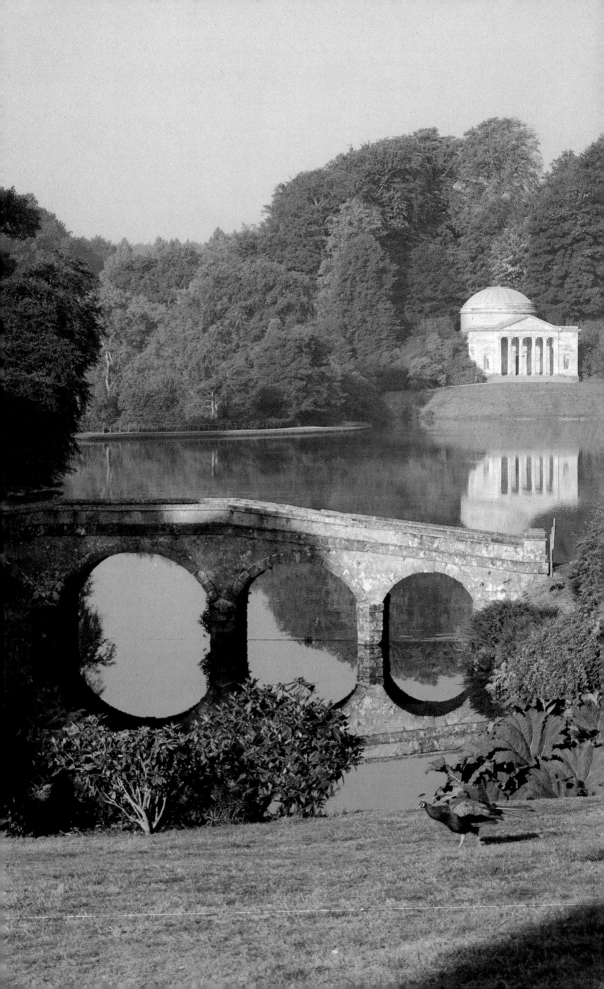

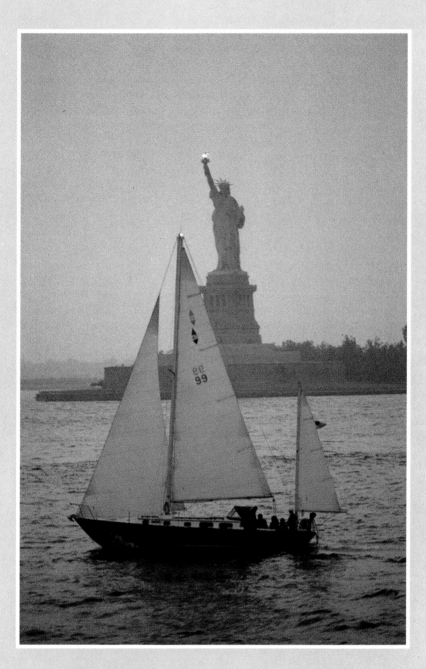

Repeating shapes While in New York I'd caught the
ferry from Manhattan on many occasions and had
already worked out how I wanted to take this shot
(above). The bonus, however, was the small yacht,
whose mainsail seemed to be straining up into the sky,
just like the torch of the statue behind.

Classic framing A classical garden such as this (left)
demanded a classical approach to framing. A fore-
ground sweep of well-tended lawn (with a centrally
placed peacock) takes the eye to half-frames of foliage,
producing a vista encompassing a magnificent arched
bridge and a mock-Greek temple beyond.

Selective focus Poor light levels and slow film left me no choice but to use an open aperture for this photograph. My decision would have been the same in any case, since the limited depth of field has rendered a distracting background completely out of focus.

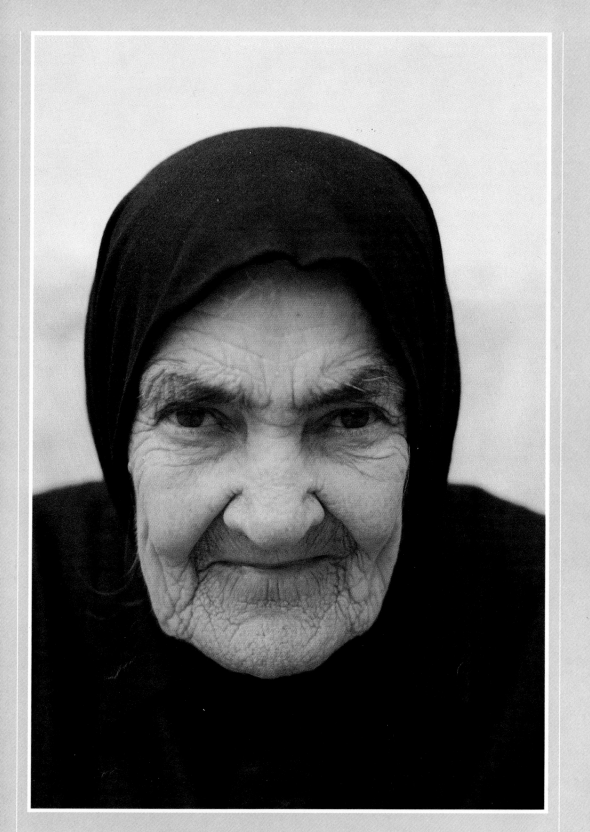

Character and expression Gentle, overcast light
proved to be a perfect form of illumination for this
octogenarian, revealing the character etched deeply
into her face without making her look tired
or haggard.

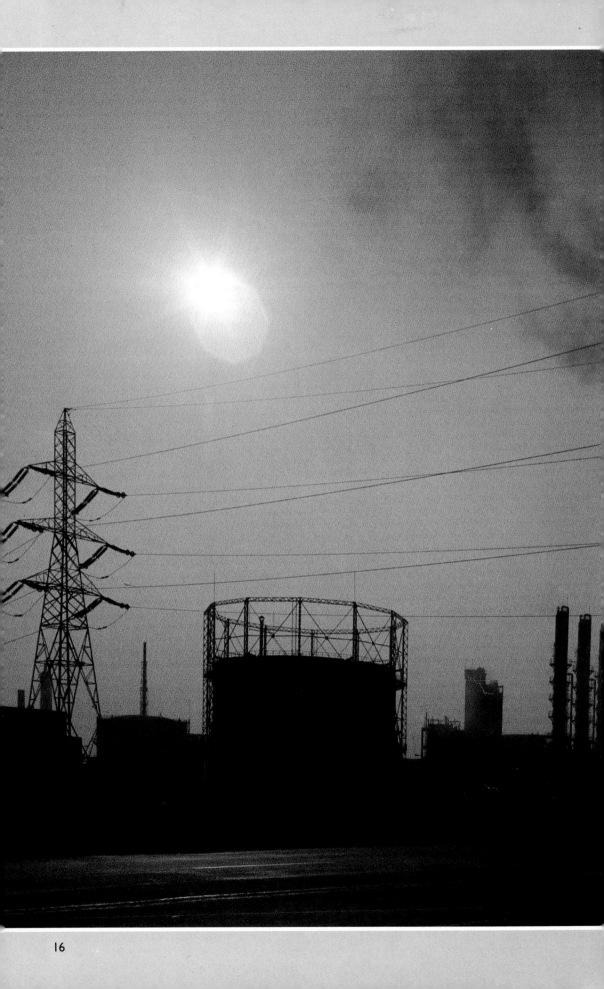

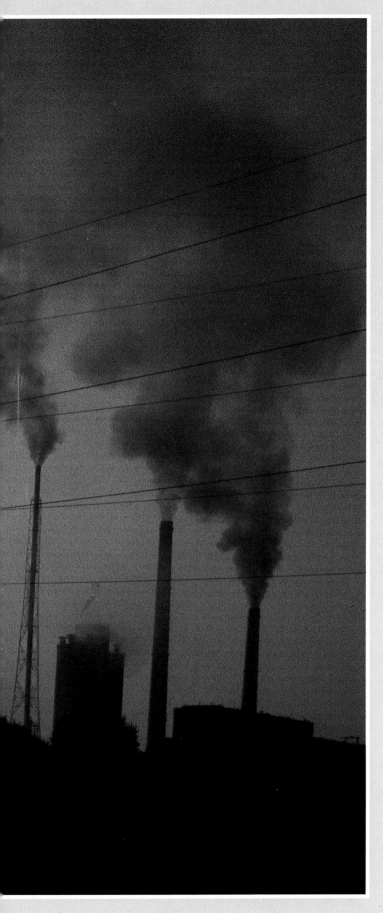

An evil beauty Although depressing subject matter, this industrial complex in Eastern Europe, spewing out its polluted waste into the air, still makes a dramatic and graphically powerful image. The grotesque nature of the pollution is made stronger by shooting against the light, and also by including the sun itself, fighting to penetrate the cloying smog.

How to use this book

This book is divided into three main sections: **The Basic Techniques, The Projects** and **Broadening Your Scope. The Basic Techniques** section gives essential information for anyone interested in taking up photography. Diagrams and photographs supplement clear and informative descriptions of the functions of the camera controls, how to choose a camera, choosing and using lenses, the best type of film, and how to use flash. The second and largest section of the book consists of 71 projects specially designed to give a good working knowledge of all the techniques needed to create exciting photographs. **The Projects** are divided into six chapters covering different categories of subjects – the essential elements, people, places, still-life, the natural world and action.

The final section – **Broadening Your Scope** – contains all the information you will need to make the most of and really enjoy your new photographic skills.

Each category is colour-coded for quick identification

The layout of the two pages in the Projects section annotated to show various aspects covered

A brief introduction sets out the principles involved

A practical assignment shows how those principles are applied

Pairs of photographs are sometimes used to compare different ways of shooting a subject

The Technical Briefing gives important pointers on how to complete a project successfully

Beautiful photographs by the author demonstrate the effects that can be created, with captions describing how they are achieved

The Basic Techniques

How the camera works

Every camera once stripped of its controls and electronic circuitry is basically a lightproof box. At the front is a lens, usually with a variable opening, or aperture, to allow light from the subject to enter for a timed period; at the rear, light-sensitive film capable of making a permanent record of the image.

Camera obscura Today's cameras are direct descendants of the *camera obscura* (meaning 'dark chamber'), which is a much earlier device used as an artist's drawing aid.

Cameras, from the most sophisticated to the most basic, share four common components: a lens, an aperture, a shutter, and a viewfinder. First, light travelling from the subject is collected and focused by the lens. It then passes through an aperture – a hole in a solid disc set within the lens – until it reaches the shutter. The shutter in most cameras is located just in front of the film. It is impervious to light and opens for a timed period to allow light from the lens to expose the film. The viewfinder is an aiming device.

'Correct' exposure
Three factors determine exposure: the light sensitivity, or 'speed' of the film, denoted by an International Standards Organization (ISO) number; the size of the lens aperture (calibrated in f numbers); and the time the shutter remains open (calibrated in fractions of a second).

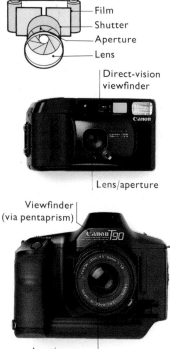

Film
Shutter
Aperture
Lens

Direct-vision viewfinder

Canon

Lens/aperture

Viewfinder (via pentaprism)

Canon T90

Lens/aperture

Viewing systems It is the difference in viewing systems that gives compacts (top) and SLRs (above) such different shapes.

Nikon ft m 20 10 7 ∞ 5 3 2 1 AF NIKKOR **50mm** 1:1.8

22 16 11 11 16 22

22 16 11 8 5.6 4 2.8 1.8

Aperture and shutter
The smaller the f number the larger the aperture (below). However, f22 at 1/60 sec, f8 at 1/125, and f11 at 1/250 will all give the same exposure.

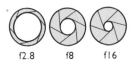

f2.8 f8 f16

Getting the right level of exposure can be difficult. It is probably one of the most worrying aspects of photography for beginners, and is something that even experienced professionals cannot guarantee to do right every time. Modern cameras, though, with fully- or semi-automatic exposure programs (see pp. 22–3) generally produce good results. But there is not necessarily only one combination of shutter speed and aperture that will give an effective image (see pp. 28–31). So, for best results, choose a camera with the option of manual override or one that at least has an aperture- or shutter-priority exposure mode.

The aperture and shutter in harness Unless automatic, the aperture is controlled by a ring on the lens marked in f numbers. A typical sequence is f2, 2.8, 4, 5.6, 8, 11 16, 22. Moving from any one f number to the next smallest (f8 to 5.6, for example) increases the size of the aperture and lets in twice as much light. The shutter speed is controlled by a dial marked in fractions of a second. A typical sequence is 8 (meaning 1–8), 15, 30, 60, 125, 250, 500, 1000. Moving the dial from, say, 125 to 250 means that the shutter will stay open and allow light from the aperture to reach the film for 1/250 sec instead of 1/125 sec. Some cameras have the option of stepless shutter speeds, i.e. any fraction in between the ones usually marked.

If the light meter indicates that a subject needs f8 at 1/125 sec, then using twice

as much light (f5.6) at half as much time (1/250 sec), or vice versa, will also give correct exposure.

Making a pinhole camera
A reasonably clear image can be formed by making a pinhole camera, using a shoe box and some kitchen foil (see below). First, cut a good-sized hole in the side of the box and tape a piece of kitchen foil over it. Make sure no light can enter round the joins. Next, take a pin and make a neat, clean hole in the centre of the foil (it's impossible to make a clean hole in the cardboard). In complete darkness fix a length of ISO 100 negative film (emulsion-side

outward) to the inside wall of the box, opposite the pinhole. Put the lid on and cover the box with a black cloth before switching on the light. All you need do now is take the covered box out into bright sunlight, aim it at a static subject, and gently uncover the pinhole. Exposure is hard to judge, but after 3 sec cover the hole with the cloth and, in complete darkness, remove the film for processing.

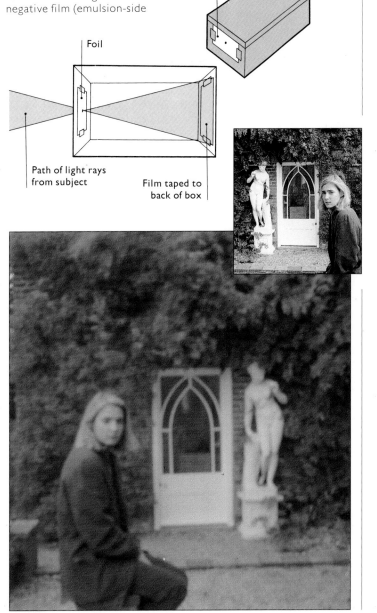

Foil

Path of light rays from subject

Film taped to back of box

Foil taped to box

Pinhole image Although not as sharp as an image formed with a lens (above right), a pinhole (right) is surprisingly clear.

Choosing a camera

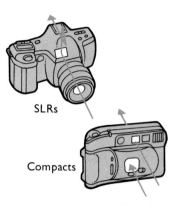

SLRs

Compacts

For amateur use as well as for many professional applications, the most popular format camera is the 35mm. This camera type is available in two basic forms: the compact, which has a permanently fixed lens, either of fixed local length or a moderate zoom; and the single lens reflex (SLR), which allows you to change lenses at will.

Light paths With an SLR, the light coming into the lens is directed up and out through the viewfinder. With a compact, the lens and viewfinder views do not exactly correspond.

The trend with modern compact and SLR 35mm cameras is towards automation (see pp. 24–5). The price you pay for this convenience is the loss of some of the more creative options offered by manual cameras. An automatic camera with full manual override gives you the best of all possible worlds.

One step down from this are cameras offering aperture- and/or shutter-priority exposure modes. With an aperture-priority camera, you set the aperture that best suits your subject

(see pp. 28–9) and a built-in program determines the appropriate shutter speed. Less common is a shutter-priority option. Here, you set the shutter speed (see pp. 30–1) and the program sets the correct aperture.

Layout of controls The trend towards automation has meant a radical shift in the form and layout of many camera controls (see below).

Manipulating the program As long as the camera displays its aperture and shutter settings, you can often impose your will on the program controlling a priority-mode camera. Imagine that you are in

Loading, single-shot and continuous selector

Shutter release

Manual shutter-speed selector

Manual ISO film speed selector (with DX option)

Exposure override (over- and underexposure)

Flash hot shoe | Viewfinder

Shutter release

Metering-mode selector

Shooting-mode selector

Spot-metering button

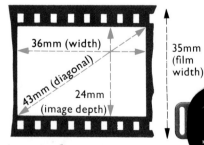

36mm (width)

43mm (diagonal)

24mm (image depth)

35mm (film width)

The 35mm format The name derives from the size film it takes (35mm width in total – above).

Flash hot shoe

Viewfinder

LCD panel

aperture-priority mode with the lens set to f 5.6 and the camera selects 1/125 sec for correct exposure. Because of the halving/doubling relationship of the aperture and shutter, if you really want a shutter speed of 1/500 sec, just change the aperture to f 2.8.

Compact or SLR?

Before deciding between a compact and SLR, first determine the type of shots you will probably take. If only snapshots are required, then a compact camera would be your best choice.

SLRs come into their own when the use of a large range of lenses and accessories is vital in the pursuit of that 'special shot'. The other major advantage of an SLR is the precision of framing—the image on the focusing screen is exactly the image seen by the lens.

System SLRs The leading makes of SLRs have a huge range of lenses and add-ons.

Parallax error This occurs when the lens and viewfinder images do not correspond. Keep your subject within the lines in the viewfinder.

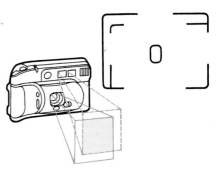

SLRs		Compacts	
Advantages	**Disadvantages**	**Advantages**	**Disadvantages**
☐ Precise framing – what you see in the viewfinder is what is recorded on the film.	■ Noisier than compact cameras because the reflex mirror that directs light up to the viewing screen must swing out of the way before exposure.	☐ With compacts, the viewfinder image is bright even in relatively poor light.	■ The major drawback of many compact cameras is parallax error when used close-up.
☐ Precise exposure measurement because the light-sensitive cells measure only the light coming into the lens.		☐ Compact cameras are small, light and easy to carry.	■ The built-in flash on many models tends to produce 'red-eye' when used for pictures of people.
☐ The range of lenses and accessories makes the SLR an extremely versatile camera.	■ Mechanical complexity of many SLRs makes them more prone to failure than compacts.	☐ Fully-automatic models give you 'point-and-shoot' opportunities and are ideal for informal and candid shots.	■ Because you view the subject through a separate viewfinder window, if you obstruct the lens this is not apparent.
☐ Even if the batteries fail, many SLRs still offer a single shutter speed.	■ Heavier and more awkward to use than most fully-automatic compact models.	☐ Absence of a reflex mirror makes the compact quieter.	
☐ Extensive range of camera models to choose from. State-of-the-art innovations in both electronic and optical engineering to be found in advanced SLRs.	■ Generally more expensive cameras to buy. ■ Flash synchronization is available with only a limited range of shutter speeds.	☐ Compacts can be used with flash at any shutter-speed setting. ☐ Many photographers prefer the rangefinder focusing system used in manual compacts.	■ The effects of any filters used over the lens (see pp. 204–5) are not visible in the viewfinder. ■ Compact cameras are difficult for people with large hands to use comfortably.

Camera automation

Apart from the different modes of automatic exposure, which were looked at on the previous two pages, the principal automated features on many 35mm compacts and SLRs are film-speed recognition, autofocus and film transport, i.e. film loading and rewind, and frame advance.

DX-coded cassettes All modern cassettes have a chequer-board pattern of squares that are 'read' by sensors in the camera to set film speed automatically.

The two must useful aspects of the recent rush to camera automation are DX (film-speed) recognition and film transport (which includes automatic loading, rewind, and frame advance).

DX-coded film

If you look on a cassette of modern 35mm film you will notice a chequer-board pat-

tern of squares (see right). Minute sensors in the film chamber of suitable cameras 'read' this pattern (there is a unique one for each speed of film) and then automatically adjust the meter of the camera accordingly. No longer need you fear the dreaded realization halfway through a film that you have forgotten to change the ISO dial since you last used the

camera, which would result in all your shots being taken at the wrong exposure. For non-DX-coded film, or when you purposely want over- or underexposure you need a manual speed-setting option.

Double exposure As long as you select and position the two subjects carefully, double exposure can produce exciting results (below).

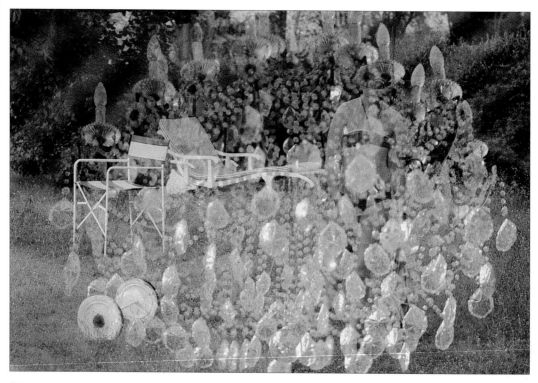

Film loading

This is another definite bonus for photographers. Once the cassette is in the film chamber, all you need do is pull out a short length of film (making sure it is correctly aligned), close the back of the camera, and then press the shutter release button. The camera then advances the film to wind on the initial amount of waste film and sets the frame counter to 1. Some cameras also automatically rewind the film when sensors tell it that the cassette is empty.

Frame advance

Almost standard now with compacts and SLRs is frame advance – the camera advances the film one frame after you press the shutter release. Many also feature a basic built-in motor drive capable of taking two or three frames per second as long as you keep the shutter release depressed – ideal for action sequences. The disadvantage with automatic film advance systems is that double exposure is nearly impossible. This involves taking two photographs on the same frame of film. Although this is not often

required, and automatic frame advance acts as safeguard against it, it can be extremely effective for unusual images and bizarre juxtapositions (see illustration below left).

Autofocus (AF)

This feature is more of a mixed blessing. With many systems the AF detectors look only at the central area of the framed image (this area is usually indicated in the viewfinder), assuming that the main subject of the photograph is centrally placed. If, however, your main point of interest is well off to one side then you may well find that it is recorded out of focus. Some systems also cannot cope with shots taken through closed windows – they focus on the glass instead. The same problem is encountered when trying to take photographs of reflections in mirrors – it is the surface of the mirror that will be focused on, rather than the reflections.

To overcome these types of problem, cameras offer a focus memory lock. You first centre your main subject in the viewfinder, focus and then lock this setting into the

camera before recomposing the picture (see illustration below) with your subject off-centre in the frame, remembering to keep it at the same distance from the camera. Although this technique overcomes the problem, it also cancels out one of the main advantages of AF – that of speed.

Potential problems Some aspects of automation can cause problems. One example is the type of autofocus system that cannot 'see' through glass, since the beam emitted by the camera simply reflects back as if it had met an opaque barrier. With a new camera, read the instruction manual carefully.

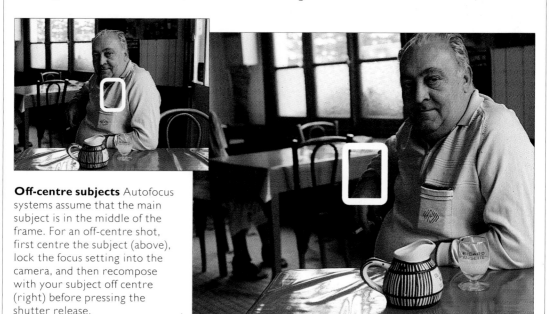

Off-centre subjects Autofocus systems assume that the main subject is in the middle of the frame. For an off-centre shot, first centre the subject (above), lock the focus setting into the camera, and then recompose with your subject off centre (right) before pressing the shutter release.

Choosing and using lenses

The ability to change camera lenses, or focal lengths with a zoom, brings a whole new breadth to your work. For the 35mm SLR there are literally dozens of different focal lengths to choose from, grouped roughly under the classifications of wide-angle, standard and telephoto. Many modern compacts now come fitted with a moderate zoom lens, which greatly extends picture-taking opportunities.

Ease of use A camera such as this (above) with a zoom lens range of 38–105mm replaces the traditional wide-angle, standard, and telephoto lenses.

Although there are many lenses to choose from, it is preferable to carry only the barest few when out taking pictures. Select films at various speeds and carry just a wide-angle and a medium telephoto with the standard lens attached to the camera.

Standard lenses

For the 35mm format, the standard lens is either 50 or 55mm. When buying an SLR, a lens of this focal length is normally part of the camera price. They are known as standard lenses because the image they produce approximately corresponds to the way the same scene would have looked if viewed by the human eye.

Standard lenses are excellent general-purpose optics, suitable for landscapes to half-length portraits. Don't use a standard for full-face close-ups, however, since you will need to get so close to your subject that the camera would be intrusive. This lens type is usually the fastest and has a wide maximum aperture (f1.4, for

Standard lens

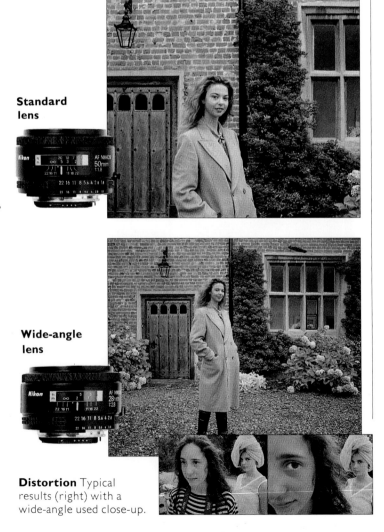

Wide-angle lens

Distortion Typical results (right) with a wide-angle used close-up.

example), and so produces a very bright image on the SLR focusing screen.

Telephoto lens

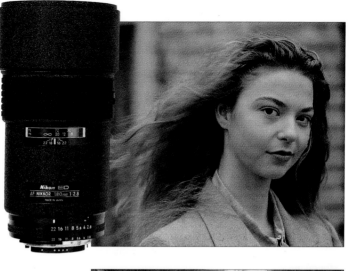

Wide-angle lenses

These take in a wider view of the subject than do standards or telephotos. As a result, everything appears to be quite small on the focusing screen. Wide-angles start at about 35mm and go down to about 21mm. Beyond this, wide-angles tend to distort the edges of the image.

Wide-angles are ideal lenses for landscapes, broad panoramas, impressive over-head sky effects and crowd scenes. They are also useful when working in cramped conditions indoors. Don't use wide-angles for close-up portraits, unless you want to create unflattering distortion (see below left).

Telephoto lens

This type of lens starts at about 75mm and goes up to 1200mm. A telephoto some-where in the range 90 to 250mm is the most popular. However, bear in mind that a lens of 250mm is heavy and when hand-holding the camera you will have to use fast shutter speeds to avoid pictures being spoiled by camera shake.

Telephoto lenses are excel-lent for pulling in close a distant subject for wildlife and nature photography. They also produce interesting perspective effects because they enlarge the middle dis-tance and background in relation to the foreground. For the 35mm format camera, many photographers consider a 90mm lens ideal for full-face portraits.

Zoom lenses

If you are thinking of buying a compact camera, then a model with a fitted zoom somewhere in the range of 35 to 90m will certainly extend the camera's versatil-

Zoom lens

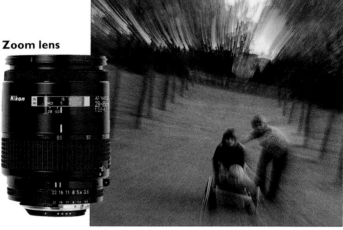

Changing lenses The three shots of the same model illus-trate how dramatically framing alters when changing lenses (above, and left). A single zoom lens, however, would give the same framing, with the additional option of zoom-movement effects (top).

50mm 28mm 180mm 28–85mm

ity. For SLR owners, zooms come in the approximate ranges of 24–35mm, 28–50mm, 35–70mm, 80–210mm, and 200–600mm. Characteristics of zoom lenses at individual focal length settings correspond to their fixed focal length counter-parts already described. How-ever, the optical quality of a fixed focal length lens is generally superior to that of zooms and zooms are also much heavier.

Lens speed

This refers to the maximum aperture of the lens. This is of particular importance to SLR users, since the brightness of the view-finder image depends entirely on the amount of light coming in through the lens (see pp. 24–5). Also, a wide maxi-mum aperture means that you can take pictures in dim lighting conditions. Gener-ally, the longer the focal length, the slower the lens.

Choosing the aperture

The aperture of the lens, calibrated in f numbers (also known as f stops), not only affects exposure, it also controls depth of field. Whenever a lens is focused, whether manually or automatically, there is always a zone of acceptably sharp focus both in front of and behind this point — this zone is known as the depth of field.

Lenses A telephoto gives a shallow picture area and depth of field (dark blue, above). The light blue area shows the greater scope of a wide-angle.

This zone of sharp focus is a feature of every lens, but its extent varies according to the type of lens and the aperture. Wide-angle lenses, for example, have a generous depth of field, and the wider the lens the more this is so. With extreme wide-angles, actually focusing the lens is practically redundant, since depth of field ensures that everything in the shot will be sharp. At the other extreme, telephoto lenses have inherently shallow depth of field. When using these lenses (and

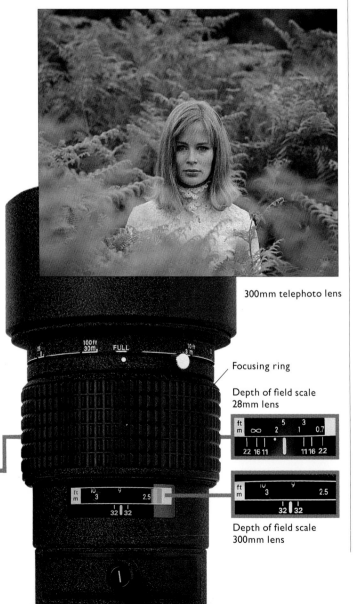

300mm telephoto lens

Focusing ring

Depth of field scale
28mm lens

28mm wide angle lens

Depth of field scale
300mm lens

telephoto zooms) you need to pay particular attention to focusing since there is little room for error.

Aperture and depth of field

The basic thing to remember here is that the wider the aperture (indicated by the smaller f stops) the shallower the depth of field. The aperture thus modifies the characteristic depth of field of all the different types of lens.

Creative control

When taking a photograph, selecting the aperture (and hence depth of field) gives you the choice of where to place the emphasis. We have seen how aperture and shutter speed are related in terms of exposure (see pp. 18–20). If, then, your subject, a head-and-shoulders shot say, is in front of a distracting background, you can moderate the background and make it less intrusive by focusing clearly on your subject's eyes and using a wide aperture (perhaps f 2.8). You will find that a fast shutter speed is necessary to compensate for exposure.

Opening up the aperture in this way will have the effect of putting the background out of focus and making the subject stand out. If, on the other hand, you feel that the background is an important element in the shot, then stopping the aper-

Wide-angle A 28mm lens has given a deep zone of sharp focus (far left).

Telephoto A 300mm lens has given a shallow zone of sharp focus (centre left).

Depth of field scale Using the depth of field scale and the focusing scale together, you can read off the distance between the nearest and farthest points in the picture that will be acceptably sharp for the selected aperture (near left).

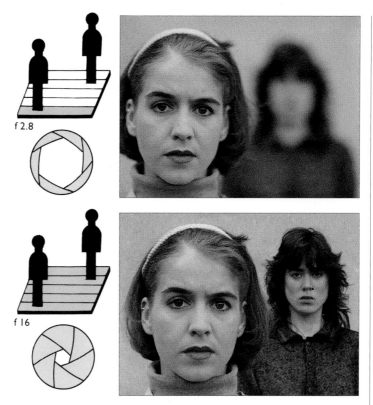

f 2.8

f 16

Stopping up and down By setting a wide aperture (at around 2.8) the subject is in focus while the background is blurred (top). However, when the lens is stopped right down (in the region of 16, say) both the subject and background are clearly in focus (bottom). In the

illustrations (above left) the blue shading represents diagrammatically what will be in focus in each case. By setting a medium aperture the subject would still be in focus, and background detail perceptible but not sharply defined.

ture down – selecting a small aperture (indicated by a large f number) – to f 16 will bring both the background and subject into sharp focus. But you will then have to adjust the shutter speed in order to get the correct level of exposure.

If, however, you want to achieve a compromise effect, with the subject sharply defined and a suggestion of identifiable background, you should select an aperture of about f 8 (and again adjust the shutter speed).

Light and film considerations

The degree of choice you have in the selection of aperture and shutter speed

depends very much on the prevailing light conditions and the type of film you are using. In very poor light, for example, selecting f 8 may mean that you need to use an impossibly slow shutter speed to attain the correct exposure or, as you will see on the next two pages, to 'freeze' the movement of even a slowly moving figure. An additional degree of control you have here is the speed, or light sensitivity (see pp. 30–3) of your film. A doubling of film speed (from, say, ISO 200 to 400) means that you can use a faster shutter speed or a wider aperture and still get the correct level of exposure.

Choosing the shutter speed

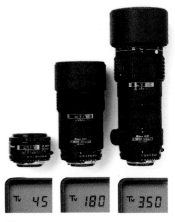

The camera's shutter speed, controlled by a dial marked in fractions of a second as well as full seconds, combined with aperture determines how much light reaches the film. But, more significantly, shutter speed also affects the way moving or static subjects are recorded, either sharp and fully detailed, or blurred and more impressionistic.

Shutter speed and lens As lenses get longer they also become heavier, requiring ever-faster shutter speeds to avoid camera shake. The displays above show stepless shutter speeds.

You need to use a sufficiently fast shutter speed in order to avoid accidental camera shake, caused by moving the camera while the shutter is open. If you mount your camera on a tripod this is not a problem, even for exposures of many seconds. When hand-holding the camera, the general rule is that you should select a shutter speed at least equivalent to the focal length of your lens. In other words, with a 50mm lens use 1/60 sec or faster; 90 to 135mm use 1/125 sec or faster; 250mm use 1/250 sec or faster; and so on. This relationship exists because lenses become increasingly heavy as they become longer, and also because a slight movement of the camera equals a big movement by the time it is transferred to the end of a long lens.

Creative control
When photographing a moving subject, you can use the shutter speed in order to interpret it. For example, if you were shooting a running figure, a shutter speed of 1/250 or even 1/500 sec might be necessary for a 'frozen', detailed image. In the same situation, with a shutter speed of 1/60 sec, the running figure will move slightly across the lens's field

Freezing action The two ways to freeze action with the camera are either by using flash, which delivers an instantaneous burst of light (left), or by using a fast shutter speed. The picture below was taken at 1/1000 sec, ensuring with this subject that no movement is recorded.

Manual exposures For subjects such as fireworks (below), when you can't anticipate the action, put the camera on a tripod with the shutter on B. The shutter will stay open until the button is released allowing for an exposure that is very long.

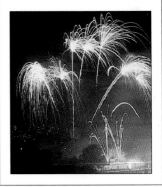

Colour negative film (daylight balanced)

Make	Brand name	ISO
Kodak	Kodacolor Gold 100	100
Kodak	Kodacolor Gold 200	200
Kodak	Kodacolor Gold 400	400
Kodak	Ektacolor Gold 160 Pro	160
Kodak	Kodacolor VR 1000	1000
Agfa	Agfacolor XR 100i	100
Agfa	Agfacolor XR 200i	200
Fuji	Fujicolor HR100	100
Fuji	Fujicolor HR200	200
Fuji	Fujicolor HR400	400
Fuji	Fujicolor HR1600	1600
Konica	Konica Colour SR-V 200	200
3M	Scotch Colour Print HR100	100
3M	Scotch Colour Print HR200	200

Colour negative film (tungsten balanced)*

Kodak	Vericolor II Pro Type L	100
Fuji	Fujicolor 160 Pro L	160

Colour slide film (daylight balanced)

Kodak	Kodachrome 25	25
Kodak	Kodachrome 64	64
Kodak	Ektachrome 100	100
Kodak	Ektachrome 200	200
Kodak	Ektachrome 400	400
Agfa	Agfachrome 50 RS	50
Agfa	Agfachrome CT 100	100
Agfa	Agfachrome CT 200	200
Fuji	Fujichrome 100D Pro	100
Fuji	Fujichrome 400D Pro	400
Konica	Konica Chrome 100	100
Polaroid	PolaChrome CS Instant	40
Polaroid	PolaChrome HC Instant	40
3M	Scotch Color Slide 100	100
3M	Scotch Color Slide 400	400
3M	Scotch Color Slide 1000	1000

Colour slide film (tungsten balanced)

Kodak	Kodachrome 50 Pro T	50
Kodak	Ektachrome 160 Pro T	160
Fuji	Fujichrome 64 Pro T	64
3M	Scotch Color Slide 640T	640

Limited in choice since most colour negative films can be corrected when printed to remove colour casts caused by mismatched film and light source.

Choice of colour films This chart contains a selection of the more popular colour films available. There are, however, others marketed under 'own-brand' names of chemists shops, large department stores, and high-street chains of photo processors. These films in most cases have been made by one of the major film manufacturers and will give perfectly good results. If you want to experiment with unusual colour results, you should try using special infrared (IR) film, any of the high-contrast films, duplicating film, or film designed for colour work through microscopes. These are available from specialist suppliers only and all will give your work a new slant.

Most slide films can be home processed. Kodachrome films, however, require processing not available in home kits.

tungsten bulbs, results would be too orange. This is because tungsten light has a lower colour temperature than daylight and thus a preponderance of 'lower' orange wavelengths. In both cases, you can attach filters to the camera lens to correct any unwanted colour casts (see pp. 204–5).

Film speed
The speed of film is denoted by an ISO number and refers to its light sensitivity. The more sensitive a film, the less light it needs to produce a correctly exposed image. Having the right speed film in the camera can be vitally important. In dim light with a slow (ISO 100) film, even selecting the widest aperture and slowest-feasible shutter speed may result in underexposure. An ISO 400 film (four times more sensitive) in the same conditions will give you the option of selecting an aperture two stops smaller (if depth of field is important) or a shutter speed two stops faster (if subject movement or camera shake is an important factor).

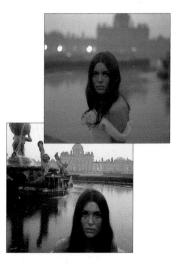

Film type and light source In these pictures, the top one was taken on tungsten-balanced film, designed for blue-deficient tungsten lighting, while the other was shot on daylight-balanced film.

Black and white film

It is fair to say that today black and white film is categorized largely as an 'art medium', despite the fact that colour film became widely available only about 45 years ago. The simplicity and power, yet rich variety of tones, provided by black and white lend themselves to every aspect of photography.

With one hard-to-find exception, Agfa Dia Direct, all black and white films are designed to produce a negative image from which prints can be made. The colour temperature of light sources will not affect the final image, though, as it does with the different types of colour film (see pp. 30–1).

Speed and grain relationship
Because of the chemical composition of black and white emulsions, fast films have a distinctly more 'grainy' appearance than slow films when enlarged. Their extra speed is produced by using larger clumps of silver-halide crystals. With a greatly enlarged photograph, these

Surreal effects This shot (right) was taken using black and white infra-red film. The foliage tones appear pale and the overall effect is stunning.

clumps appear as a grainy texture, which can be intrusive and, if very pronounced, can lead to an image lacking in clearly defined detail and with poor contrast.

Slow film
This category of film ranges between about ISO 64 and ISO 100. Although not ideal for low-light work, in

Slow and fast film For this portrait (above left), bright conditions allowed the use of slow film. The resulting fine-grained image has plenty of detail, especially in the subject's skin texture.

Low light conditions (above right) necessitated the use of fast film for this atmospheric portrait. Contrast is softened and the picture has a distinctly grainy appearance.

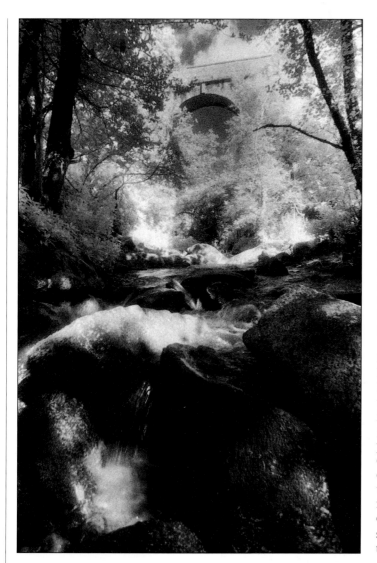

brighter conditions slow films produce exceptionally fine-grained results with good image detail and contrast. Consider using slow films for subjects such as natural history, portraits, and landscapes.

Medium films

The ISO numbers for this group of films range between about 125 and 400 and these films are the most popular, general-purpose black and white emulsions. The benefits from the extra speed they offer amply compensate for any slight increases in graininess. Subjects suitable for this group of films are similar to those for slow films.

Fast films

Fast films are in the range of ISO 400 to ISO 3200. The upper end of this category of films displays a distinctly grainy appearance when printed. If the subject is chosen with care this type of effect can be used to enhance the image. These films are ideal for low-light work, especially when using a fast shutter speed (see pp. 28–9) to freeze motion.

Choice of black and white films All the films in this chart, which is in no way comprehensive, are negative/positive (i.e. they produce a negative film image for printing a positive photograph). All, too, are suitable for home processing. It is worth bearing in mind that, when circumstances demand, most films can be exposed as if they were one or two stops faster than their stated speed. An adjustment in film processing time (known as film 'pushing') will then be needed and there will be some fall-off in image quality. All frames on that film must then be exposed at the same speed, since you can't adjust processing times for just part of a film.
Nominal rating only.

SOME POPULAR BLACK AND WHITE FILMS		
Make	**Brand name**	**ISO**
Kodak	Technical Pan	25
Kodak	Panatomic-X	32
Kodak	T-Max 100 Pro	100
Kodak	Plus-X Pan	125
Kodak	Royal Pan	400
Kodak	T-Max 400 Pro	400
Kodak	Tri-X Pan	400
Kodak	Recording film	1000
Kodak	T-Max P3200	3200
Ilford	Pan F	50
Ilford	FP4	125
Ilford	XP1	400*
Ilford	HP5	400
Agfa	Agfapan 25 Pro	25
Agfa	Agfapan 100 Pro	100
Agfa	Agfapan 400 Pro	400
Fuiji	Neopan 400 Pro	400
Polaroid	PolaPan CT Instant	125

Camera flash

Add-on flash Although varying greatly in shape and style, modern add-on flash units offer tilt-and-swivel movements, variable light output and adjustable beam width, at a handy and compact size.

There are two different types of camera flash: built-in units that are an integral part of the camera (most common with compact cameras); and separate units that attach to a special mounting 'shoe' on the top of the camera (most common with SLRs but also found with some compacts).

Virtually all modern flash units contain a light-sensitive cell that measures the light reflecting back from the subject and controls the duration of the flash exposure. Some cameras with 'dedicated' flash units measure the flash light reflected back from the film itself and cut off the flash light when it is correctly exposed. Once attached to the mounting shoe, these dedicated units become an integrated part of the camera. They lock into the camera's circuitry, changing the shutter speed to that required to synchronize with the flash output, and they receive information from the camera on the aperture set and the film speed in order to determine how much flash light to deliver.

Red-eye
A possible problem with the built-in flash found on many older compacts is known as 'red-eye', since the pupils of people's eyes show up bright red. This is caused when the flash is too close to the

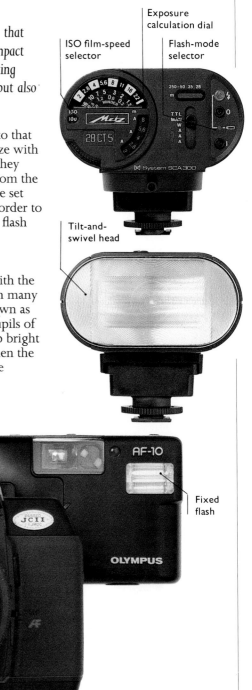

Exposure calculation dial

ISO film-speed selector

Flash-mode selector

Tilt-and-swivel head

Integral flash Built-in flash units, once found only on compact cameras, are now making an appearance on some SLRs (below), further enhancing their ease of use.

Flip-up integral flash

Fixed flash

Inverse square law If you double the distance between flash and subject, illumination covers four times the area with correspondingly less intensity.

camera lens. With fixed, forward-facing flash this is impossible to correct. (Improved design has almost eliminated red-eye on better-quality modern compacts.) SLRs, however, are physically larger, and the distance between flash head and lens eliminates this effect.

Bounced flash

Another problem with forward-facing flash is that it produces stark, generally unattractive results. All modern separate flash units have tilting and/or swivelling heads that allow the flash light to be bounced off the ceiling or nearby wall. Results are softer and more natural-looking. Beware, though, if using colour film, since the flash light will take on the colour of any surface it is bounced off and produce a colour cast throughout the whole picture.

Flash fall-off

The illuminating power of flash falls off rapidly. Every time you double the distance between the flash and the subject, light covers four times the area and, thus, is only one-quarter as strong. This accounts for results common with flash-lit pictures where objects in the foreground are properly exposed while those farther away become progressively darker and eventually indistinguishable. To overcome this, ensure that your flash is sufficiently powerful for the job. Flash power is indicated by its guide number (GN) – the higher the GN the more powerful its output.

Flash fall-off also occurs when the spread of light is not as great as the angle of view of the lens. This produces a well-exposed central area with progressively darkening edges. You either need to change lenses and use one with a narrower angle of view or use a light-diffusing attachment over the flash head. This will have the effect of spreading the light from the flash over a wider area but, of course, will also result in a corresponding loss of flash intensity.

Fill-in flash These shots (above) show how flash can be used to improve balance and contrast in daylight.

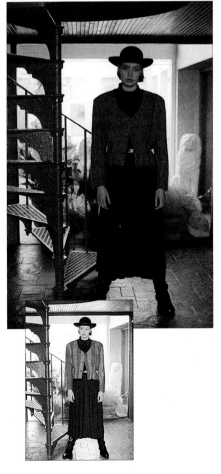

Bounced flash Flash used straight on usually results in unnatural illumination (smaller picture, left). In the larger version, the flash was bounced off a special reflector (below), which attaches to the flash unit itself and overcomes the problem of potential colour casts. The general lighting effect is now far more atmospheric and natural-looking.

Red-eye If the flash and camera lens are too close together, red-eye often results (above).

Colour through the day

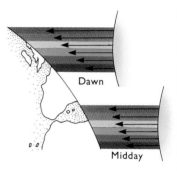

Dawn

Midday

The colour of light At dawn (or dusk) sunlight strikes the planet obliquely and travels through large volumes of atmosphere. This scatters the blue wavelengths, leaving more red. At midday, sunlight is more direct and intense.

It is often the case that some of the best photographs are taken at the least social times of the day — very first thing in the morning or toward sunset, and even on into the night. These are the times when either most of us are still in bed or thinking of putting our cameras away because there is not sufficient light. But light at these times has a special soft and delicate quality.

Learning to get the most out of photography means seeing the world around you with the same impartiality as the camera lens and film.

Early morning light
In the first hour or so of light, the sun shines obliquely on to the earth and the rays of light must travel through a large volume of atmosphere to reach your position. It is the shorter blue wavelengths of light that are most easily scattered and filtered out on this journey, and so the light around sunrise is often tinted a delicate pinky-red. Mist, too, is common first thing in the morning, turning familiar scenes and aspects into

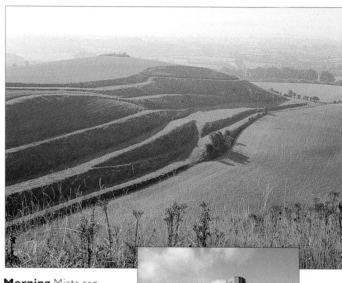

Morning Mists can linger for a few hours after sunrise (above).

Midday Strong colours and short shadows often feature at midday (right).

After sunrise As the sun climbs higher, scenes are often lit by general blue skylight (above).

dream-like visions. To capture these images you must be up well before sunrise. Give yourself plenty of time to adjust to the light. Watch the effect the sun has as it creeps up over the horizon — every second colours intensify as the light level increases and shadows seem almost to race over the landscape.

Midday light
The sun in its few hours since rising has travelled more directly overhead. As a result there is less atmosphere to scatter the blue wavelengths, which now dominate the scene. Contrast is now harsher, more sharply defined. Shadows are very much shorter and denser in

tone. It is often suggested that this intensity of light is something that cannot be used to advantage. It is this very intensity that strengthens and saturates the colours around you. Glare from the sun can be a problem, but even this can be turned in your favour. Taking care not to point the camera directly at the sun, allow the flare from its periphery to increase contrast to such a degree that all around you is rendered as dramatic silhouette. To do this, take your light reading from the bright sky itself, thereby underexposing everything else.

Early evening light
In the early evening, just before sunset, sunlight once more produces a warm, pinky glow. It is interesting that the more polluted the atmosphere, the more dramatic and varied these colours become. Caution is still advised here, since even the

dying rays of light from a setting sun can be sufficiently strong to damage your eyes, especially if focused on with a telephoto lens.

An added bonus at dusk are the first streetlights twinkling on or the glow of house lights. These can add welcome highlights to what are generally low-contrast scenes. Also, if shot on daylight-balanced film (see pp. 32–3) the lights will appear more orange than they really are – an effect although not accurate, nevertheless very acceptable in most instances.

Bear in mind that light levels will be changing virtually by the second. Unless you are using an autoexposure camera, you will have to monitor your light meter readings constantly. A tripod is also extremely useful – it is a pity to miss shots simply because you cannot hand-hold the camera at very slow shutter speeds.

Night light
In large towns and cities there is always enough light for the adventurous photographer. Streetlighting, shop windows, fluorescent signs, illuminated billboards and car headlights all make good light sources for unusual shots. You will have to abandon any expectations of recording colours accurately, but you will be amply rewarded. After rain is often a good time for night photography – wet roads and puddles of water reflect any available light, giving interesting double images and a little extra illumination to help exposure.

Again you will certainly need a good, sturdy tripod. Do not be surprised if your exposure meter fails to respond to what light there is – you will have to operate on a trial-and-error basis by bracketing exposures. This means taking perhaps three or four exposures of the same scene under different shutter speed and/or aperture combinations. Exposure times of many seconds are not uncommon, so you should also have a lockable cable release in order to keep your shutter open longer than its programmed times.

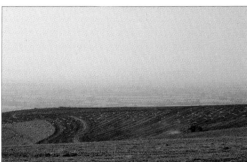

Evening The low sun toward dusk casts a soft, warm light, enlivening scenes with a unique intensity (above).

Night The afterglow of sunset provides some background illumination against which the city lights glow like miniature jewels (right).

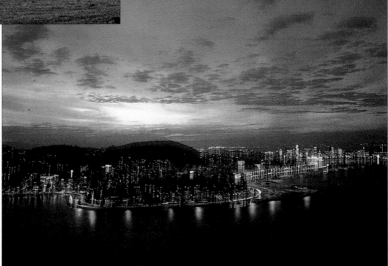

The Basic Techniques Summary

With any craft, the first requirement is total familiarity with the technical aspects of the medium and its tools. To re-cap briefly, the essential elements of any camera are:

1. The lens: collects light reflected from the subject and focuses it at the exact point occupied by the film.

2. The aperture: an adjustable opening in a disc inside the lens. The size of the aperture determines the amount, or brightness, of light that reaches the film, and hence affects film exposure.

3. The shutter: a physical barrier in front of the film that opens for a timed period. The shutter thus determines the amount of time that light passing through the aperture is allowed to act on the film.

4. The viewfinder: allows the camera to be accurately pointed at the chosen subject.

In both compact and SLR cameras, focusing, aperture and shutter may be automatic and/or manual.

Film for the 35mm format camera is available in black and white (from which prints are made) and in colour. Colour film is available as print film or reversal film (also known as transparency or slide film). All these film types are available in a range of different 'speeds'.

When the camera controls, their operation and their functions have become second nature, it is time to concentrate on the aesthetics of photography.

The next section – The Projects – shows camera techniques that are useful in all areas of photography. As each assignment is completed, you will have new knowledge to apply in the next, so that a solid background of photographic skills is gradually built up.

The Projects

THE ESSENTIAL ELEMENTS

The projects in this introductory chapter aim to
provide familiarity with a core of basic photographic techniques.
These include accurately recording the shape, form, and
surface characteristics of objects, the many different types of
colour usage, perspective to give depth and distance,
and composition to give structure to photographs. The basics
of black and white photography are covered for those more
used to working in colour.

First steps Learning to convey the three-
dimensionality and tactile qualities of your subjects and
the appropriate use of colour, are some
of the first steps in photography.

The power of shape

Of all the essential pictorial elements, shape is the most basic to our understanding of objects and scenes. From a distance somebody can be recognized by shape alone, because a figure once robbed of its form, texture or colour is reduced to its most powerful element — that of a silhouette, which is pure shape.

The first stage in this project is to produce a silhouette – perhaps of a person, but equally of any object that has a strong and interesting shape. One of the so-called 'rules' of photography is that you should always have the sun at your back when taking pictures. Well, for a silhouette you must do the opposite, and place your subject between the light source and the camera. For the effect to work properly, take your light reading from the highlight. In this way, the side of the subject facing the camera will be massively underexposed and thus reduced to shape alone. When working outside, your light source will be the sun, but this technique is just as effective indoors, where you can use photofloods or even domestic tungsten lights to give you the extreme contrast needed.

The second part of the project requires you to take a set of photographs where shape is the dominant element and the other elements play a subsidiary role. Examples include a mixture of subjects, but notice that in three of them the figure or object has been set against the sky-line. This is a simple and effective way of emphasizing shape against an uncluttered background. Where shape is part of a general scene, it needs to be very powerful, or it can become submerged.

Silhouettes For the outside shot (above) a light reading was taken from the sky adjacent to the sun. For the studio picture (below) two photofloods were directed on to the backdrop, making sure no light spilled on to the model.

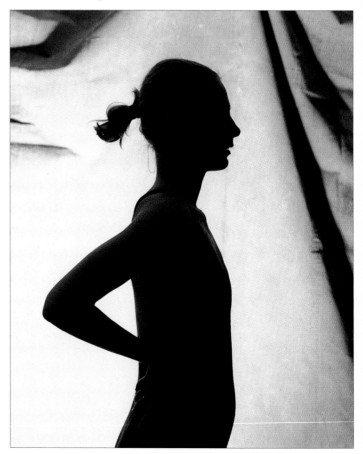

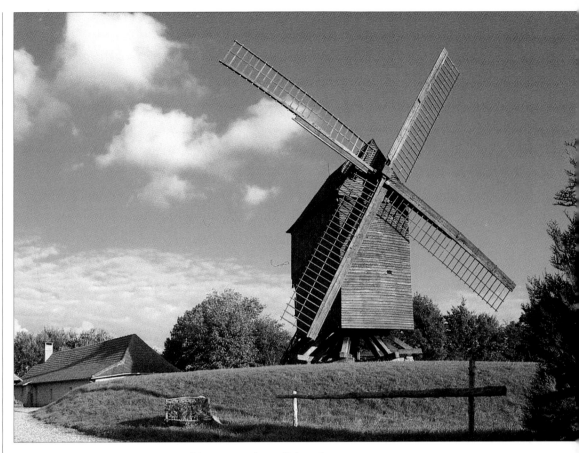

Geometric shapes I was attracted by this Normandy windmill (above) because it is composed entirely of strong geometric shapes.

Dynamic shape In this strongly patterned setting (below) the figure could easily have been lost. However, the diagonals of her legs and torso have produced a dynamism that pulls her out of her surroundings.

Shape vs colour Colour is tremendously powerful (right), yet limited in area. Had his shirt also been bright, the impact of shape would have been lessened.

Shape vs pattern Overcast light in Rio (below) helped to suppress the impact of the pavement mural, allowing the portly policeman to dominate.

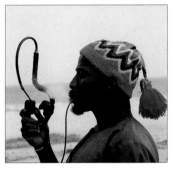

Technical Briefing

To achieve the different pictures for this project, you can use any type of camera. For silhouettes with autoexposure cameras, take a reading from the brightest highlight, lock the reading into the camera's memory, and then recompose your shot for the strongest effect of shape. Bear in mind, though, that looking directly into the sun through a camera can be dangerous.

See also:
Projects 2, 3 and 4

Form that gives substance

Whereas shape can be effective as a two-dimensional description of appearance, form adds the third dimension, that of depth, and hence reality. The appearance of form depends on the way light strikes an object, the transition from highlight to shadow that produces roundness and solidity.

The form, or three-dimensionality, of a subject is a function of shading, either of colour or of tone. An area of flat colour or tone has no impression of depth. It must be graduated.

In this project you can use either natural daylight or domestic or studio lighting to produce studies high-lighting this essential picture element. One common mistake many people make is to overlight subjects, which has the effect of killing form, so keep lighting simple and not multidirectional.

Directional sunlight To take this portrait (below) I pos-itioned myself on the subject's shadow side and turned her head so that the sunlight lit one side of her face. Hence form and texture are both very well described.

Contrasting techniques In this still-life (right) where there is a gentle graduated tone (between wall and window sill) there is still strong indication of depth. The subtle play of light on the cup and saucer accentu-ates their roundness.

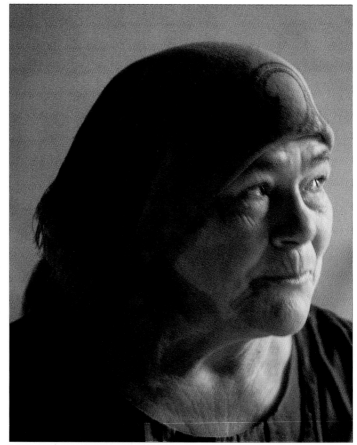

Gentle form With this marrow flower (above), the gentle veining of the tightly curled petals needed equally gentle sidelighting.

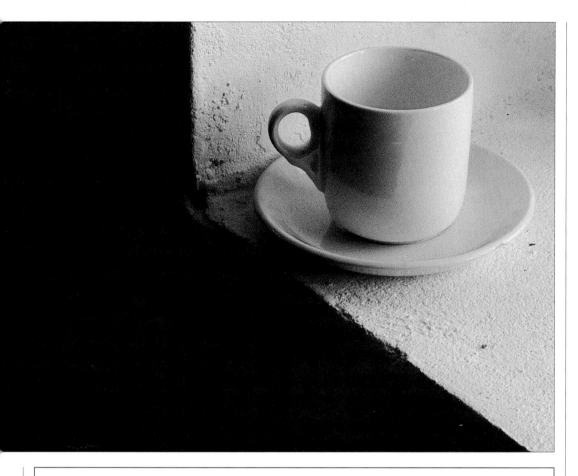

Lighting direction For the first shot of this model (right) lighting was frontal. Shape is well defined but there is little impression of form. Next (below right) the light was moved to one side. For the final shot (below) the model turned so the light struck her at about 45°, thus combining form with a much stronger shape in this picture.

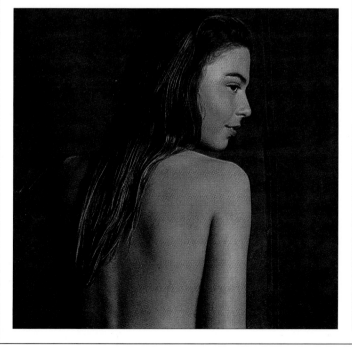

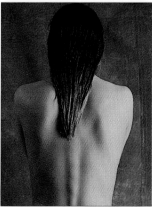

Texture in photographs

Technical Briefing
In order to produce a good representative set of surface textures, it is best to use a wide-angle and a telephoto lens (or a single zoom covering this range). For shots that enlarge texture beyond normal recognition, you will need to use close-up accessories, or a zoom with a macro facility.

See also:
Projects 1, 2 and 15

Texture is the visual interpretation of the tactile surface characteristics of objects and, as such, has an important role to play in nearly all successful pictures. Because touch is so much part of our everyday experience, strong texture in pictures helps to form part of the two-dimensional illusion of reality that is photography.

Capturing texture is the first real refinement of the image, so at the completion of this project you will have reached an important staging point. Texture is the quality of an object's surface, and shows you what it is made of and therefore adds a tactile quality to a photograph.

The appearance of texture is dependent on the angle of light striking the surface. Low, raking light will illuminate high points, casting shadows into dips and hollows, and allowing the real texture of surfaces to be seen, rather than just flat areas of colour. This is true for isolated areas of small detail as well as broad panoramas. Many of the best landscape photographs were taken by the light of a low morning or evening sun.

Texture in context This type of image is not difficult to find (right). The different surface textures dominate without question, conjuring up an almost nostalgic quality associated with a sturdy old building that has finally succumbed to the elements.

Contrasting textures For this picture (right) shallow depth of field was used to accentuate contrasting textures. First there is the smoothness of the arm and stalks; then the roughness of the man's fingers; and, finally, the silkiness of the ring and seed heads.

Composition in texture A flat, restricted light from an overcast sky (below) has reduced texture almost to pattern. It is described by colour differentiation.

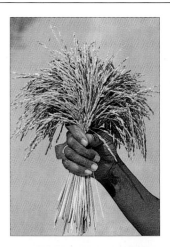

Lighting direction These wooden boards (above) looked smooth in midday sunlight. As lighting became more oblique toward dusk, however, shadows formed in the hollows, thus emphasizing texture.

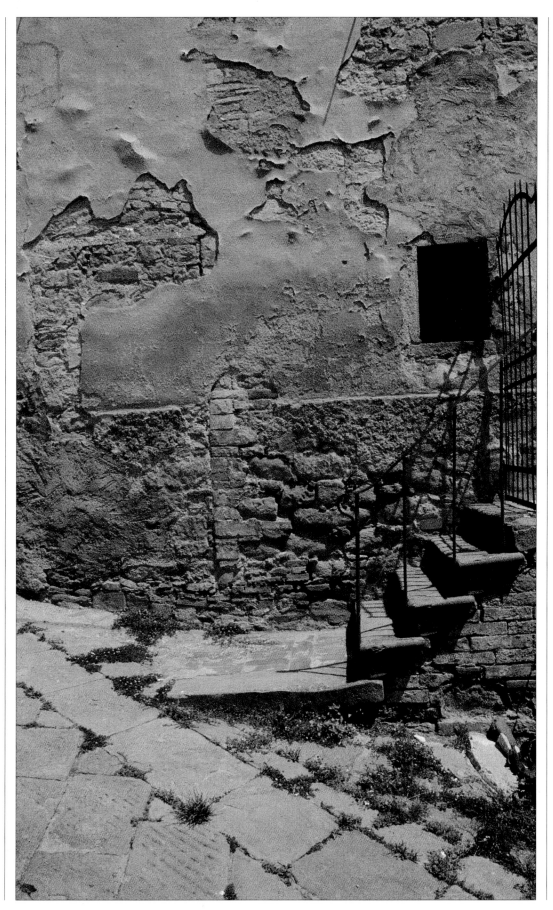

Seeing and isolating pattern

If you look back through pictures you have taken and pick out the ones you find most pleasing, a large percentage of them will probably feature some aspect of pattern. There is a type of instinctual recognition of pattern around us, both natural pattern, and pattern in artefacts and the man-made environment.

This project explores the use of pattern to bring order to potentially chaotic images. By selecting angle of view (through your choice of lens), camera position, and even lighting quality, you will be able to present visual information in a selective way.

When researching locations for this current set of pictures, bear in mind that pattern is more than a simple repetition of shape, such as in a line of hills, an avenue of trees, or the massed formations of roofs in cities and towns. More subtly, pattern exists in colour usage and in tone distribution, in the detailed structure of plants or in people's faces all turned in the same direction.

Sometimes, in order to recognize pattern, a new camera position must be adopted: right down low, perhaps, to capture a shot of legs in a crowded street; or up high looking down from a balcony to see pattern reflected in the roof of a car.

Focal length, too, is significant: a telephoto cutting away the clutter to isolate a small area of pattern; or a wide-angle stretching the boundaries of the frame. As with lenses, so with lighting: often it is the arrangement of light and shade on an object or landscape that is at the heart of pattern.

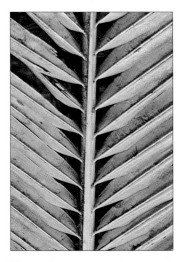

Nature's patterns Nature does not use pattern arbitrarily (above). A 135mm lens shows how a palm frond channels rainwater down to its roots.

Technical Briefing
What is often most important with pattern is being able to isolate elements through your choice of lens, lighting or camera position. An SLR with interchangeable lenses or a compact with a zoom lens is your best choice of equipment. However, if selected with care, many scenes can be shot using a single lens.

See also:
Projects 1, 2, 3 and 10

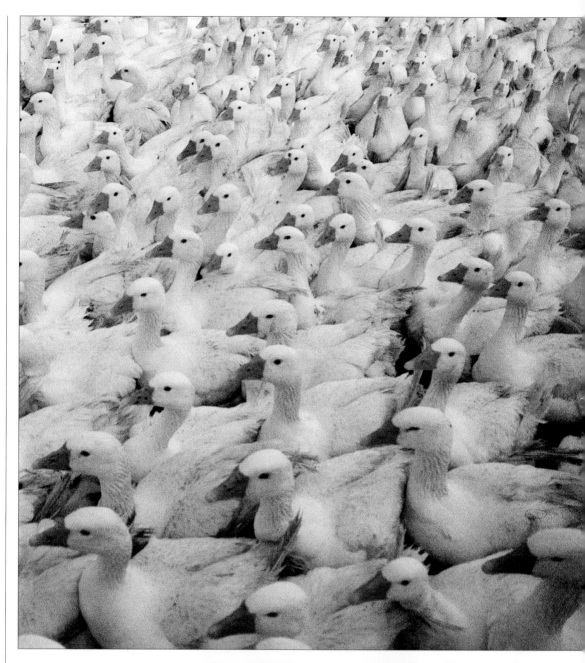

Repeating shapes The two pictures (above and right) demonstrate the importance of camera position on pattern. For the larger picture I stood on the bonnet of my car to isolate the flock of geese. The overhead view focuses attention on the repeating colour patterns provided by their orange beaks and black eyes.

Manmade pattern Strongly evident here (left) is the pattern created by linear perspective. This effect is strengthened by the broad front encompassed by a 28mm lens.

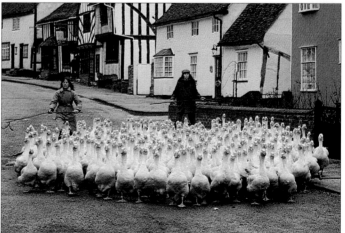

Bright colour and contrast

Colour contrast is most readily understood when you juxtapose the primary colours – red, blue and yellow. Another type of colour contrast occurs when you place a primary colour in close association with its complementary – blue with orange, for example, red with green, and yellow with magenta.

Bright, contrasting colours can create a carnival-like atmosphere in photographs. There is an exuberance or vitality, giving pictures a feeling of movement and gaiety, a spontaneity often lacking in images composed of more sombre colours.

For this project find as many good examples of colour contrast as you can. Good hunting grounds are often amusement arcades, billboards, and street murals, but don't overlook the possibilities inherent in rows of parked cars, houses, window displays and clothing.

Technical Briefing
The degree of colour intensity, or saturation, depends on the light falling on the subject. You might find this project more instructive if you set up and photograph two contrasting coloured objects in bright sunshine and then in the flatter illumination of an overcast sky. If you use slide film, then slight underexposure (half to one stop) tends to increase the colour saturation of the subject.

See also:
Projects 6, 7, 8 and 9

Come and buy Manufacturers use imagery and bright colours to attract children (right). This sweet machine attracted my attention if not my money.

Contrasting primaries It was the contrasting red and blue (below), that caught my eye, but the cut-off legs gave me the starting point.

53

Colour for impact

The manner in which colour is used in photography is a personal choice. Restrained use of colour may sometimes be desirable, and there are times when bright colours can make an emphatic statement, draw attention to particular elements of a composition, or create an air of flamboyance, even extravagance.

In nature we find it easy to accept any colour of foliage with virtually any colour bloom on a single plant, for example, and not think the combination at all gaudy or unattractive. However, with our clothes, wall coverings and furnishings, we all tend to have an instinct, derived from culturaly defined notions of taste, as to what colours look good together. Most of us would probably agree, for example, that red and green don't sit happily together, whereas red and yellow have a certain affinity for each other.

But what is of vital importance is the relative strength and proportion of these colours when they are seen together. And, interestingly, our perception of the strength of a colour has much to do with the colour of its surroundings. In general, a colour seems more intense when surrounded by a darker, contrasting colour and less intense when surrounded by a paler one – an important factor to remember in colour photography.

In this project it should be interesting as well as instructive if you use a model as in the sequence of pictures below. Dress your subject in bright, contrasting colours and then position him or her in as many, widely varying coloured surroundings as you can find, and compare the results.

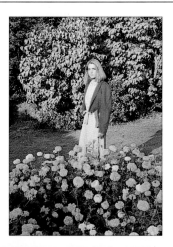

Exercise in colour This sequence of four shots of the same model in very different settings shows the impact of colour. In the first picture (left), blue, red, and green – the jazziest combination imaginable – is made tolerable by the generally flat lighting. Bright sun and the introduction of orange (right) produce pronounced discord. With the two shots below, neutral surroundings (left), and the inclusion of a large area of green hedge (right) lessen the contrast and attention reverts to the model.

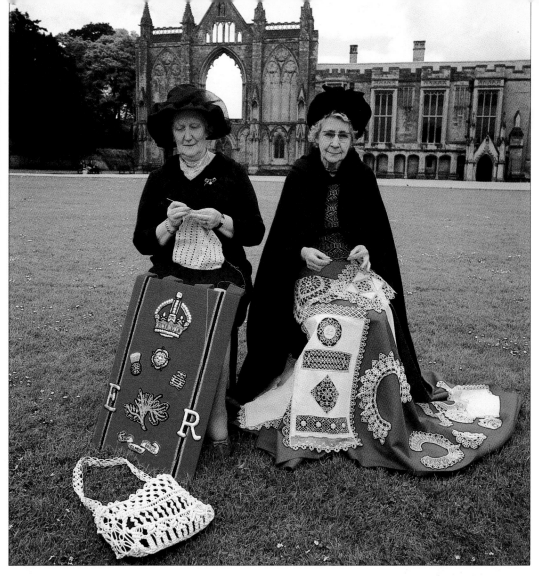

Contrasting primaries The vivid blue and red backgrounds of the needlework (above) contrast effectively with both the green grass and the black clothes.

Colour framing As well as framing the boy's face (right), the jacket colour is bright enough to stand out against the brilliant blue sea.

Technical Briefing
Set up some coloured objects, all the same size, and photograph them against both neutral and coloured backgrounds of varying intensity. The objects' size and distance from each other will appear to change.

See also:
Projects 5, 7, 8, 9 and 63

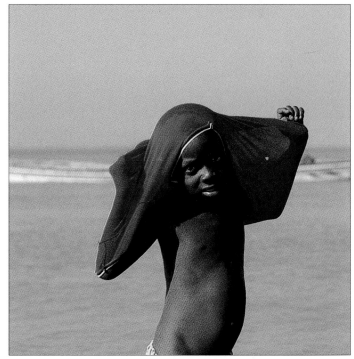

A touch of colour

Technical Briefing
Lighting has much to do with the impact of colour, but of equal importance are your choice of lens (to include and exclude compositional elements), camera position (to determine precisely where and how colours relate to each other in the frame) and aperture. A zoom lens can be a great help.

See also:
Projects 5, 6, 8, 9 and 40

Colour does not have to be widespread to be effective. The degree of impact a small area of isolated colour has depends to a large extent on the hues surrounding it. For example, in the picture on the opposite page where sombre tones dominate, the single red rose, small in the frame, demands the viewer's attention.

Colour contrast In this shot (below) the eye is irresistibly drawn to the vibrant contrast of the man's pink headband against his dark face and hair.

Colours look most striking when placed against a muted background hue. This might be the natural property of the background itself, or due to the fact that it is positioned in deep shade.

Changeable weather conditions, like a sudden gap in heavy cloud allowing a narrow corridor of sunlight to illuminate a small area of the landscape below, often provide the alert photographer with a wonderful opportunity for this type of colour usage.

For this project keep a look out for good examples of small areas of commanding colour within large images. Having found a likely subject, work your way around it, checking in the camera viewfinder all the time to see how the effect you want can best be accentuated. Perhaps you will need to search a considerable distance to find the right angle of view in order to exclude extraneous colours or objects that would lessen impact. A zoom lens can also be of great help, using its variable focal length as a cropping device, all the time refining and honing your composition.

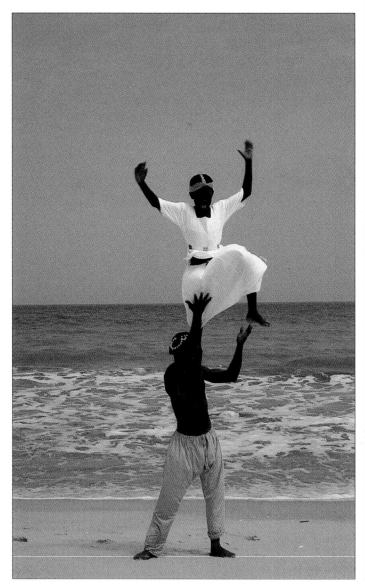

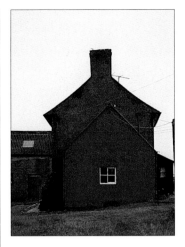

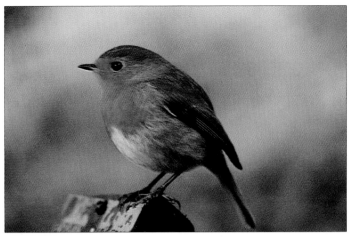

Colour within colour A small area of white (above) in a larger area of red set against muted grey, makes this a composition of colour within colour.

Nature's paintbrush For this subject (above) I used open aperture to diffuse the background and so force attention on the robin's chest.

Symbolic colour Resting sadly on the grave marker set in the church floor (below), this single red rose speaks volumes of love, warmth and remembrance.

Restrained colour usage

All things bright are not necessarily beautiful — a point well worth remembering when shooting in colour. In certain circumstances, a restrained, more muted, and harmonious palette of colours is more evocative of mood and appealing in nature than an ill-planned cacophony of dazzling hues.

Colour saturation is noticeably lessened in low-intensity or diffused light. When the sun is low in the sky (see pp. 38–9), colours tend to merge and harmonize. In mist, fog or rain, too, when everything is viewed through highly diffused light, colour range is softer and more restricted.

For this project, apart from using appropriate weather conditions to produce quieter subject colours, you will need to take comparative pictures of the same subject in bright light and shadow to see the changing effect this has on the scene.

Deep shadow The extremely low light levels (right) meant shooting at 1/30 sec for this picture of feet under a table. The surrounding wood has imparted a warm mellow cast.

Technical Briefing
Fill-in flash can be used very successfully to produce photographs with a restricted colour range. Compact cameras with built in flash usually calculate correct exposure automatically, as do SLRs with dedicated flash, making them easy to use.

See also:
Projects 5, 6, 7, 9 and 35

Sun and shade Whether you opt for bright sun and high contrast or the more subdued effects in shady conditions depends on the type of picture you want – there is no one correct way. In the first version (below left) I placed the group in the dappled shade of a tree; colours are subdued and harmonious and expressions relaxed. In the next version (below right) the noonday sun has brought all the colours alive but the poses seem more rigid.

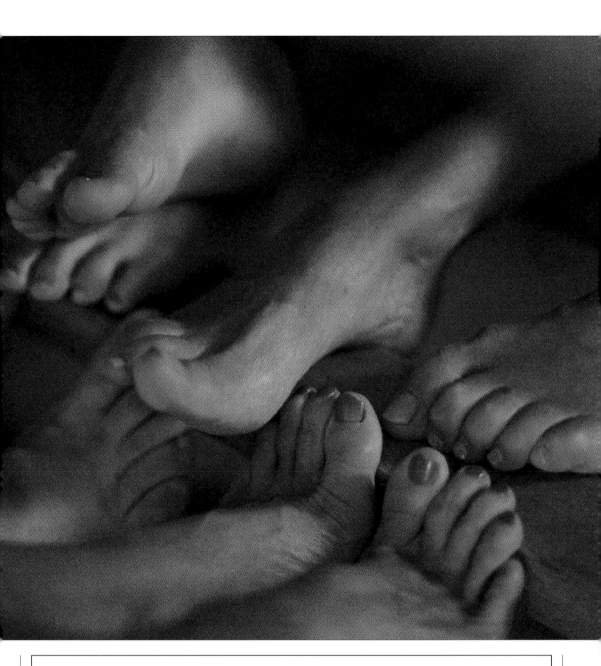

Sunlight and fill-in flash In the first shot (below left) the colour scheme is harmonious, but fill-in flash has killed all contrast and the result is flat. The weak winter sun, however, (below right) has produced just the right level of highlight on the girl's rich red hair to harmonize with the russets and golds of the background leaves. The dark colour of her coat and hat, and the gently green-tinged tree trunks complete this very effective colour scheme.

Diffused colour

Colour diffusion has much to do with the quality of light. Basically, diffused colour lacks the full-bodied saturation associated with strong and vibrant hues. This desaturation can be the result of rain, mist or even smog, where particles in the air scatter light and colours tend to blend and merge.

All-weather photography
In sunlight the colours here (above) would have jarred, but the flat, overcast light has produced harmony.

C olour can also appear diffused because of the surface characteristics of the subject. For example, a matt or textured surface will scatter light falling on it and so dilute the impact of the underlying colour. Conversely, a gloss surface will reflect light without materially affecting the subject's inherent colour.
Another important factor

affecting the sharpness or diffusion of colours is that of focus. Check this by looking at a nearby area of colour. Then, if you view the scene through your SLR viewfinder out of focus, you will see the colour begin to spread and merge with neighbouring colours. Set a small aperture on your lens, say f11–16, then, as you depress the SLR depth of field button, you

will see on the viewing screen that all colour in out-of-focus areas immediately becomes sharp.
As well as taking advantage of naturally occurring examples of diffused colour, photograph at least one pair of comparative pictures: the first with subject and background sharply focused; the next with the same background colour out of focus.

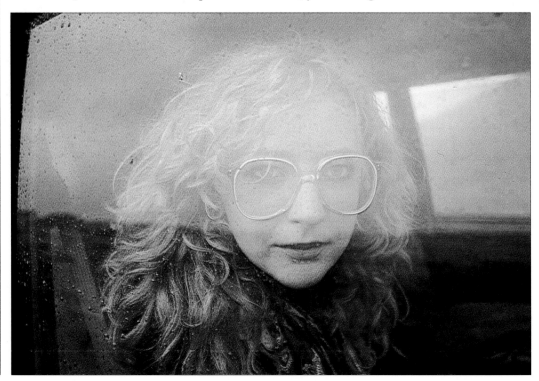

Reflections By overlaying this image of a girl sheltering in a car (left) with the reflected image of sky and land in the window, her brilliant red hair appears muted in colour.

Early morning light The low light of early morning (above) accounts for the subdued colouration. Without the dusting of frost the darker rope would have segmented the image.

Shadowless light Overcast conditions (below) have produced an almost shadowless landscape composed of distinctly different yet harmonious shades of green.

Technical Briefing
In order to preview the effects on colour of differential focus (see pp. 28–9) it helps to have an SLR with a depth of field preview button. With automatic cameras, remember to switch to aperture-priority mode in order to take the comparative pair of pictures. If this is not possible, select a shutter speed that forces the camera to set the apertures you need.

See also:
Projects 5, 6, 7, 8 and 35

Tone as a picture element

You are most likely to know about tone in the context of black and white photography, where it refers to the range and strengths of greys in an image between solid black and pure white. Tone, however, also applies to colour — its various hues, shades, and tints — and can be used to great effect.

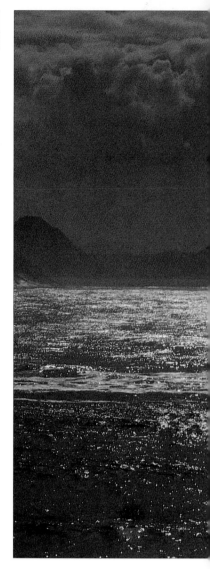

This project aims to show that tone is yet another layer of communication between yourself and the picture's audience. Just as texture, for example, tells the viewer how an object might feel if handled, so the selective use of tone communicates the form, mood or atmosphere you want to convey.

In this project you will need to produce a set of pictures that, because of their tonal content, achieve a wide range of different moods. Images composed predominantly of dark tones, for example, can often be read as enclosed, sombre, threatening, even furtive and 'not really intended for your eyes'. These are known as 'low-key' images. On the other hand, pictures full of light tones can be regarded as candid, spacious, open and relaxed, and are known as 'high-key' pictures. Images can be studio shots (below) or general views (right).

High and low key With tone, as with colour, you do not necessarily want a 'perfect' exposure. Overexposure in transparencies (below left) can further lighten and brighten a high-key shot, while underexposure (below right) can cause shadows to become more dense for a low-key effect. You will notice that where the model's face is hidden in shadow, you start to become more concerned about her situation than her mere physical appearance. In contrast, the high-key image concentrates your attention on the face.

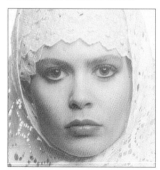

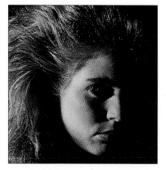

Technical Briefing

Tone needs to be interpreted by the camera, using factors such as exposure, lighting direction, surface qualities of the subject and the contrast-recording abilities of your film. With black and white, all colour is reduced to shades of grey, hence your main ally becomes the juxtaposition of tonal contrast. This can be drastically manipulated with filters, either strengthening or subduing the effect, and making high-key or low-key images.

See also:
Projects 1, 2, 3 and 4

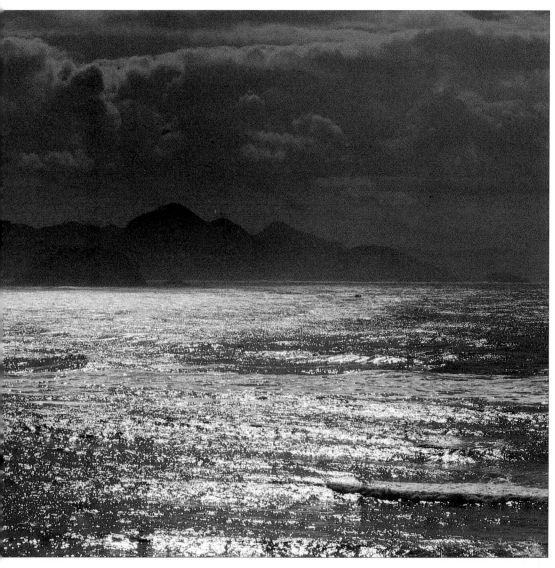

Tonal contrast In some respects, this was a lucky shot (above), taken with a compact camera set on automatic. For an instant only the sun broke through the heavy clouds producing this intense high-light. Had I had more time, I might have zoomed in on the high-light, producing a bright-seeming, sunny picture. Had I concentrated on the land and clouds, it could almost have been taken at night. Here it is the tonal contrast that has given the power and drama.

Muted tone Early-morning mist over the desert (right) softened and subdued further an already limited tonal range. The feeling of depth and distance is heightened by the gradual lightening of tone toward the distant pyramids.

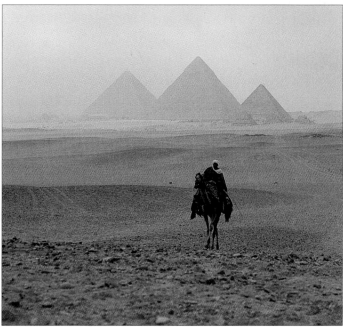

Black and white or colour

Colour photography is undoubtedly the most popular medium and some 95 per cent of all film sold worldwide is either colour print or slide material. Unfortunately, most people when buying a camera for the first time automatically choose colour film and never explore the potential offered by the black and white medium.

Colour version Seen in colour, this Yorkshire farmhouse has an inviting quality; the countryside, though rugged, seems open and invites thorough exploration.

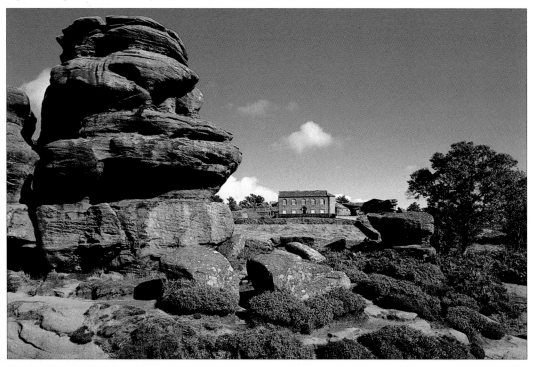

Colour adds realism to a photograph. We live in a world of colour; our thoughts and our dreams are in colour; and we use colour symbolism to denote moods and emotions. So why then with colour film so easily accessible and versatile does black and white film still have its enthusiasts?

The easy answer, ironically, is that it removes that very quality of realism that is so often thought desirable in photography. With colour gone, the picture is a mere interpretation of the scene. In a real sense, all photography is an abstraction; it is a two-dimensional illusion of what is in reality a three-dimensional world. Shooting in black and white simply takes this process a stage further, allowing the photographer to interpret rather than record.

For this project you will require a roll of colour and a roll of black and white film. Ideally, you will also need a second camera. Shoot both rolls of the same subject, but in the colour picture take care to balance the colours and various hues, and with the black and white try to increase the drama of the picture using the shadows and highlights to create maximum tonal contrast.

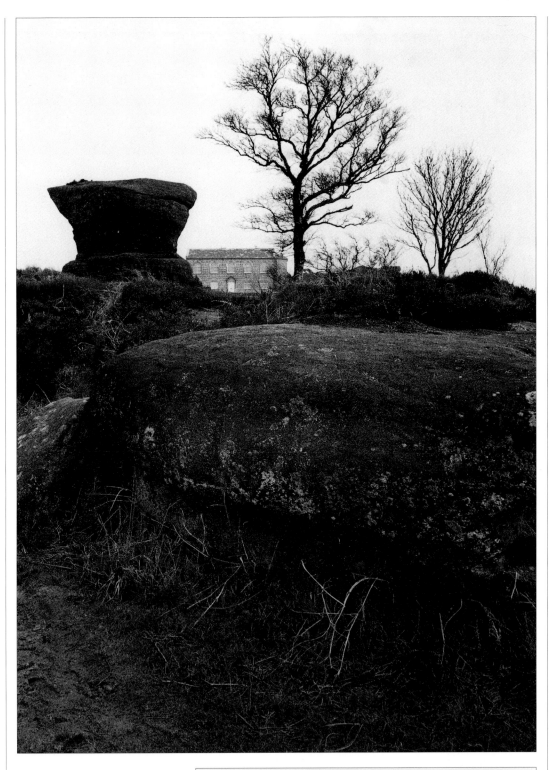

Black and white version Here is the same farmhouse, this time in winter and from a different angle. The scene has now taken on a sense of drama, almost of malevolence. Also note how tonal contrasts, such as the dead foreground stalks against the dark tone of the grass, assume far more importance.

Technical Briefing

If you use two cameras you will be able to take identical versions of the same scene on both films. If possible, use different lenses, make the most of the colour and the various tones from black to white and change angles of view.

See also:
Projects 12, 13, 14 and 39

The tonal range

In black and white photography, the term tonal range refers to the variety of greys between pure white and black. Many large photographic stores stock a specially printed grey scale, which shows the complete range of tones. Each tone on this scale represents one f stop of exposure as you go from black to white.

Our perception of tonal value, and film's response to it, are determined not only by the intensity of light, but also by its direction and by the surface characteristics of the object it illuminates – i.e. how much light the surface absorbs or reflects.

If you are inexperienced with black and white, this project is very important. Using a high-contrast subject, you should make three exposures – one using a highlight reading, one a shadow reading, and finally an averaged reading of the two previous results.

Technical Briefing
In order to take highlight and shadow readings successfully, you need to know what type of metering system your camera has – centre-weighted, spot, averaging and so on. Check your user's manual. Another important pointer to remember for this project is that the tonal differences between your project pictures will be seen much more distinctly if you use a slow, fine-grain film.

See also:
Projects 10, 11, 13, 14, 28 and 39

Full-tone Although predominantly dark, the image of a milk pail (right) contains a full range of well separated tonal values between black and white.

Low-key In this case the picture (below) consists mainly of tones between mid-grey and black giving an overall effect that is much darker.

High-key In this photograph (above) tones range from white to mid-grey. This has created an image containing mostly light tones and is, therefore, generally referred to as high-key.

Using light tones

Just as colour and its intensity can determine mood and atmosphere, so too can the tones in a black and white photograph. By restricting the tonal range to mid-grey and lighter tones, as is generally the case in the photographs on these pages, it is possible to imply brightness, openness, candour and space.

In this project it will be useful to enlist the assistance of a person to act as your model. The objective is to produce a set of pictures with a restricted, high-key tonal range. Dress your model in white or pale colours. Lighting should be frontal, bright, diffused daylight or diffused studio lighting. Take your first exposure as recommended by your light meter, then another, half a stop overexposed, and then a third exposure a full stop overexposed, and compare the results.

Back lighting Although my subject, Marc Chagall (above), was wearing dark clothes, I took a shadow reading so the result was high-key.

Reflected light Strong sunlight reflecting back from the wooden boards (below) gave soft, detail-revealing illumination.

Reflective surfaces Surrounded by light, reflective surfaces, this boy's first haircut (above) was certainly a high-key affair.

Overexposure One-stop overexposure (left) ensured that all tones were high-key.

Technical Briefing
If using a fully automatic camera that does not allow you to overexpose easily, use the back light compensation dial, available on many cameras; or override the DX film-speed setting and dial in a film speed slower than the one you are using. This will force the camera to increase exposure.

See also:
Projects 10, 11, 12, 14, 18 and 39

Using dark tones

As demonstrated in the previous project, restricting the tonal range of a photograph tends to generate a particular mood. By allowing mid-grey to black tones to predominate, it is possible to impart a feeling of sinister foreboding, confinement of space, mystery and menace to your picture.

By this stage it is becoming apparent that there is no single 'correct' exposure – an image is too light or too dark only if its appearance does not conform with the photographer's interpretation of the way it looks.

This exercise is to produce a set of photographs with a restricted, low-key tonal range. As before, you will need a model, but this time dressed in dark, sombre-coloured clothing. Illumination should be muted but directional (not diffused) daylight or studio light. Take the first shot using the settings recommended by your meter, the second, half a stop underexposed, and when printing, use contrasting paper and print darkly to make a dramatic picture.

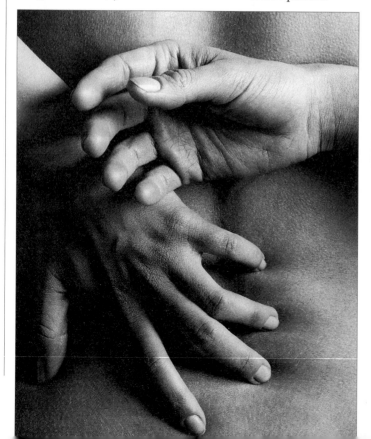

Dramatic lighting Here the aim was to show form and modelling (left). The idea was to emphasize drama within the form using directional lighting to create plenty of contrast and produce a very dark cave-like effect in the cup of the hand, and shadows to make almost gully-like indentations in the surface of the skin.

Age vs youth A close-up of an ancient, gnarled root and trunk (above) has isolated a largely low-key subject. Looking beyond these, however, the saplings seen against a pale sky seem to be signalling their youth by being presented in a comparatively high-key way and adding another dimension to the picture.

Technical Briefing
An additional factor that determines the tonal compostion of black and white images occurs at the post-camera stage, in the darkroom. Soft grades of printing paper are capable of reproducing more tones of grey than hard grades, thus helping to manipulate the mood of the image.

See also:
Projects 10, 11, 12, 13, 28 and 39

Perspective in photographs

Perspective is an indicator of depth for the photograph as a whole. In essence, perspective gives the visual impression that you are looking at a three-dimensional scene. The main types of perspective used in photography are linear perspective, aerial perspective, overlapping forms, diminishing scale and differential focus.

Differential focus For this effect (above) I used the widest aperture and closest focusing distance. This has projected the sharp rose forward while pushing the others way back.

F or this project a set of five photographs, each one making strong use of a different type of perspective, is required. In aerial perspective you need to make use of the fact that colours and tones lighten and tend toward blue as they recede. With overlapping forms, the objects must be at different distances. Likewise with diminishing scale – things appear smaller as they recede. Linear perspective is most readily evident when you see lines you know to be parallel (railroad tracks, for example) appear to converge or even meet in the distance. For differential focus, focused and unfocused objects must be at different distances from the camera.

Diminishing scale The largest element in this picture (above right) is the foreground head. This leads us back to the seated monks, and then the two figures in the background. Their greatly diminished size gives the illusion of depth.

Linear perspective Although this picture has many varied patterns (right), it is the linear perspective created by the central path that dominates. The effect has been heightened by using a wide-angle.

Aerial perspective The progressively lightening tones in this photograph of the Swiss Alps (above) immediately tells us that each peak is farther way than the last.

Overlapping forms Here the overlapping forms of the tombstones and church doorway (left) tell us that the picture has depth. Diminishing scale is also implied.

> ### Technical Briefing
> You can use any camera but if you have only a wide-angle lens then differential focus effects can be difficult to achieve, since depth of field at every aperture is extensive. You must ensure that the near object is very close up to the lens and well separated from the others.
>
> **See also:**
> Projects 2 and 16

Fore-, middle and background

This is the first of four projects on photographic composition and, as such, deals with the most basic compositional element — that of foreground, middle ground and background. These image planes are, like perspective, powerful indicators of depth and distance in the two-dimensional photograph.

Technical Briefing
All manner of compositional devices are at your disposal when defining image planes, and none of them is dependent on equipment. First there is subject placement; then comes colour harmony or discord; next selective focus and depth of field; and then on to exposure and lighting, diagonal line, and so on. Recognizing this aspect of photography is more a matter of perception than of equipment.

See also:
Projects 9, 17, 18 and 19

Your first project on this subject is to produce at least three photographs that stress, individually, the foreground, middle ground and background of your compositions.

Think of the three image planes as areas in which you can place subject elements to create a deliberate effect or to highlight a particular part of the frame. It is usually best to have only one dominant element in a picture, with all others having subordinate, yet supportive, parts to play. In this way one image plane is immediately assigned a dominant compositional role.

The first thing a picture needs to do is to attract the viewer's eye. Then, if as a whole the subject matter warrants it, the eye is led around the image planes taking in the detail. Therefore placement of the dominant feature is vital.

Background Establishing a foreground feature gives a sense of immediacy, but the poles in no way distract from the church (below). The middle-ground gondola adds atmosphere without competing for attention.

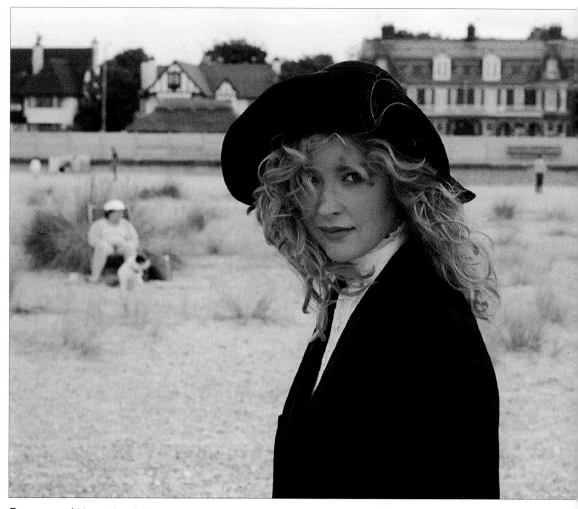

Foreground Here, the girl is obviously the subject (above), but looking past her, we can still see the supporting players in the middle and background. An aperture of f8 on a 50mm lens ensured that focus was limited to the foreground.

Near middle ground The diagonal lines formed by the car (above), plus that of the wall, firmly fix attention on the dog and also seem to thrust it deeper into the frame. Colour harmony then takes the eye to the sodden players farther back.

Middle ground Sandwiched between two dark image planes, this cathedral and township in Peru (above) seem almost plucked out of the frame by the intensity of the light. The well-lit background hills complement, not compete.

Horizontal slices The image planes in this shot (above) are a series of horizontal slices. Foreground, middle ground and background are well defined, but since they all contain only simple subject elements there is a sense of unity.

Using frames in photographs

Another compositional element that plays an important role is framing. In fact, most of us instinctively use frames of one sort or another when composing pictures. But frames can also be more positive than this, and more subtle, and can be of immense help in placing greater emphasis on the main subject.

For this project you will be expected to use your imagination and, in separate photographs, show the use of as many different framing devices as you can. Frames do not have to be something apart from the main subject, such as a branch or an arch. Equally, a frame could be a hat or coat collar used to frame a face.

In most cases you will want the frame to complement and support your subject, rather than distract from or conflict with it. If you are using colour, think how it can influence mood and atmosphere through contrast or harmony.

Technical Briefing
You need no particular camera or lenses for this project, but bear in mind the supportive role frames should usually play in picture composition. There is always the danger that a thoughtlessly used framing device will distract attention from your primary subject.

See also:
Projects 16, 18 and 19

Hands and hair The diagonal thrust of this picture (below) is emphasized by the position of the girl's hair and hands as a frame for her face. Her hands also help to fill blank areas.

Doorway A very simple framing device is a doorway (below). Here, the tonal contrast between the white frame and the dark background projects the subject forward.

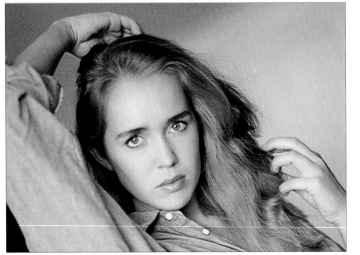

Frames for depth The effect of this framing device (above) is to draw you deep into the photograph. Minor detail gives interest without distracting you from the main subject.

Foliage The use of foliage in this picture (below) helps to prevent the background overwhelming the figure and it also cuts down on potential glare from the white wall behind.

Window This is a conventional framing device (below), but one intended by the designer of this garden in Kashmir. Seats are provided so that the garden can be viewed as a living picture.

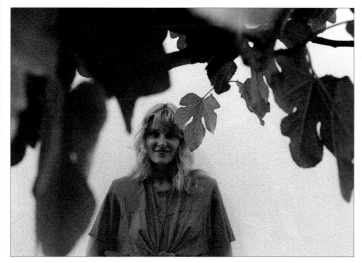

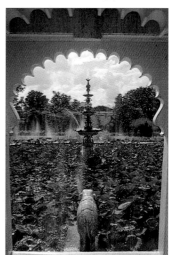

Using unusual viewpoints

Without even realizing it, the vast majority of photographers take nearly all their pictures from much the same viewpoint — that is from a normal standing position. With only a little thought about viewpoint you will often be able to give a new and arresting insight into what are very familiar situations.

Technical Briefing
This project demands a careful and thoughtful approach. While fine-tuning your approach, be prepared to shoot a lot of film, working your way right round the subject. Later you can sift through the results, isolating and analysing the ones that have something different to say. Initially, these subtle differences are often easier to see once the scene has been reduced to the two-dimensional format of a photograph or slide.

See also:
Projects 16, 17 and 19

For this third composition project you need to produce a set of pictures, each one taken from a viewpoint that either introduces an unusual association with, or that challenges our normal perceptions of the subject. Think about how to interpret your subjects, spending time working out shooting angles and lenses.

Overhead view For an unusual view of this model (right) I arranged her red hair like tongues of flame.

Half view You can often produce an unusual viewpoint (below) by what you leave out rather than include.

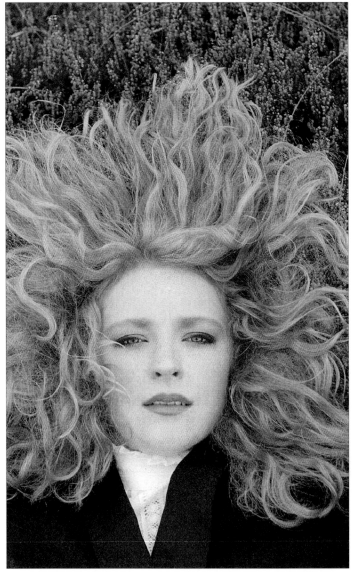

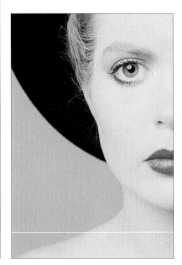

Shooting from below These
two pictures (above and left)
illustrate that a low viewpoint
and wide-angle lens can pull in
subject elements that might
otherwise be missed. Both
shots demand increased atten-
tion on the part of the viewer
simply by the inclusion of the
two ceilings.

Centre stage By way of con-
trast, this seemingly straight
viewpoint (right) says some-
thing obliquely about the sub-
ject, painter Graham
Sutherland, whose own work is
so characterized by human
figures in isolation.

Emphasizing elements

Technical Briefing
Although the rule of thirds is an important consideration, it is not always relevant – many other factors have to be taken into account, depending on the atmosphere you want to create. As with nearly all aspects of composition, subject arrangement is more a matter of being sensitive to the impression made on the viewer, and is not dependent on any particular type of camera or lens.

See also:
Projects 16, 17 and 18

One of the ways of emphasizing specific areas of your composition is to position significant subject elements using the 'rule of thirds'. If you divide your frame vertically and horizontally into thirds, then anything positioned on one of these lines, and particularly where the lines intersect, will have additional impact.

Instinctively many of us follow the rule of thirds when composing photographs: for instance, by ensuring that the horizon is one-third from the tip or bottom of the frame instead of dead centre; or a tree or building is one-third into the shot from the left or right when acting as a frame for a subject. The perverse thing about rules, however, is that you can also make a positive statement by deliberately breaking them.

For this project find an open area with a broad sweep of largely uncluttered horizon. First, take a picture with the horizon centred in the frame, then another with it one-third from the bottom (emphasizing the sky), and finally one-third from the top of the frame (emphasizing the ground). Comparison of the finished images will give a good idea of the different atmospheres that can be created by the judicious placement of the important subject elements.

Central horizon I saw the scene (below) as an abstract arrangement of shape and colour, an impression reinforced by the central horizon.

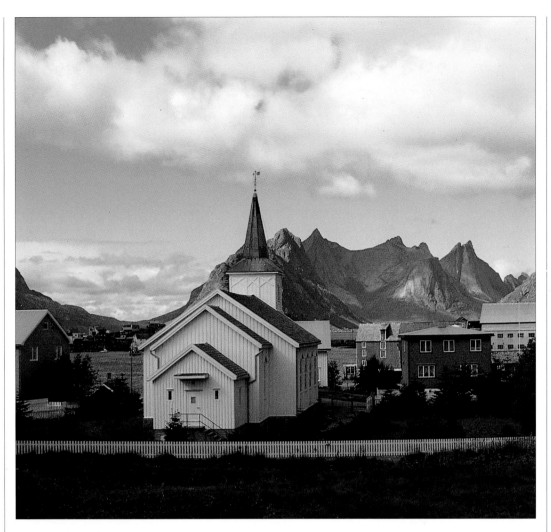

Intersection of thirds The cannon (below) is strategically placed at an intersection of vertical and horizontal thirds in this composition which is dominated by circles.

Shape as emphasis In this Norwegian scene (above), there is a rhythm created by the church gables and distant peaks. The single splash of red is one-third into the frame.

Central figure This is an example (below) of placing an important feature centrally to foster a slightly unrealistic air. The surroundings give the appearance of theatrical props.

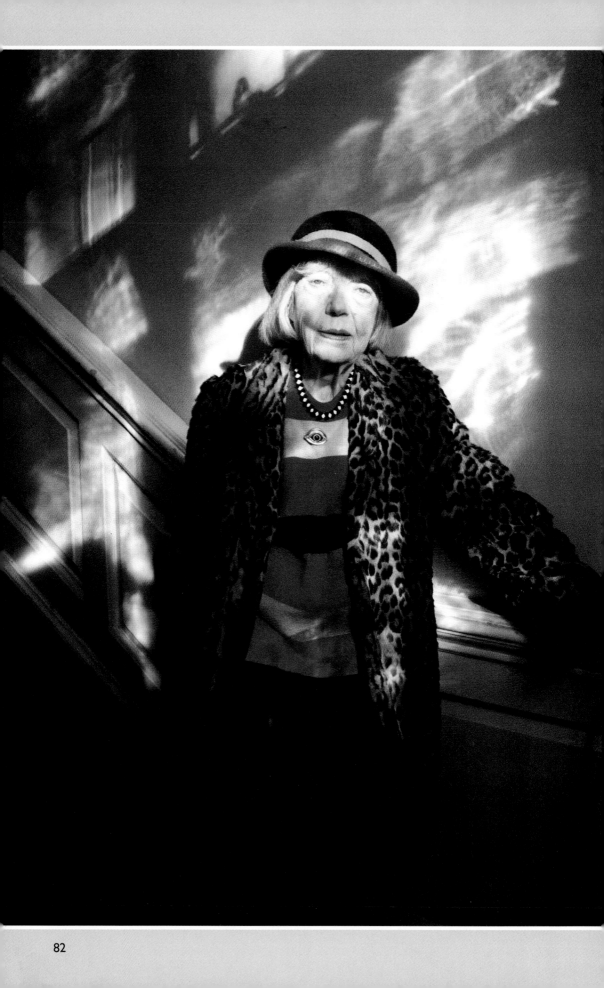

PEOPLE

Of all the areas of photographic interest,
taking pictures of people must rate as one of the most
popular. Projects in this chapter build on the techniques learned
in the previous one, and are applied in such practical
situations as using natural light and artificial
light with single figures and groups, the use of props,
photographing children, and street portraits.
Throughout this chapter the emphasis is on learning to
interact with the subject in order to record more than a mere
physical likeness.

A painterly light A vital component of portrait photography is
lighting quality. Here parts of the image appear bright only in
contrast with the poorly lit stairway. More intense illumination
would have pushed contrast up and caused the subject, the
Surrealist painter Eileen Agar, to squint.

Portraits in natural light

Portraits in particular demand careful lighting, and daylight is often the easiest and most appealing light source to work with. The pioneering nineteenth-century portrait photographers depended almost exclusively on daylight, the best producing powerful studies still considered hauntingly beautiful today.

Although perhaps not immediately obvious, there is more than one type of natural daylight. Sunlight from a clear midday sky entering a room from a small window, for example, acts as a spotlight, brightly illuminating one side of your subject. Conversely, indirect light entering through a large window (or a small window diffused with tracing paper) gives a more gentle effect. There will still be light and shade on your model, but contrast will be less extreme.

This project is designed primarily to allow you to discover the different lighting effects achievable using natural sunlight. You will need to take a number of shots in different qualities of light: sunlight diffused by clouds (or through diffusing material over windows); direct sunlight; direct sunlight bounced off reflectors made of various materials (see pp. 206–7). Also, to gain a better understanding of how different lighting suits different people, practise on several models, both old and young, male and female. Use a variety of poses, in both hard and soft lighting to see which works best.

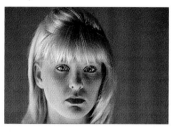

Full face Here I positioned the model in direct, undiffused light and used a reflector under her face to give a little uplighting.

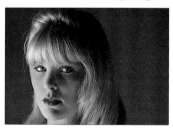

Three-quarter By turning the girl's face to give a three-quarter view, form and modelling are immediately stronger.

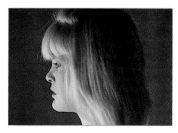

Profile A variation of poses that can be used on any subject. Experiment with various lighting and viewpoints to get the liveliest pictures.

Technical Briefing
The type of reflector used makes a vast difference to the quality of the light. For instance, one made of matt-white cardboard gives a soft, diffused effect, while one made of kitchen foil gives a much crisper, brighter light. A mirror could also be used to reflect light; a good-quality mirror should reflect, reasonably accurately, the same quality of light it receives.

See also:
Projects 1, 2, 3 and 48

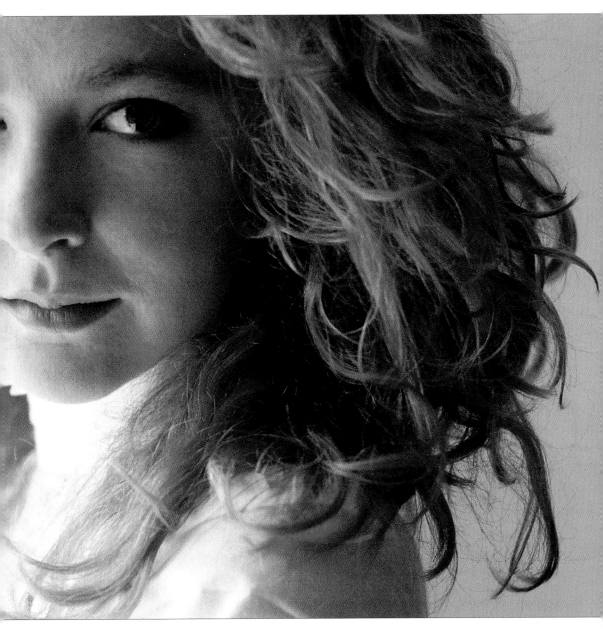

Direct and diffused light For the first shot (below left) I placed the tripod-mounted camera between the model and the window. To avoid blocking the light with my body, I fired the shutter standing off to one side using a long cable release. In the next shot (below right) I moved her back farther from the window and used reflectors either side of her face for a flatter tonal effect. In the large version (above) I moved in close to exclude most of the background. She is now positioned to one side of the window with a reflector to the right of her face.

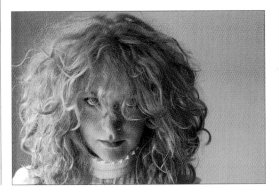

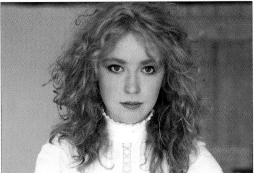

The figure in available light

Many of us buy a camera primarily to take pictures of people, in order to have a record of friends and family over the years. The vast majority of these pictures will be taken by available light — that is either natural daylight or light normally available indoors, including ordinary domestic tungsten lighting.

Technical Briefing
Lighting for your shots should be only existing light, either natural daylight or ordinary room lighting. Sometimes, daylight indoors coming from a source such as a window can become concentrated and thus inappropriately contrasty. If so, you can tape tracing paper over the glass to diffuse and soften its effects. If shooting by artificial light with slide film, use either filters (see pp. 204–5) or the correctly balanced film to avoid colour casts (see pp. 32–3).

See also:
Projects 20, 23, 24 and 26

The composition of your picture is partly determined by the colour, shape and form of your subject, which are affected by the direction and quality of your lighting. But giving life to the picture very much depends on the mood and expression brought out by the interaction between subject and photographer.

In executing this project there are two basic ways of approaching your subject. First, by using a close viewpoint, a telephoto lens (see pp. 26–7), or a very restricted depth of field (see pp. 28–9), you can concentrate attention on the figure and exclude extraneous parts of the environment. Interest will then be concentrated only on your subject.

The second approach is to show a single figure in an environment of some sort. You can achieve this by adopting a more distant viewpoint, using a wider-angle lens, or selecting an aperture that gives an extensive depth of field. However, you must ensure that elements that appear in the foreground or background work in a positive way, giving the photograph added impact and enhancing rather than conflicting with your main subject.

Formal composition Posing outside the church (above) this Italian priest relates strongly to the setting.

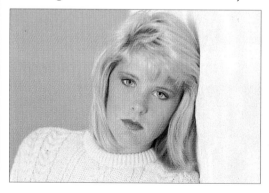

Isolated figure When I selected the setting for this model (above), I was largely motivated by her skin texture and hair colour. The plain white and beige of the walls lit by soft natural light were perfect for a delicate, high-key interpretation.

Available light indoors Here I was shooting indoors (above) using domestic tungsten lighting and artificial-light film. Although the composition is simple, the sweep of the wall lights add an important dynamic feature to a static scene.

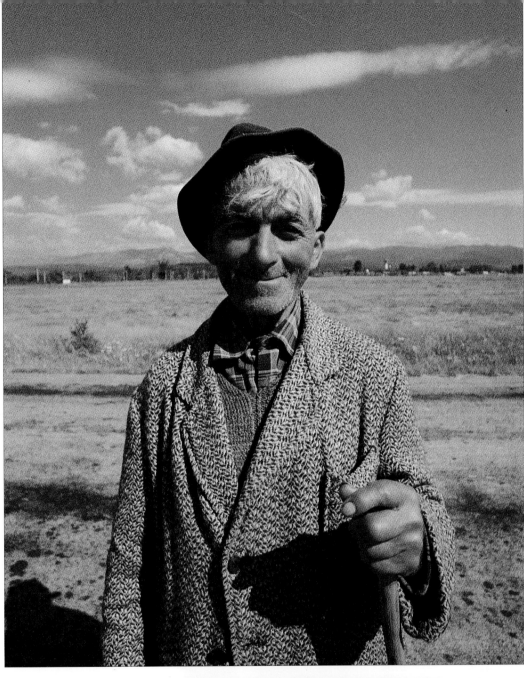

Facial expression In this picture of a Romanian shepherd (above), facial expression tells us much of his character – good humoured, open, and expressive. Even while I was taking his picture, he told me numerous funny stories through an interpreter about his life and work.

Perspective It is linear perspective (right) created by the bench seat and back that takes the eye to the elderly farmworker. Only after taking in her form do we start to explore the rest of the setting, which adds to our mental picture of a rural scene.

Composing group shots

Everybody who uses a camera has at some time tried to compose a group photograph — a family gathering, a group of friends, the local football team, and so on. Often the results are straight record shots, with personnel arranged simply to allow everybody to fit within the confines of the camera's viewfinder.

Y ou will need the co-operation of a handful of willing subjects for an hour or so. This should not be too difficult. Many local groups (drama societies, for example), are always on the look-out for useful publicity stills.

The object is to take three or four pictures of this group in a variety of poses, each one displaying how composition alters their apparent relationship to each other and their surroundings. The idea is to get right away from the usual line-up of bodies across the frame.

You will find it easier to create an impact with your pictures if it is immediately apparent when somebody looks at them why you took the shots in the first place — in other words, if your pictures have a dominant theme. Once you have this theme, you should be able to find a logic in the different arrangements of personnel for your project pictures.

First steps To show an unthinking approach (above right), I asked these people to form a line across the grand hall. By contrast (right) the varied heights and positions make you study each figure.

Interest through depth In this radically different approach, using lines of people going away from the camera has introduced more depth to the arrangement and also strongly implies status.

Tighter cropping This version (right) requires a considerable control, carefully arranging people so that each can be clearly seen. Increasing the apparent shooting height also focuses attention very firmly on the decorative walls.

The group in context By changing to a wide-angle lens (below), pulling farther back, and placing the group off to one side, emphasis has shifted to the hall itself.

Technical Briefing
In many instances, you will find a tripod invaluable, allowing you to adjust individual poses while maintaining precise framing. A wide-angle lens may be useful for portraits of large groups of people.

See also:
Projects 25 and 26

Enhancing the image

Good, dramatic picture-taking opportunities sometimes occur because of a fleeting trick of the light, a chance combination of light and shade, for example, or a colour tint from nearby reflective surfaces. Each of these, and there are many, many more, can be turned to your advantage if you are alert to such opportunities.

Simple light and shade This type of image (above) is possible with any camera. Here I used a compact, locking a highlight reading into the memory before placing the girl in shadow.

With portraits relying on natural light, there is always an element of luck involved. Certainly, for a simple like-ness, most types of lighting will be adequate. But here we are attempting to go beyond that, and to produce images that make the viewer stop and think about the how, why and where of the subject or situation.

You must regard this pro-ject as an on-going, long-term theme, since it depends on you being in the right place at the right time. You can improve the odds a little, however, by staying alert to those fleeting and rarely predictable lighting effects, noting the exact time and place that they occur, and then returning the next day at the same time. So rather than building an elaborate set or designing a lighting arrangement in a studio, find the lighting you want and take your model to it.

Shadow as subject For this picture (right) the model's face is used as a backdrop for the shadow of the fern. The camera was on automatic and produced a perfectly suitable averaged reading for the shot.

Variations on a theme I used the orange-tinted light of the setting sun (above left), taking my exposure reading from the face. A

few seconds later (above right), I opened up one stop and breathed lightly on a lens filter to spread and diffuse the light.

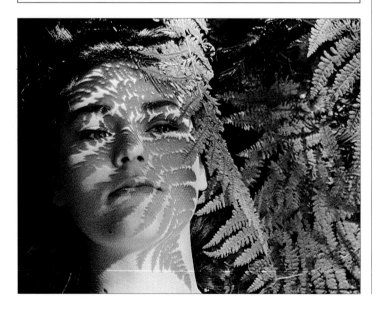

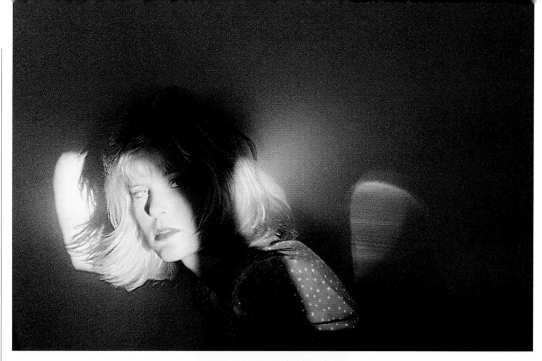

Dramatic light and shade
Here, contrast was extreme
(above), with a high-intensity
spotlight of sunshine illuminat-
ing the girl's face. The rear
highlight is in fact a reflection
from her hair.

Shadow and shape It is largely
the sympathetic shapes (right)
created by the cast shadows
from the window and the
model's hat and neckline that
give this picture its strength.

Backlighting After positioning
this model (below) directly in
the beam of sunshine, I took a
shadow reading, turning her
blonde hair into a radiant halo
of white.

Lighting quality This room
(below) was lit by the cool light
of a north-facing window (back-
ground) and the warm light of a
south-facing window lit the
model's face.

Technical Briefing
This project relies on you
being able to manipulate the
quality of strongly contras-
ting light, taking readings
from either shadows alone
or just the highlights. With a
manual camera, move for-
ward until the area of tone
you want fills the frame,
setting the aperture and
shutter, then recomposing
the shot. With automatic
cameras, lock the reading
into the memory before
recomposing.

See also:
Projects 40, 41 and 42

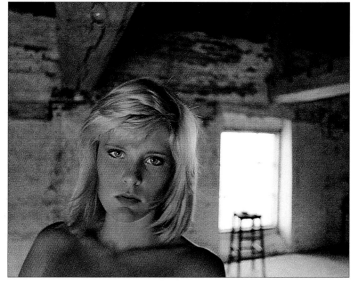

Using screens and reflectors

For the most part, photography is concerned with representing reality, so when you present images of objects treated in an obviously unreal way, it is possible to trigger all manner of reactions. These reactions are often heightened when the image is only subtly different from the conventional treatment.

This project is concerned with using devices, such as screens, reflectors and mirrors, to produce interpretations of subjects, rather than simple representations of their physical appearance.

Because we associate so strongly with images of people, and have such very fixed ideas of the way people should appear, images will have additional impact if you use people as your foil in these photographs.

Mirrored surfaces
It is worth bearing in mind where the lens is focused when taking pictures of reflections. The reflection of somebody in a mirror is, in fact, twice the subject-to-mirror distance from the subject; if your subject is 1m (3ft) from the mirror, then the reflection is 2m (6ft) from the subject. So, focusing on the mirror's surface will put the reflection out of focus unless your depth of field is sufficient (see pp. 28–9). This can be a problem with infra-red auto-focus cameras, since these will invariably focus on the mirror surface itself, and not on the reflected image.

Mirror images In these two pictures (top right and above right) you can see two treatments of mirror images. In the first, the reflected image looks like a painting. By positioning the girl off-centre in the second shot I destroyed that illusion and also gave more information about the setting.

Reflections The etched glass reflections (right) have worked very well, making it hard to tell without careful scrutiny what is shadow and what is etching.

Screens By shooting through a fly-screen door (below), all illusion of depth has been removed. It is almost as if the girl's face has been printed on to the surface of the screen.

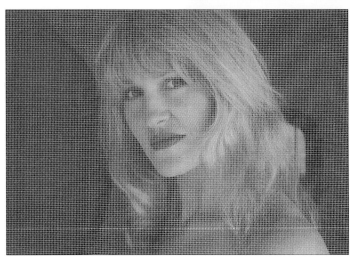

Watery illusion Reflections from the rippled water's surface (above) cast dappled light over the girl's form.

Surreal imagery The mirror-topped table (below) reflecting an image of a seemingly disembodied head gives a disturbing surreal quality to the picture.

Double profile In this portrait of the sculptor Ralph Brown (below right) his reflection makes a double profile – echoing the three-dimensional medium he works in.

Technical Briefing
Using an infrared autofocus camera makes focusing on reflected images difficult. The camera may also find it hard to cope with screens in front of the image, assuming that the screen itself is the subject. Contrast–comparing autofocus systems are much more versatile. These work on the principle that an accurately focused image is inherently more contrasty than an out-of-focus one, and so constantly adjust the lens position until maximum contrast is obtained within the focus target area indicated in the centre of the viewfinder.

See also:
Projects 23, 25 and 26

Position and associations

One aim of portraiture is always to attempt to go beyond simple physical likeness. We can learn much about character from facial expressions, as you will see in the next project, but much can also be implied, real or otherwise, about relationships and status from how figures are positioned in the frame.

Advice is frequently given along the lines that a photograph should have only one dominant subject or theme, and that giving too much information will distract the eye and diminish the picture's impact. However, it is also true that objects and other people included in the frame can tell the viewer a lot simply by association.

The aim of this project is to produce a series of shots in which composition draws an implied relationship between people or between people and objects. The elements that you can make use of to strengthen association include line, shape, form, perspective, colour or tone, and framing.

Bear in mind that physical proximity, a camera angle that produces a visual alignment of people or objects, or similarity of expression can all imply a relationship.

Framing and colour By using the boy as a half frame (right) with all the other figures 'shepherded' to one side of him, a family relationship is implied, despite the fact that this was a communal pool shared by a number of villas. Colour also unites the composition: the blue of the pool water is echoed in the padded chairs, the man's costume, towels, umbrella and the summer sky.

> **Technical Briefing**
> You could treat this project as a posed exercise. However, since you will then know precisely what relationship exists between the elements of your shots, it will be difficult for you to view your efforts objectively. It will be more effective if you photograph found or candid situations instead.
>
> **See also:**
> Projects 23, 24 and 26

Person and object In this hotel in Jaipur, India (above), it appears as if the waiter is about to round the corner and present his trays of delicacies to the expectant mural.

Colour harmony These two figures (above) are strongly linked by colour. The eye travels from the smaller figure, through the warm mud brick, to the taller figure.

Viewpoint The alignment of these two figures (right) as a result of camera viewpoint, as well as their apparent isolation, makes it seem reasonable that a relationship exists between them.

Character and expression

One of the hardest jobs of the portrait photographer is to capture character and expression on film. Many people, unless professional models, tend to freeze up when confronted by the camera, so a vital part of your job is to make them relax and draw out that quality that brings life and vitality to a portrait.

Forceful personality J.B. Priestley (above) was a very forceful subject. In my view the shot captures him perfectly, with a pipe clenched firmly in his mouth.

I n this project you will have to find three different subjects, taking a portrait photograph of each that, because of the expressions you have captured, tells the viewer something of their personalities.

Your subjects here could be friends or members of your family. However, there is nothing to stop you being a bit more adventurous and asking somebody you do not know well to pose for you.

Nevertheless, for this particular project it is important that these are posed shots and not simply candid portraits that are taken without the subjects' knowledge.

Although these must be posed pictures, you do not need a formal studio setting. From my own experience, people unused to the limelight are often far more relaxed having their picture taken away from a studio where everything is rather

strange and formidable. Another tip you might find useful is to talk to your subjects constantly, not necessarily about the photographic session but about the things they enjoy doing. Once you have them talking freely and starting to enjoy themselves you are halfway there. And, if you are lucky, your subjects might turn out to be natural performers, actually relishing their time under the scrutiny of the camera lens.

In the workplace You can often say something extra about your subjects by posing them where they work. This was certainly the case with the sculptors Eduardo Paolozzi (below) and Elizabeth Frink (below right). Both these people were far more relaxed and natural when posed in their own studios. Each shot was taken in natural light using a 90mm lens.

Changeable moods For my session with the writer William Golding (above) I needed to be alert. His moods could swing in an instant from being extremely serious to being uproariously funny. To allow for fast shutter speeds in natural daylight I used ISO 200 film and supported the camera by hand.

Thoughtful pose This is another example of the benefits of photographing somebody in his own workplace (left). Here the artist David Hockney was thoughtfully examining one of his own works and despite my frontal position was only partially aware of my presence.

Technical Briefing
It is best not to approach this type of subject matter with too many preconceived ideas. Stay alert to the subtle changes taking place during a photographic session and go along with them, rather than attempting to impose your will on the subject. The usual lens for portraiture is anywhere between 80 and 135mm, but 28–35mm wide-angles can also be used to good effect.

See also:
Projects 20, 21 and 25

Informal street portraits

Technical Briefing
The most useful lens to use is probably a moderate tele-photo – say, something in the region of 28mm for a full-length figure and 85mm for full face, or wide-angle which will avoid intruding too much into people's space. Another useful lens is a zoom, with a maximum extension of about 85mm. With this you have a choice of framing, and if you are confident you can work quite close in with the lens zoomed back to standard or even moderate wide-angle.

See also:
Projects 20, 21, 23, 24 and 26

Unposed street portraits are not necessarily candids, since the subject might well be aware of the camera's presence. The difference with this type of portraiture is that the subject is not directed by the photographer. Rather, you must be alert to likely faces and situations, frame up quickly and then shoot.

Taking revealing studies of people in and around the streets has as much to do with your own personality as it does with that of your prospective subjects. The more relaxed and outgoing you are, the more likely you are to receive a positive response, but bear in mind that reactions to the camera are often culturally determined, ranging from indifference or mild embarrassment in the West to strong religious or moral objections in parts of the East. It will be in your own best interests to do a little research before starting this project, unless of course you are planning to work locally.

To fulfil this project produce at least four studies of different people. The pictures should be fairly close-up.

Because you will be working quickly, it is best to pre-focus the camera (or use autofocus) and to preset exposure controls whenever a manual camera is used. You will then draw less attention to yourself and even have the picture in the bag before the subject actually realizes that you are there. This type of portraiture can produce some very rewarding results.

Curious onlooker This Romanian farm worker (below) had come into town for the weekly market. He was very curious about all the activity and of me and my camera, and when I turned to take his picture he was extremely pleased. Because of the language barrier not a word passed between us, but his consent was obvious.

A moment's reverie I was immediately taken with this Asian man's far-away expression as he sat at an outdoor café (below). Not wanting to disturb him, I pre-focused and set exposure before lifting the camera off my lap. I took many more pictures of him afterward with his consent, and I couldn't stop him smiling.

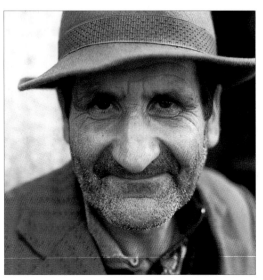

Rapt attention A moment before taking this picture (below) I had been shooting the big top going up at a circus. Out of the corner of my eye I spotted this workman standing tensely watching the operation.

Good-natured indifference I took many close-up pictures of this mailman in Manhattan (above) using a wide-angle lens. You often find that public officials are used to their role as 'local colour'.

Pearly child I was taking pictures of the Pearly king and queen when I noticed that their daughter (below) seemed a bit left out. She was pleased to be the subject of this picture, but a bit shy in front of the camera.

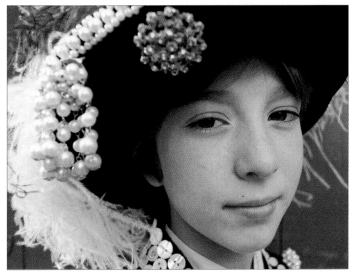

Portraits in black and white

Technical Briefing
Black and white film is in many ways more accommodating and forgiving of error than colour. Its contrast latitude means that you can vary exposure considerably from that recommended by your light meter and still produce good images. To be able to take full advantage of this, however, a manual camera or one offering manual override is extremely useful.

See also:
Projects 10, 12, 13, 14, 20, 21 and 26

The prime requisite of a good portrait, whether in black and white or colour, is that it reveals something of the nature of your subject. Just as colour was used and selected to express mood or personality, the many different tones between black and white can fulfil much the same function.

It can be liberating to change from colour to black and white. In a garden setting, for example, a portrait can be spoiled by over-intrusive or discordant flower or foliage colour; in the studio, the choice of the appropriately coloured background paper can cause endless headaches while you search for the one that evokes the right atmosphere for a shot most effectively.

Drawing on experience from the previous projects, you will be using lighting, focal length, character and expression, but adding the dash of drama that suits black and white so well.

Shooting into the light The interior of this church (above) was quite well lit. Having the figure walk into the light, though, allowed me to use a smaller aperture, hence rendering the surroundings ominously dark to create an almost sinister image.

Body language After taking a series of trad . poses of this mother and son (above), I arrang . them at opposite sides of the room, looking away from each other. Immediately an undercurrent of tension is introduced into the photograph making it much more interesting.

Matching background and foreground Using black and white film does not relieve you of the responsibility of selecting an appropriate background. In this portrait of the painter John Bellany (above) I took the obvious course of using one of his own pictures as a backdrop. All I really needed to do then was to pose him in such a way that his expression and posture echoed those of the figures behind him and, in particular, of the dog to his right. This has the effect of linking him with his work in an unusual way and has created a striking image by careful juxtaposition.

Taking children's portraits

Technical Briefing
Children's moods are volatile but as subjects they are a never-ending source of delight – and of good pictures. Remember, for completeness you need to record the sad and tearful moments as well as the happy or absorbed ones.

See also:
Projects 26, 27 and 30

The keynote when taking children's portraits is informality. When taking portraits of adults it is feasible to use a tripod as your subject will probably stay within the scope of your lens. With children I recommend hand holding the camera, fast film, a long lens, and the briefest shutter speed your camera offers.

Floods of tears Young children (right) can dissolve into tears for no apparent reason. The session had probably gone on a little too long and he was simply overtired.

This is perhaps a more difficult project than it initially appears. You will need to put together a set of four portraits of different children, where each one goes beyond a mere physical impression of a child at a particular point in time. It is part of your task to show something of his or her mood and personality as well. These are not strictly candids, since your subjects will to a degree be aware of the camera's presence.

A basic mistake people often make when photographing children is to stand with the camera at adult eye level, thus shooting down at them. It is better to squat down so that the camera is on their eyeline.

On the whole, children enjoy having their picture taken. They are also naturally curious and it may be best to let them look through the camera viewfinder so that they become familiar with what you are doing. Their attention span is usually limited and, if you are not too intrusive, they will soon forget all about you and get on with their own activities. This is when you can really get to work.

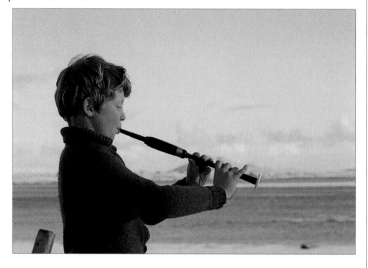

Lost in music This unposed image (above), was taken on an island in the Outer Hebrides. The evening sunlight captures perfectly the tranquillity of the lonely setting.

Quick reactions This is very much a snatched shot (below) taken in Romania. Cameras in that country are not a common sight and he was obviously very pleased to be my subject.

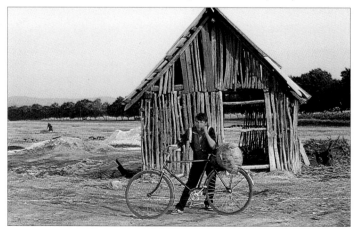

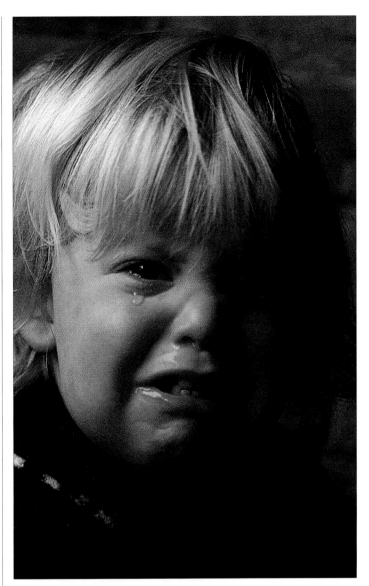

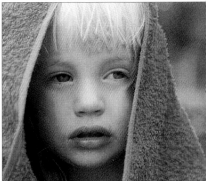

Framing The bright red towel (above) acts as a dramatic frame for the little girl's face.

Paper seller I took this shot (below) in the Gambia, and the little paper seller seems rather overawed.

Contrast and surroundings These two shots were obviously posed for the camera. In the first (below left) the little girl wanted me to take a picture that included her dolls but I chose to pose her in a doll-like position to give an ironic emphasis to that desire. In the next picture (below right) she was acting out her interpretation of the fairy-tale *Little Red Riding Hood*, and I like the contrast of the delicate child and the fierce dog.

Children at play

Many of the problems associated with taking portraits of individual children discussed in the previous project disappear once children are at play with their friends. No longer do you need to worry about them becoming bored with the photo session, distracted or even wanting to know what you are doing.

Technical Briefing
The type of lens best suited to a project such as this has a lot to do with your own personality. A long lens will allow you to hover on the perimeter of a play area picking off shots at a distance. However, you may then miss out on the children reacting to the camera. A medium or wide-angle lens lets you get right into the midst of the play, but then you may miss out on the children simply being themselves. A zoom lens is probably your best option.

See also:
Projects 27, and 29

This project is in two parts. The first involves visiting any local area where children congregate and taking a series of semi-candid pictures showing how they relate to each other through play. Obviously some of them are going to want to perform for the camera, but don't encourage them to pose, even though good pictures can still result.

Alternatively you can set up your own sequence for a group of children. Provide toys or props for them and just see what fun develops.

Studio shot Having assembled this schoolgirl quartet in my studio (above), I concentrated on shape using back lighting to make a fun silhouette.

Street scene/I Never be shy about taking this type of shot (right), taken in a street in Naples. It is not difficult to see who is leader of this little band.

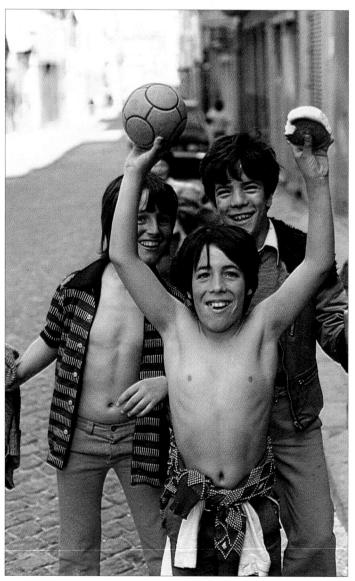

Street scene/2 This is an extremely common sight on hot summer's days in New York (above). It was so simple to take, since the boys could not have cared less about passers-by or the camera.

Concentrated attention I took this picture (right) through the railings of a school in Spain. What attracted me most to it was the look of concentration on their faces.

Zoom movement These two children (below), came running up as soon as they saw the camera. To increase the sense of movement, I zoomed the lens during exposure.

Group portrait Initially, one of these Romanian children (right) climbed on to the horse: in seconds it was littered with them, producing a formal yet spontaneous picture.

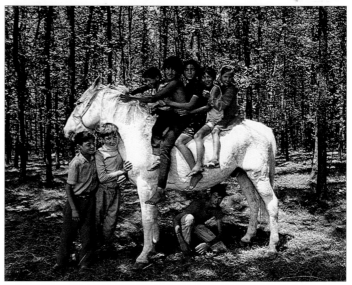

A day at the coast

The sun shines, light levels are good, people are relaxed and happy, bright colours abound, and the scenery is often spectacular — some of the factors that make a photographic project at the beach a fun activity. Some precautions are necessary, however: salt spray and sand are deadly enemies of delicate camera mechanisms.

People tend to shed their inhibitions with their clothes. They come to the beach in order to enjoy themselves, stretch out on the sand and doze in the sunshine, windsurf, play football, and ride donkeys. Best of all, nearly everybody brings a camera, making the beach one of those locations where you can blend in by putting a camera to your eye and capture relaxed and natural shots. When taking shots for this project, take advantage of the open space offered by a beach setting. Even on a popular and crowded beach, there will be plenty of freedom to move around a subject, perhaps to isolate a figure or group against the backcloth of the sea or sky, or to shoot from the other direction to show them against any attractive land features behind.

Beach panorama A distant viewpoint and 135mm lens gives a good-sized image (above). Back lighting subdues colour and simplifies the picture.

Against the light Using a small aperture or fast shutter speed (above) darkens the general view but will also dramatize shape.

With the light This shot (above) shows the difference when shooting with the light. Colour and detail are clearer, but impact can be lessened.

Technical Briefing
As a precaution keep the camera in its ever-ready case to protect it against damage from sand and salt water. Keep a UV filter on the lens at all times and make sure the lens is capped when it is not in use. If light levels are good, as is usually the case at the seaside, only a slow to moderately fast film, some-where in the range ISO 64–200, will be needed.

See also:
Projects 6, 30, 68, 70, and 71

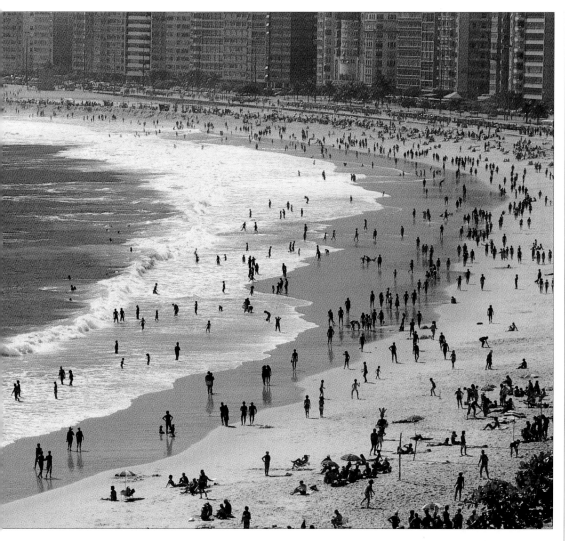

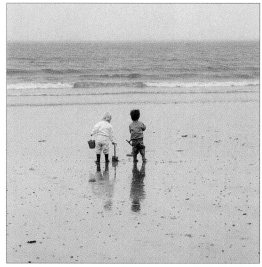

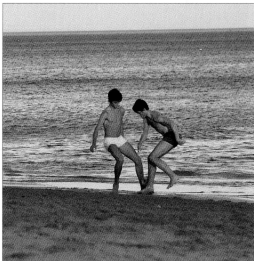

All weathers Fed up with the poor weather, these two toddlers (above) decided to brave the elements and go exploring. A wide-angle lens makes them seem smaller and more isolated against the vast empty spaces of the beach, ocean and sky around them.

Beach football The slowly dipping late afternoon sun has drenched these two beach football fanatics in a golden glow of detail-revealing light (above). A low shooting angle ensured that the immediate foreground was in contrasting shadow, which has heightened the effect.

Photographing a wedding

How you approach an important assignment, such as photographing a wedding, depends on whether you are to be the chief photographer or simply a guest taking supplementary shots. If the responsibility is yours alone, then bear in mind that for the couple these could be the most important pictures of their lives.

With a wedding you cannot shoot a retake, so check camera, flash and lenses thoroughly. Unless you are sue that your batteries are fresh, renew them.

Work on the wedding picture requirements starts before the big day. First, talk to the couple and agree on the shots required. Weddings follow a predictable order of events, so this should not be hard. Some brides like informal shots before they leave home, or pictures could start with the bride arriving at the church. If you want to shoot during the ceremony, get permission beforehand. At the same time, you could scout the best shooting positions. Obvious shots are the couple at the altar and signing the register. Afterward you will need pictures of the couple alone, with the best man, bridesmaids and pages, both sets of families and close friends, shots including all the guests, and finally the couple departing.

At the reception, cover the speeches, reaction shots of small groups of guests, and the cutting of the cake. But, very importantly, stay alert to amusing or revealing picture opportunities. These will occur thoughout the day — there may be a touching moment between the couple, for example.

Informal preview Shots of the bride before the ceremony (above) are popular. Here, the old mirror behind gives the gown an antique look as well as showing the lovely lace bodice to best advantage.

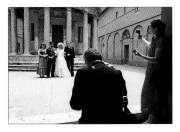

Reducing contrast When the sun is intense and high (above), use flash to lighten shadows and reduce contrast.

Set pieces These two pictures (above and left) are just two of the many set pieces expected of wedding photographers. For the bride and her bridesmaids, find a suitable plain, unobtrusive background. Make sure the sun doesn't cause your subjects to squint. For the picture of the couple at the altar, there was ample natural daylight available. In dimmer conditions, you will need a tripod, a fast film and a long exposure.

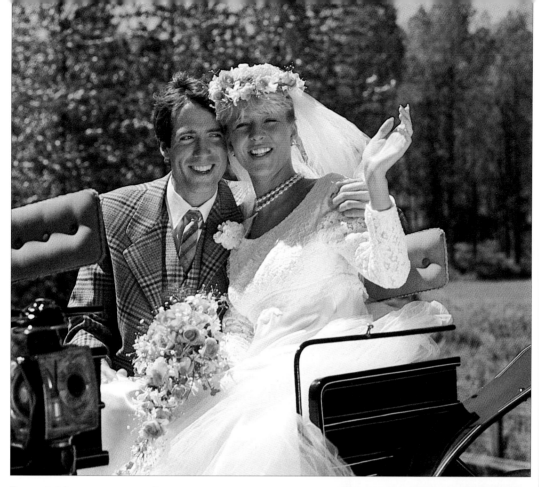

Eye-catching conveyance A shot of the couple leaving the church (above) is a must and is enlivened if the vehicle is something unusual – like a horse and carriage. Fill-in flash killed facial shadows that would have been cast by a high sun.

At the reception Outdoor receptions (right) make your job easier. As well as being well lit, people are more relaxed and natural.

Technical Briefing
Because you will be shooting under a wide range of lighting conditions use a medium fast film, something between ISO 400 and 800. Print film is your best option since it will tolerate both natural and artificial light, and making multiple copies is easier and less expensive than with slide film.

See also:
Projects 20, 22, 23 and 26

Detail Small details, such as the cake decoration (right), can be very significant to the happy couple and possess great sentimental value for them. Bear in mind that wedding pictures are stored-up memories preserved for the future.

Photographing a public event

Technical Briefing
Whenever you are likely to be shooting in low light you will need to use fast film. (The indoor shots for this project were taken on ISO 1000 film.) If using slide film, you may also need to consider whether to choose daylight- or tungsten-balanced film. Be guided by the predominant light source. In fact, at a circus, the ring lighting is nearly always strongly coloured, making casts inevitable.

**See also:
Projects 9, 30 and 32**

When photographing a public event, especially an indoor one such as a circus, there are certain things to consider. You may need permission from the organizers, especially if you want to use flash, and you must not interfere with the proceedings. And you need to use plenty of fast film.

To fulfil this project, select some sort of public event or performance. This could be the local drama society's play, a street theatre, or a choral or an orchestral performance. Whatever the choice of subject the aim should be complete coverage. This will encompass the event as it is finally seen by the audience, but include some behind-the-scenes shots as well, such as actors putting on make-up and costumes or circus animals being fed.

For shots not ordinarily available to the public permission may be necessary, as for these circus shots. It was happily given on the understanding that I did not spoil the view of members of the audience, block the aisles, or use flash where it would interfere with the performers.

With any performance, your chances of good shots are vastly improved by doing some homework beforehand. This often means seeing the show first to scout out the best shooting angles and making some determination of light levels and which lenses will be the most useful, and returning the next night well prepared.

Animal magic With these two pictures, poor light levels have worked to my advantage. The only illumination was the centre-ring spotlights, which cast a very limited pool of light. This meant that all distracting background detail, such as the audience, was cast into deep shadow and thus excluded, focusing all the attention on to the stars – the animals.

Comic relief The pictures on the opposite page were taken during a matinée performance. But before the show began I had received permission from the owner to wander around the site and photograph the show-people rehearsing their acts. This comic weightlifter (above) is a natural performer and immediately went into his routine as soon as he saw the camera pointing at him. Likewise with the pair of juggling clowns (right).

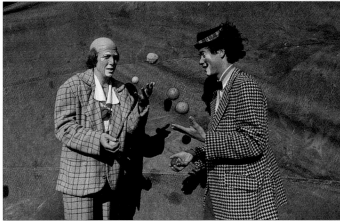

Complete coverage As part of the aim of complete coverage, I turned the camera on this group of young girls, who were completely enraptured by the show. Typical of children of their age, they are not at all inhibited by social convention. Flash fall-off is evident, but this helps to isolate them from their surroundings.

PLACES

Many of the projects in this chapter
involve taking a series of pictures using a variety of angles
and/or lenses in order to reveal different aspects
of the same subject. Since light forms the basis of all
photography, many of them also concentrate
on the changing pictorial qualities of daylight and how these
affect colour, mood and atmosphere.

Breaking the rules Tilting the camera well
back to include the tops of these towering monuments to
engineering ingenuity has caused all vertical lines to converge
severely, introducing movement and vitality
to an otherwise static scene.

Improving the image

Pictures of places rate high on the list of most photographers' priorities. In most instances, a successful scenic picture is the result of a planned approach, where the photographer has gone to the trouble to find promising or unusual points of view, or has waited for favourable changes in the light or weather conditions.

Technical Briefing
Whenever you are trying out variations on the same scene, you will find the ability to change lenses, or focal lengths, of great value. An SLR camera, with standard, wide-angle and telephoto lenses is obviously ideal in this instance, but so, too, are compact cameras with built-in zoom lenses. These built-in lenses typically give a range varying from moderate wide-angle to moderate telephoto.

See also:
Projects 35, 36, 37 and 42

T o illustrate the different approaches possible with a single subject, I have used Mont St Michel, off the Normandy coast. For your project, the scene does not have to have a building, although there should be a prominent feature of some description to act as the focal point for your work – perhaps an interesting rock formation, a waterfall, or a gnarled, old tree.

With an imposing building or any place of great natural beauty, you will need to make an early start in order to avoid the almost inevitable influx of visitors in their cars, caravans and coaches. Another reason for an early start is the often spectacular lighting conditions found in that short period after sunrise. Dawn can provide wonderful light and colour – mists that create a delicate pinkish haze, which momentarily turns to gold as the sun breaks through. You may also find locals going about their business who might add a human element to your picture but who, like those early-morning mists, will have disappeared by the time the first tourists start to arrive later in the day.

Wrong viewpoint It is easy to see what went wrong with this picture (left). My viewpoint has robbed the medieval abbey, poised dramatically on its pyramid of rock, of all its grandeur and isolation.

Local colour This viewpoint (above) gives a better idea of St Michel in relation to the coast. I noticed the cyclist posing in such a way that his body shape reinforced that of the mount behind, giving stronger interest and impact.

Bird's-eye view From a few hundred feet up (left) you can see most of the building, and the warm cast of the lights inside the lower buildings gives a welcome highlight. The cost of the plane trip was equivalent to just two rolls of film and was well worthwhile.

Incoming tide By evening (above) the mud flats seen from the air were transformed into a seascape. The man in his boat, like the cyclist, is a useful element of human interest.

Framing In this early-morning shot (right) the mount is framed in a gap in the trees. I used a telephoto lens to pull the mount up in size and the haze is a very good indicator of depth and distance.

The time of day

No matter what area of photography you are most interested in — landscape, natural-light portraiture, architecture, still-life or wildlife — the time of day you choose to shoot can really have a startling effect on results and help to create very different images of the same subject.

I t is not just that at different times of the day the quality of light changes, as it certainly does (see pp. 38–9); there is also something less tangible. Different times of the day seem to have their own rhythms.

For the natural history or wildlife photographer, early mornings hold the promise of dew-jewelled spiders' webs or frost-encrusted leaves. Colour may be more diffuse at this time, whereas an hour later the warming sun would not only have intensified hues, but may also have coaxed some hungry insect predator in front of your lens.

For the landscape or architecture photographer, a knowledge of how the subtle play of light affects the subject throughout the day is vital. Pictures here are entirely dependent on the relationship of highlights to shadows and the juxtaposition of colours or tones. Portrait or candids photographers know only too well the importance of time of day — the leisurely pace of early morning, when people have time to talk and to pose, crumbles under the onslaught of daily routines.

As a guide, I have included a range of subjects taken from early morning (below) to early evening (far right). What you need to do for this project is to set aside a full day to record the same general scene showing all the important changes that occur throughout the daylight cycle. The end results may well be quite fascinating.

5.15am The overriding feeling from this shot (below) taken in Norway is of tranquillity. Not even the lone fisherman disturbs the calm, clean water.

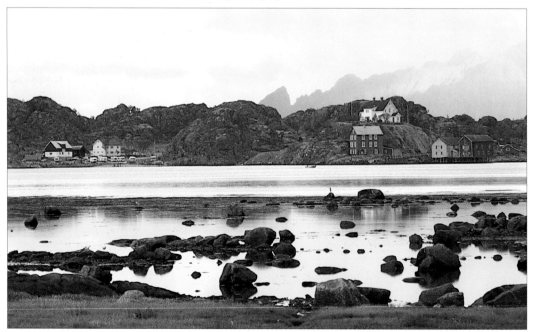

10am I intended this (above) to be a straight architectural picture at a hospital in Morocco, but a curious nun appeared at the window.

6pm There is not much movement (above) in the full heat of an Australian summer's day. For this shot I waited for the low sun to rimlight the sheep.

8.45pm This redbrick Tudor gatehouse in Essex (below) has caught the last rays of sun. The low sun has also suppressed foreground detail.

12 noon This mosque in Cairo (above) is simply splendid. The harsh, high, midday sun has made even more impressive the ornate facade. Exposure was taken from a highlight reading.

Technical Briefing
The type of equipment you need depends entirely on the type of photography you are interested in. So that you can see the effects of different times of day in a series of shots, seek out the best viewpoint for the prevailing lighting conditions as well as taking some set shots of your subject in the same position throughout the day.

See also:
Projects 34, 36 and 37

Shooting around a facade

You should never be satisfied that any given subject can only be done justice from a single point of view. It is possible with a building, for example, to show it from many different angles. Moreover, buildings, like any other subject, project mood and atmosphere depending on when they are photographed.

For this project you will have to locate a deta-ched building standing in its own grounds. This will give you the opportunity to shoot it from a great variety of angles. The building itself need not be grand or even of any particular architectural merit – an ordinary house will do. What should come through in your photographs is how varied a single facade can appear when you use different parts of its setting to project different moods. Start early in the morning to ensure minimum interfer-ence from people or cars.

> **Technical Briefing**
> There is no time limit for this project. It might be a good idea to revisit your chosen site on a few differ-ent days and at various times of the day to see if the build-ing's character changes dramatically. Any camera/ lens combination is suitable.
>
> **See also:**
> Projects 35, 37 and 40

Foreground feature Making use of a powerful foreground feature (right), in this case the stairs and urns, has given a marvellous feeling of grandeur, depth and setting.

Conventional view Here is the conventional view of this Tudor stately home. It shows a good sweep of the broadwalk and the house's imme-diate surroundings and would normally be quite acceptable, but that important element of depth is missing from the picture.

Off-centre For this version I pulled back just a little and moved to the left. Accordingly, the house has diminished in size, but a single urn is included to counter the bulk of the now off-centre house. This more interesting composition also effectively conveys a feeling of depth.

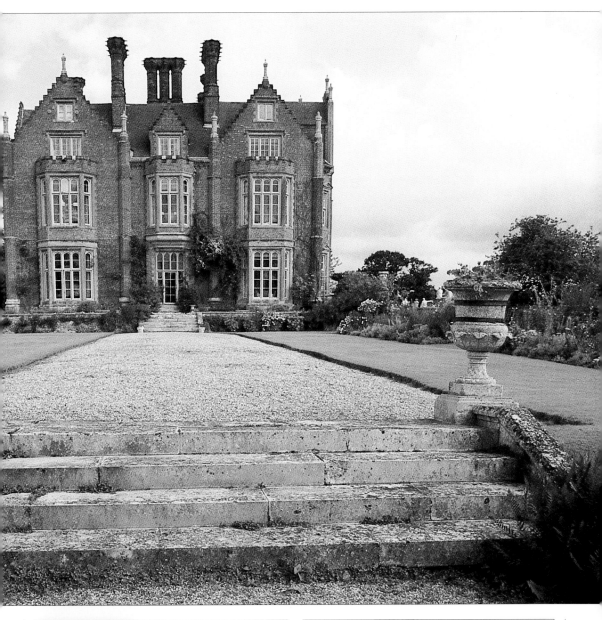

Framing Here the house is partially obscured by an attractive frame of trees and shrubs. This effect of peeping through the foliage has produced a feeling of considerably more depth and even a touch of mystery – implying that perhaps you shouldn't really be there at all.

Changing weather Although I spent less than an hour at this house, the weather started to become stormy near the end. Instead of putting my camera away, I took this last shot low down to isolate the house against the darkening clouds, giving it a rather foreboding look.

A sense of place

Your approach to any large-scale, outdoor subject, such as the magnificent Schwetzingen sculpture garden in Germany shown here, must be influenced to a very considerable degree by the prevailing weather conditions. No matter how adverse they are, it is still possible to capture a sense of place.

F or this project you need to research an outdoor location. You could, for example, choose as your subject a church and church-yard, a farmhouse and its surrounding buildings, or an old mill and its environs. What you need to show through your pictures is sufficient information about the man-made and natural features to give a complete and balanced impression of what it was actually like to be there at the time. Bear in mind, however,

that the weather is neither for you nor against you. It is simply a factor you have to work around. So, don't put your camera away because it is overcast or raining – just look for a different approach to the subject.

House and setting You nearly always need an establishing shot (below), which shows the house and its setting. Here I chose a view where strong foreground contrast offset an expanse of dull sky behind the house.

Details By concentrating on details (above) you can omit completely indicators of weather. The bright green and light lavender colours give the impression that they were shot in much sunnier weather.

Behind the scenes For this picture (below) I worked my way behind this statue and shot upward, using overhanging foliage to mask the sky. The Virginia creeper gives a lift on the dullest of days.

And the rains came Gardens are seen in all weather, even in the rain (above). In this picture, I particularly like the apparent disinterest of the figures in the high drama being played out behind them.

Technical Briefing
Completeness is the keynote of this project. As well as overview shots, you must show the features of your chosen location that give the place its essential 'feel', its atmosphere. Lenses ranging from wide-angle to moderate telephoto will be useful, and a zoom will give variety.

See also:
Projects 35, 36, 40 and 42

Close and closer still For the first picture of this ballustrade a standard lens was used, and the impact of the sun symbol has been diluted by the view behind, and especially the overcast sky. For the next shot I moved viewpoint to show the gold leaf against heavy shadow, and used a 135mm lens. In fact, the dull conditions helped by giving very even lighting without any highlights.

Landscape in monochrome

The term 'monochromatic' is often misused to mean black and white. In fact, it really describes a scene predominantly of a single colour or shades of a colour: the many shades of green making up a tree-filled, grassy landscape, for example, or the acres of red roofs that characterize the urban sprawl on the periphery of cities.

Apart from the examples above, where the elements of the composition themselves determine the colour of the scene, it is often the quality of light and the prevailing weather conditions that work together to produce a monochrome effect.

Colour film allows you to be very selective in what you image, and for this project selectivity is the key. Certain conditions, such as mist and snow, act as a filter, subduing the colours of objects and making them appear as shades of the same hue. Time of day (see pp. 38–9) also has a major influence on colour perception. At sunset or sunrise, whole landscapes can be suffused with pinks and reds. In fact, low-light conditions generally have the effect of merging colours into a single hue. At dusk, bright colours always appear much more subdued, for example. Storm conditions can also work favourably. For example, the steely blue-grey of a turbulent sea and the colour of billowing storm clouds are so similar that distinguishing the water from the sky can be very difficult, if not impossible.

Technical Briefing
It is possible to produce a monochromatic image using one of the many single-colour filters readily available in all camera stores. However, in most cases the effect would be rather artificial compared with the gentle washes of colour that nature provides and it is best to seek monochromatic subjects.

See also:
Projects 4, 5, 34, 35, 37, 40, 42 and 43

The great equalizer In terms of colour rendition, snow (above) really is the great equalizer, turning winter scenes into delicate, almost black and white, images.

Autumn sunlight This shot (left) was taken on the edge of a pine forest. The pine needles littering the floor precisely echo the autumnal hue of the sentinel-like trunks.

Selective view For this Tuscany landscape (right) I used a 135mm lens to concentrate on the fresh green of the young crop of sunflowers and the grassy slopes behind.

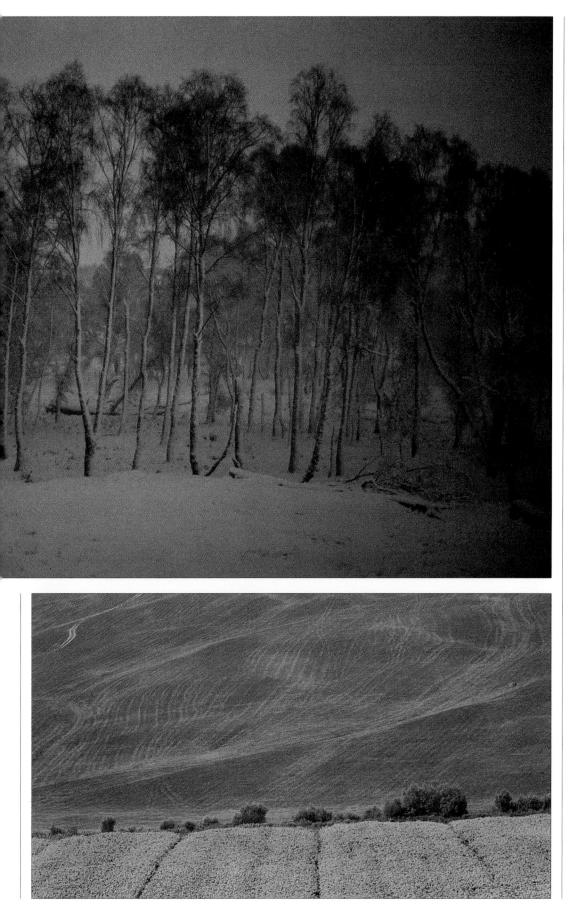

The black and white landscape

The approach taken to the black and white landscape is often very different from that used for colour, with the myriad shades and hues that help to define shape and form, texture and pattern. In black and white photography, you will need to become familiar with the way colour translates into tones of grey.

Technical Briefing
As well as polarizing and UV filters, which you may be familiar with from colour work, a yellow filter can be used to darken the tonal response of blue sky slightly, and thus increase the impact of any cloud formations. By using a deep red filter a daylit scene can appear to be lit by moonlight. Other filters will change the tonal response of vegetation or make stonework reproduce lighter or darker.

See also:
Projects 10, 16, 40 and 42

In general, photographers find the representation of reality offered by colour film easy to accept and work with. For instance, a mixed group of trees all have subtly different shades of green that will all be apparent in the finished picture. In black and white this type of distinction may be lost. Instead, however, you could find a bonus in the form of a stronger graphic content and a very different atmosphere.

Exploiting the different moods of the black and white medium forms the basis of this project. When choosing possible views, look for strong line, bold contrast and dramatic skies. There are filters (see pp. 204–5) that may be useful to change the tonal values of parts of the scene to create a different, more dramatic image.

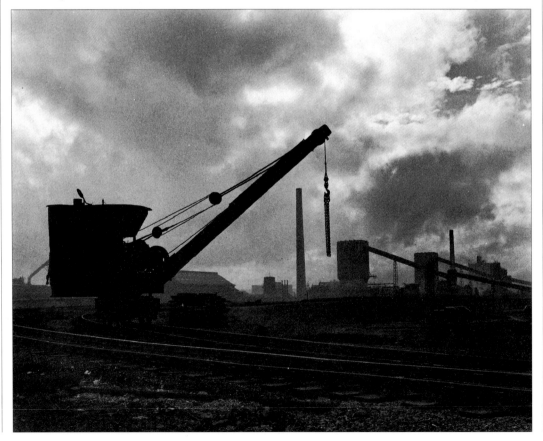

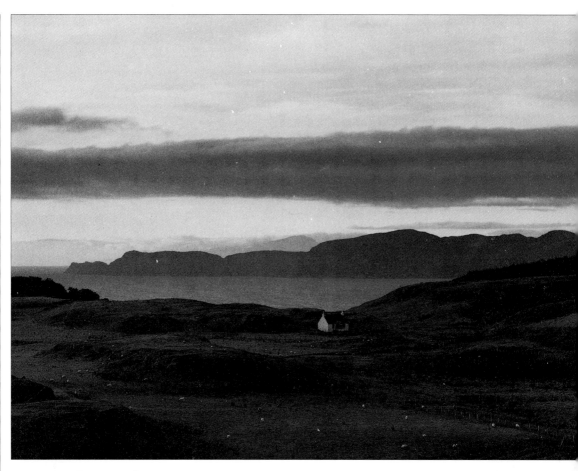

Tonal wash The image above clearly demonstrates some of the qualities of black and white. First, the foreground shows form well, through alternating dark and lighter tones. The sheep and the farmhouse are in good contrast against the overall darker tone. The sky is simple and strong, having the appearance of being applied in rather a painterly wash.

Silhouette Shape tends to be strengthened when rendered in black and white (left). Shooting against the sun has produced powerful graphic shapes silhouetted against a massing sky.

Linear perspective In the shot of a frost-covered moor (right) the power of line is apparent, with strong linear perspective leading the eye straight up towards the horizon.

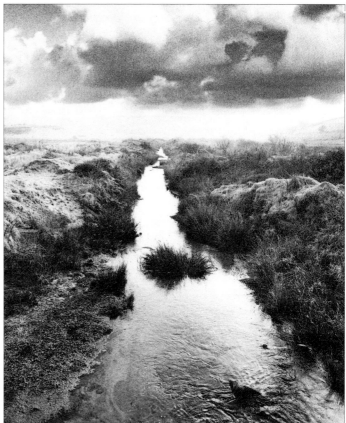

The changing light

Natural light is ever changing and always unpredictable, one moment shining from a clear sky, endowing every feature in the landscape beneath with a wealth of detail, and then suddenly shafting out of storm-heavy clouds, brilliantly spotlighting some features, while throwing shadows across the once-familiar terrain.

The word photography means literally 'drawing with light', and it is one of the never-diminishing fascinations I have with photography that no matter how many times I shoot a particular scene, it can always appear subtly different. All that it requires is to take the time to really look and, of course, to see.

The best type of day to undertake this project is one holding the promise of rain when you can expect to see some dramatic and rapid changes in lighting. If all goes well, and you are in the right place at the right time, you should aim to take a series of shots within a short time – say, about 5 minutes maximum – each shot creating a different mood.

The pictures here represent the first I took with a new autozoom compact. For a period prior to this I had been using a half-plate view camera. However, I lost so many good shots because of the long set-up times during which the light would change, that I went to the other extreme. All pictures were on ISO 200 film with the camera set at f5.6 on aperture-priority mode.

Restricted time span Taking landscapes is thought to be rather a sedentary pursuit, but when you have a powerful sun, wind and clouds, the landscape changes so rapidly that before you get the camera to your eye, that particular scene is gone for ever. In the large image (right) the energy of the sunlight seems almost enclosed and protected by the surrounding sweep of mountains. Seconds later (below) the clouds moved apart and I zoomed the lens back to encompass this new lighting effect. And again, in what seemed only to be seconds (below right), the clouds descended once more.

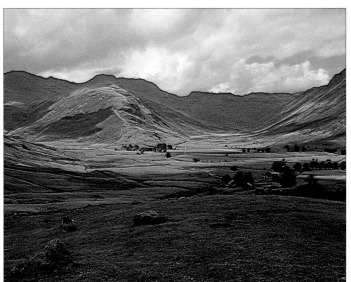

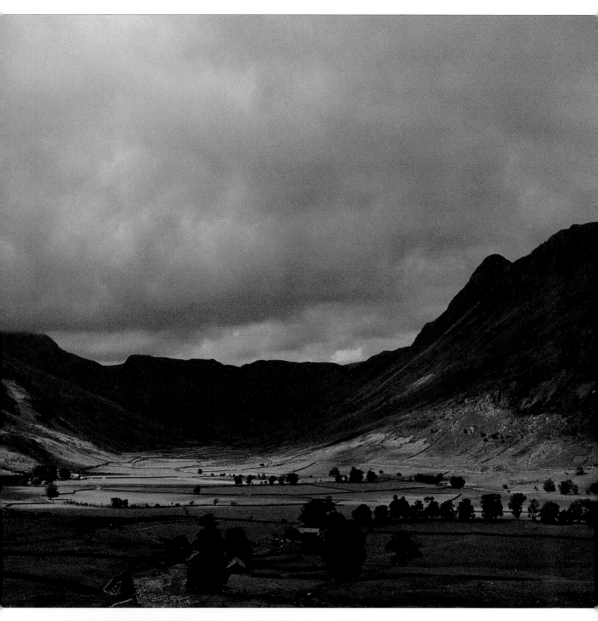

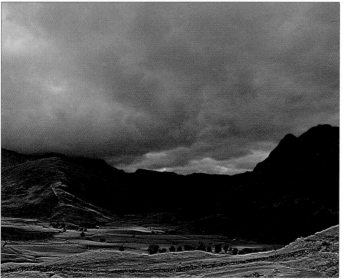

Technical Briefing
Remember, you are trying to capture the ephemeral quality of changing light. You need to have your camera (if manual) prepared in advance, preferably preset to at least the approximate aperture, shutter speed and focus setting. Automatic cameras, compacts or SLRs, are a great help here, since they are quicker to operate. Auto film advance minimizes the risk of missing shots whilst winding on.

See also:
Projects 35, 36, 37, 41 and 42

Shooting into the sun

If the sun is included in the shot be very cautious. It is potentially as dangerous to look directly at the sun through a camera's viewfinder as it is with the naked eye — even more so if you use a telephoto lens. However, including the sun in the picture, perhaps seen through haze, can produce spectacular results.

et us now set aside the old adage about always having the sun behind you for taking pictures. Certainly, anything lit frontally by the sun will be fully detailed and descriptive, but good photography should be more interpretative than that.

So your project this time is to produce a set of pictures, some featuring the sky and sun as the principal subject, but others where the presence of the sun in the shot gives a new perspective on a familiar subject. The main problem you will encounter is excessive contrast. Even if you take your reading from the sky at about 45° to the sun, everything else will be underexposed. If you take a reading from a subject lit by the sun, then the sky itself will be overexposed. The captions here will give you some pointers on how to avoid or exploit excessive contrast in your pictures.

Technical Briefing
For the sun starburst effect you need a manual or aperture-priority camera so that you can select very small apertures. For some detail of subjects back-lit by the sun, open up the aperture a little or use the back light compensation control found on most automatic cameras. Usually, to overcome extreme contrast problems wait for clouds to obscure the sun or position yourself so that some light is cut out.

See also:
Projects 8, 12, 20, 25 and 29

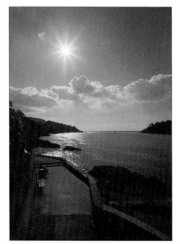

Exploiting contrast By metering from bright sky (above) I threw the ugly pier into deep shadow. The sunburst effect comes from using a small aperture, f22.

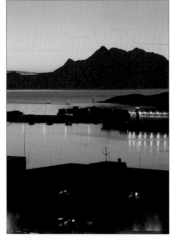

Afterglow A way to avoid excessive contrast is to use the afterglow of sunset as a light source (above). Illumination is strong enough for an attractive sky.

Obscured sun Another way to overcome excessive contrast is to wait for the sun to drop in the sky towards late afternoon and hope that clouds will partially obscure it (right). The dramatic crepuscular rays of light thus formed bring alive an otherwise ordinary scene.

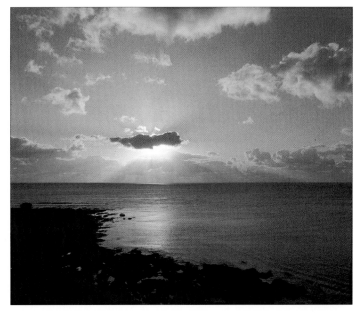

Hazy sun The atmospheric haze associated with large cities can work in your favour (below). Here, dust particles reduced light levels and scattered light generally, showing a little, but very important, modelling on the skyscrapers of New York's famous skyline.

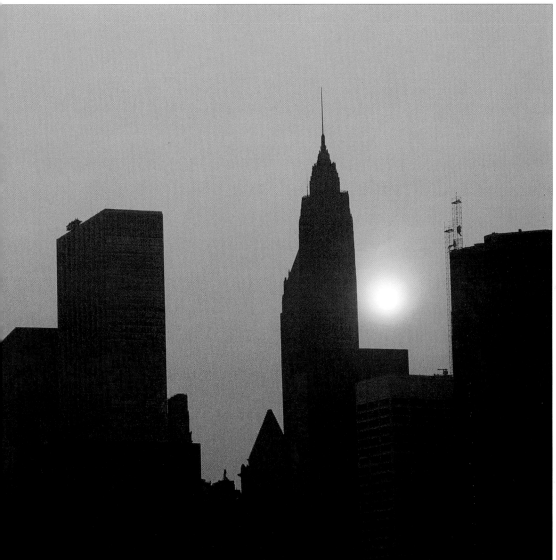

Difficult weather conditions

Difficult weather conditions by implication usually mean poor light. In mist, rain, fog or snow, light readings are low, colours muted or obscured completely, and the temptation is to stay indoors out of harm's way. The irony is that some of the best photographs are taken in the most hostile of weather conditions.

Y ou will have to carry out this project over an extended period, waiting for a variety of different weather conditions. Remember, the greater the range of conditions you manage to include, the better the set of pictures you will produce.

The project is not dependent on any special type of camera or lens but, because of the almost inevitable poor light, reasonably fast film – ISO 200 or faster – is called for (see pp. 32–5). You will also have more choice of exposure settings with a fast lens – working at maximum aperture all the time gives you very few depth of field options (see pp. 28–9).

Mist and snow
An important point to bear in mind is that in mist and snow scenes there tends to be a lot of either scattered or reflected light about. A general light reading can then lead you to underexpose your pictures, especially distant figures or buildings.

Moonlight snowscene This shot (right) was taken not long after dusk, with the moon already high. The reading was from the sky, which has made the scene generally lighter.

Frosty dawn This magical scene (right) meant being in position for sunrise. Just half an hour later and the frost, the mist and the silvery luminescence would have gone.

Mist An interesting feature of mist (above) is that it wipes out the background, and objects not normally of much interest to you can take on a completely new feeling.

Rain Hard rain (above) has muted and softened colours producing a study in colour harmony and concentrating attention on the crazy juxtaposition of houses and windmill.

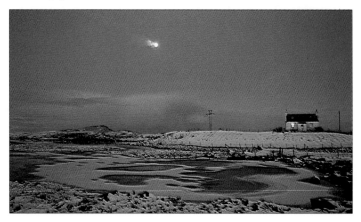

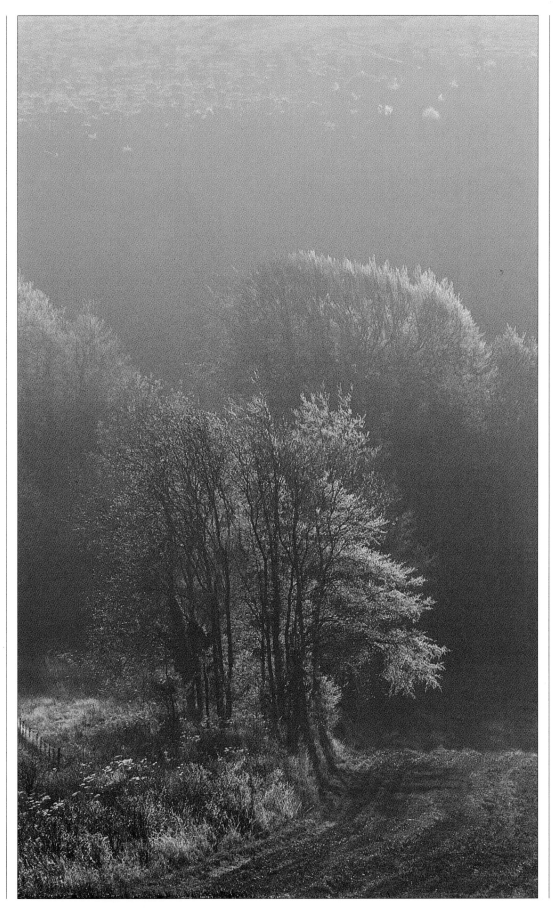

Featuring dominant skies

All too often, photographers concentrate on the physical features in their pictures — buildings, people, a line of hills or trees, and other natural or artificial elements — and fail completely to notice if the area of sky included in the frame is making a positive contribution to the composition.

Despite the lack of attention paid to the sky in many photographs, the majority of shots are framed with a centrally running horizon, which gives the sky equal prominence in the finished picture. But the sky is often worthy of being the subject itself, with the landscape below playing a mere supporting role.

Although this project concentrates on sharpening your awareness of the sky as a picture element, it is equally about correct exposure. There is often a difference of many

Leaden sky This briefly leaden sky in Portugal (above) acted almost like a lid, trapping light and intensifying colours. Light reflecting from the mottled-white paving threw illumination to the sides.

stops between the sky and the ground, so you have to decide just what you are going to meter for. At all costs avoid taking a reading from an area on the ground that will cause the sky to be rendered as a block of featureless white.

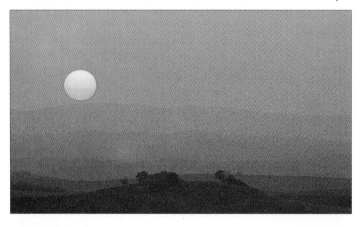

Setting sun The setting sun through a hazy atmosphere (left) spreads a wash of colour over the landscape below.

Summer storm Near darkness falls as a storm front rolls in (below left). Here I exposed for the clouds, reducing to silhouette the distant copse of trees.

Above the clouds Cloudy shadows cover the land (right) and the elevated viewpoint shows sunlight on the other side of the clouds.

Technical Briefing
To overcome the problem with many autoexposure cameras, which try to 'average' exposure for sky and land, and produce a satisfactory result of neither if contrast is extreme, either switch to manual operation or use the exposure lock to expose only for sunlight.

See also:
Projects 40, 41 and 42

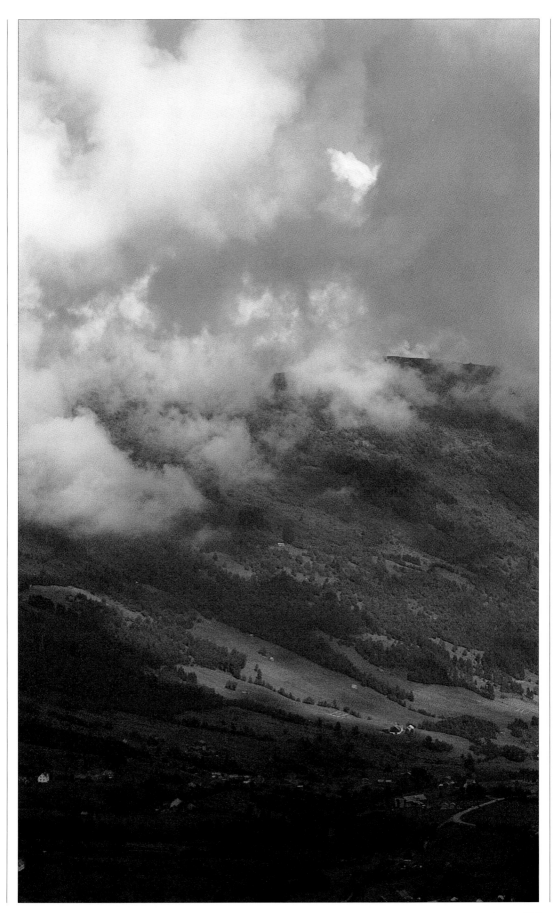

Dusk and night photography

Once the colour and drama of the sunset sky have largely subsided, most people pack away their cameras. However, with today's fast films and wide aperture lenses, photography can continue well into late dusk and early evening, especially if you use some type of camera support combined with long shutter speeds.

Probably the best time for most 'night' pictures is that transitionary period between dusk and night proper. It is then that there is still sufficient form-revealing illumination to give substance and a degree of modelling to your subject. Once all light has vanished from the sky, contrasts become impossibly harsh for film to cope with, and you are left with either over-bright, spreading highlights surrounding lit windows and streetlights or inky black, impenetrable shadows.

For this project get your-self into position well before sunset. Set up your camera on a tripod taking into account features of the artificial or natural landscape that you want to emphasize in your shots. As light levels begin to drop (and this happens rapidly toward dusk), you will notice that what might have been an insignificant feature in full light takes on far more prominence once reduced largely to shape, or vice versa. So be prepared to alter your framing continuously as the light level changes.

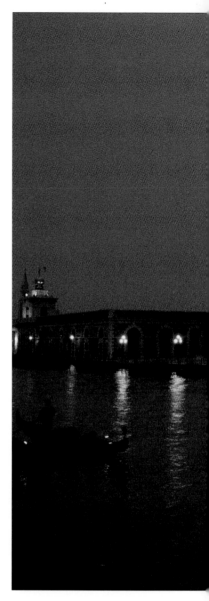

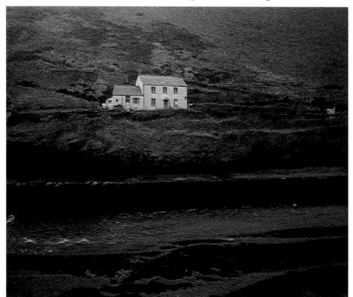

Reflected lights Venice is a photographer's delight (above). The sun had been below the horizon for about 10 minutes when this shot was taken. I stood waiting for the gondolier to reach that beam of watery light. Exposure was 1/4 sec.

A touch of light The gloom of early evening (left) was entirely appropriate for this scene. The only warmth comes from a single lit window, its colour strengthened by being shot on daylight-balanced film.

Sunset glow In a bleak and desolate location in Normandy (right), golden sunset light has produced a welcoming and friendly landscape.

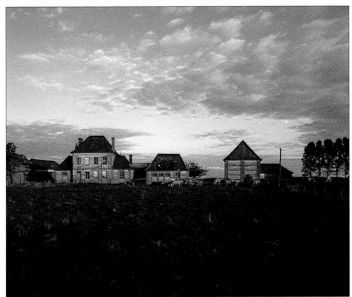

Technical Briefing
It is not unusual for camera meters to give misleading readings in extremely low light levels, or simply not to register at all. Unless you are an experienced night photographer, it is advisable to take bracketed shots at dusk and night of important subjects. With the camera on a tripod, vary exposures by half to one full second. As an added safeguard against camera shake, use a cable release to trip the shutter.

See also:
Projects 35, 40, 41 and 43

An industrial landscape

The scope for powerful landscape imagery is by no means confined to the picturesque. As you can see from the pictures on these pages, even a landscape suffering the heavy imprint of industrial development and decay offers you every opportunity to sharpen your technical and pictorial skills.

Technical Briefing
This project is not dependent on specialist equipment or lenses in order to achieve the desired effects. The typical wide-angle fitted as standard to most compacts is a perfect optic to capture the industrial activity while also including the wider landscape. A moderate telephoto is also useful for isolating and accentuating important elements, and fast film will give added flexibility for twilight shots.

See also:
Projects 42, 43, 46 and 47

For this type of imagery you will find that every city, town or village will show some signs of industrial activity – not necessarily the large-scale estates I came across in northern Europe (opposite) and Frankfurt, West Germany (below), but perhaps the more human-scale tragedy of this abandoned farm in Cornwall (right).

Change of use What was once an idyllic agricultural scene (below) is now dominated by pyramids of waste dug in search for china clay. Note the abandoned tyre in the foreground.

Industrial haze A dull day has compounded the filtering effect of industrial discharge (right). By keeping the buildings low in the frame I have accentuated the strong vertical elements.

The effect of light The oblique lighting of late afternoon (above) was ideal to bring out the wonderful roundness and texture of the smoke spewing from the chimney.

You will need to find two or three different industrial landscapes, aiming to convey not only the monolithic character of large-scale plant and machinery but also a sense of place and context. Remember, industry does not exist in isolation; there is also a vital human element.

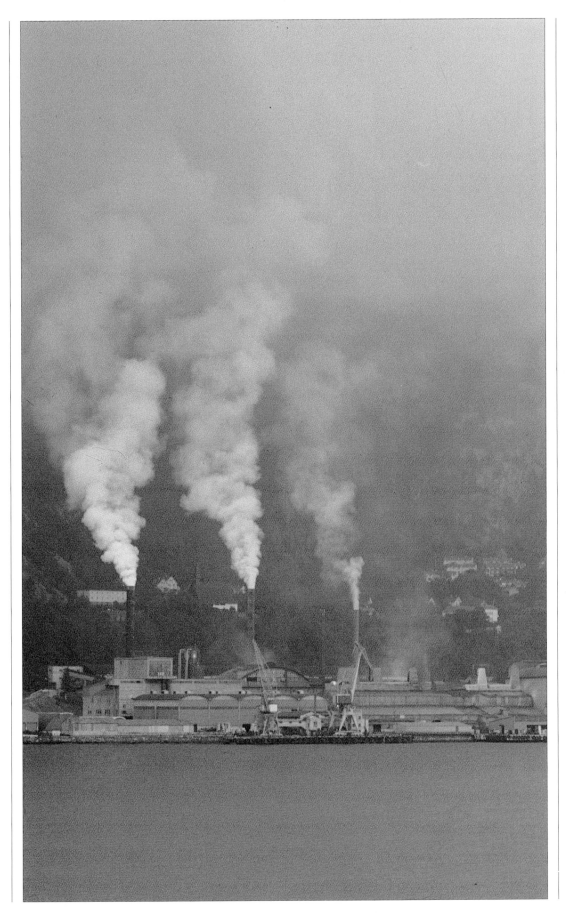

Beauty in strange places

It requires an inquisitive personality, a more refined sense of 'seeing', to find beauty in strange or unusual places. Landscapes devoid of obvious elements of pictorial charm make a refreshing change from scenic views and can become instead fascinating abstract compositions in shape, texture and form.

Just as nightmare images can have a disturbing persistence, a magnetic quality that persists long after wakening, so too can photographs such as these, which seem to have taken on an almost alien character.

Nothing demonstrates more clearly your ability and familiarity with the photographic medium than a well-rounded portfolio of pictures containing contrasts of both subject matter and style. In light of this, you need to find an unusual landscape setting, not necessarily one devoid of human habitation, but one that would by most ordinary standards of judgement be termed an eyesore and 'unphotogenic'.

What you should be looking for primarily are powerful, graphic shapes, contrasts in light and dark, perhaps unusual lighting effects and, most important of all, subject matter that does not immediately 'reveal all' to the viewer. For these examples I restricted myself to just a few miles in the same region of Cornwall, using as my subject the different aspects of the clay pit excavations shown in a shot on the previous project.

Technical Briefing
If the weather is bad, take along a plastic bag for your camera. Cut a hole in the bag for the front of your lens, and use a UV filter to stop water splashing on to the lens. Light levels decline alarmingly as the sky darkens before rain, and even fast film and a wide aperture may make hand-held shots difficult. As a safeguard, strap a sturdy tripod to your camera case – the inconvenience of the extra weight could well pay big dividends in the end.

See also:
Projects 38, 40, 42 and 45

Working around a subject
Although a landscape devastated by mining activity, I saw nothing here but beauty. These waste heaps, set against a pink-streaked twilight sky and mirrored in the waters beneath, take on a grace of their own. Perched on top of the excavations (left) is the original farmhouse, long-since abandoned. But the steep clay cliff running away from it has more the appearance of an artist's palette with a river of pink down the middle. The final shot (opposite) is a flooded pit, striking against an equally dramatic, rain-heavy sky.

Shooting a cityscape

The richness and diversity of subject matter to be found in any large urban setting makes cityscape pictures a favourite with photographers. The pattern and line of towering buildings, the contrasts of the modern and traditional, or the human element that is the heart of the city, make a feast of images for your camera.

Large towns and cities vary enormously in feel and character. Some are largely of the here and now, having come into being only during the last few decades or having swamped entirely whatever original settlement might have existed. Others may have managed to retain their architectural and historical links with the past, alongside newer features.

The idea behind this project is to produce a set of photographs that encapsulate your perception of a particular town or city. Remember to watch out for those small details or juxtapositions that will really convey the atmosphere of the place.

Technical Briefing
To do justice to this project, try to spread your pictures across an entire day. Cities have their own pace and rhythm, which changes from morning to night. Type of equipment is not so important – a wide-angle is useful for broad shots, while a moderate telephoto is ideal for details and candid shots of people.

See also:
Projects 35, 40 and 48

Telling detail During a very brief stopover in the Gambia (below), my eye was immediately taken by the incongruity of the tropical light falling on this quintessential British symbol.

Dramatic imagery This type of picture is always dramatic (below). I chose an intersection flanked by tall buildings and used a 28mm lens to include all four corners.

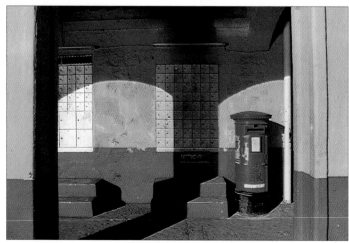

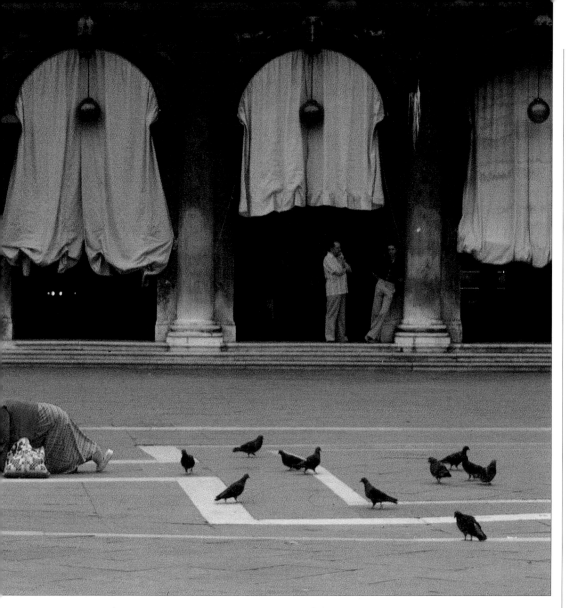

Human touch In this view of St Mark's Square, Venice (below) the early-morning jogger seems to say that the city is more than simply a tourist destination.

Humorous element Again in St Mark's Square (above), a woman feeds the local pigeons, watched seemingly by four enormous, shrouded figures formed in the arches.

Reflections Here, at Blackpool (below), a distant view has included the illuminations twofold, using the wet sand and shallow water as a mirror to give a very evocative effect.

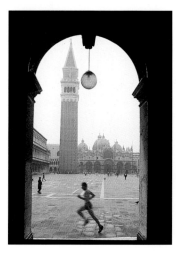

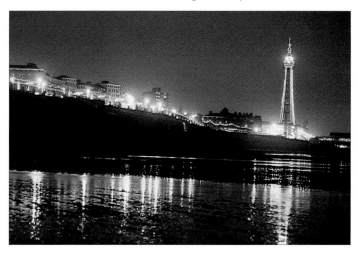

Architectural viewpoint

Architecture is a recurring theme in photography, usually involving specialist, large-format equipment. However, all the pictures on these pages were taken using a 35mm SLR and a compact camera. Far more important than equipment is having a clear notion of precisely what you want to achieve.

Technical Briefing
You will undoubtedly have an advantage with this project if you can change lenses or use a zoom lens. If you determine that your subject is best seen near sunrise or towards dusk, then fast film will be called for. Alternatively, you might want to retain the finer grain characteristics of slower film and thus use longer shutter speeds or wider apertures. A tripod may be necessary if shutter speeds become too long.

See also:
Projects 40, 41, 44 and 47

It is time of day, and hence the direction of natural sunlight, that is your chief ally in architectural photography. Architectural structures are multi-, and often minutely, faceted objects, three-dimensional as a whole and also when viewed in detail. Light striking a particular surface might at one hour of the day reveal a rich profusion of detail, while in a picture taken just a few hours later you might see nothing more than an area of deep shadow.

In conjunction with time of day and the direction of light is where you should position yourself in relation to the subject. In narrow streets hemmed in on all sides, your options might be limited, but where the setting allows, always wander freely around, looking all the time through the viewfinder to see how various perspectives relate to the shape of your picture format.

For this project you are to produce a set of pictures of the same structure. With each image you should communicate something fresh about the subject, using both lighting direction and viewpoint to best effect.

High viewpoint For this shot of Florence Cathedral (below) I used a second-floor window opposite. This viewpoint gave accurate perspective.

Low viewpoint With these Egyptian columns (right) still standing after a thousand years, I tried to convey the majesty of their civilization.

Working around a subject

The three pictures you see here of the Eiffel Tower were taken within 45 minutes of each other using a compact camera with zoom lens. For the traditional shot (below) I was some distance from the Tower with the lens set at 70mm. This allowed me to include the complete structure while still making the horse a good size. In the next picture (right) the viewpoint encompassed the Seine, which gave a better feel of the Tower's setting. In addition the frame of bare autumn branches helped to introduce a little more interest into the immediate foreground. My favourite shot, however, was taken from directly beneath the Tower (below right). It is in fact the earliest shot I took in this sequence and shows the low sun striking the tracery of ironwork. In terms of visual interest it holds the viewer's attention far longer than the others. The lens was set on 35mm.

Architectural detail

It is the camera's ability to isolate detail that makes it a unique recording device, but the photographer's ability to recognize the potential in the first place is paramount. Isolated architectural features can take on a meaning of their own, but first you must learn to do more than look — you must learn to see.

The last two projects have been taking you closer and closer in on architectural subjects, starting first with cityscapes, and then, if you like, zooming in on single structures. Here, you are going in still further, refining all the time your ability to see and appreciate images within images.

For this project you are asked to produce a wide range of pictures of archi-tectural details, each one carefully selected so that it stands alone, without relying on the viewer's knowledge of the building. It does not matter if you use the same building for all the shots, as long as each one highlights something new. Windows and doors are obvious candi-dates for your attention, but don't overlook the often abstract qualities of pattern, shape and colour discord.

Painted panels This simple image (above) taken straight-on with a 135mm lens, shows the weather-worn painted panels of a fisherman's cottage in Romania. Obviously once brighter and gaudier, the panels have mellowed.

Selective focus To isolate the alabaster figure (below left) I used the widest aperture my lens offered to throw the back-ground out of focus.

Decorative motifs It is only when seen in isolation and at leisure (below) that you can truly appreciate the beauty of a mosaic of this scale and quality. It was taken by subdued window light.

Pattern in isolation The front of this barn in Romania (above) has been transformed into a wonderful exercise in pattern. The woven fence in the foreground leads the eye on to the strong verticals of the door timbers, again framed by wooden tiles.

Abstract detail This roofline set against the sky (right) was the only feature of note in what was a particularly unpleasant villa in Portugal, yet it has made a powerful image.

Texture and pattern Late afternoon sunlight (below) has made a feature of the pattern and texture inherent in stone and glass.

Tiled detail Here, the ornately tiled exterior (below) contrasts well with the austere interior that can be seen through the window of this rather unusual Portugese house.

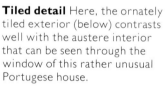

Technical Briefing
The type of lens needed for this project depends entirely on the scale of the architectural detail. Obviously, very small details require a long lens in order to fill a reasonable area of the frame. You should, however, be able to produce an acceptable range of pictures using nothing more than a standard lens and, wherever possible, moving in close in order to isolate and fill the frame. If you have a fixed focal length of a moderate wide-angle (say, 35mm), then use its inherent close-focusing characteristics to allow you to move in even closer.

See also:
Projects 1, 2, 3 and 48

Knobs and knockers

When out photographing in a particular locality, it can be instructional to pick on a very narrow theme. This could be any manner of things: windows, doors, cars, flowers, faces, and so on. A good and varied set of pictures can generate a lot of interest as well as being fun to shoot.

This type of project can be undertaken in any spare few hours in your locality, when on vacation, or just out somewhere visiting. For my example here I chose door knockers.

Keeping to the theme of knobs and knockers, there are some technical aspects to be taken into consideration. Because these objects are usually quite small, a moderately long lens will be needed – anything from about 80mm to 135mm. A compact camera with a zoom is ideal. However, if you have a compact with a fixed focal length of about 35mm, it would be preferable to choose larger objects as your theme.

Moreover, because doors are often recessed and, therefore, slightly in shadow, you will need moderately fast film – somewhere in the region of ISO 200–400 (see pp. 32–5), depending on the general light levels. Reinforcing the need for fast film is the fact that since you are using a long lens, you will also have to select an aperture of about f8 or 11 for sufficient depth of field (see pp. 28–9). The use of fast film may enable you to get away with not using a tripod.

Variations on a theme All these pictures were taken in a small town in West Germany, and I purposely limited myself to two hours, using a compact camera with zoom lens. I took many, many more shots in that time, but these examples give the flavour of what can be achieved. Although the knockers can be fascinating artefacts in their own right, they gain extra strength from the surfaces against which they are presented, hence this project is also an exercise in textures – some smooth and highly polished and some more interestingly crazed, weather-worn or bubbled.

Technical Briefing
Medium-fast film (ISO 200–400) and a moderate telephoto lens are the basic requirements here. You will want to be using a shutter speed of about 1/125 or 1/250 sec (to avoid the need for a tripod) with a small aperture of about f8 or 11 (for sufficient depth of field). Because depth of field is limited with a telephoto, even at small apertures, make sure the camera is square-on to the door, otherwise pictures may not be uniformly in focus.

See also:
Project 49

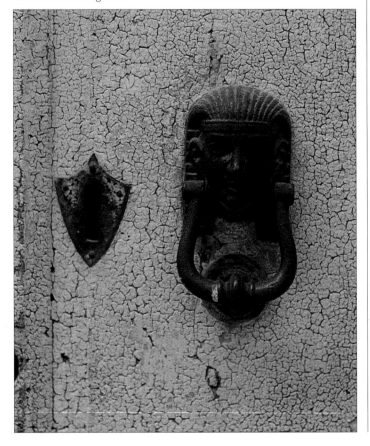

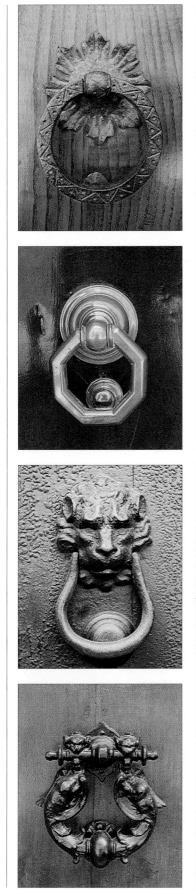
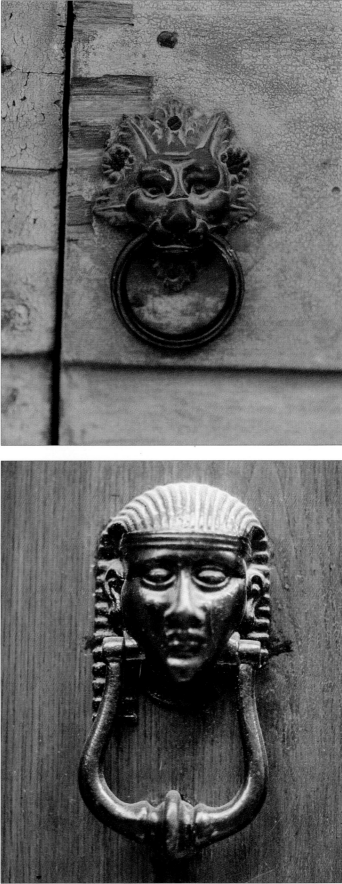

Simple interiors

When shooting an interior setting a choice has to be made between two different basic approaches: either to rely on available lighting from doors, windows, skylights and domestic lights; or to use additional artificial lighting, such as flash or studio tungsten lighting units.

Technical Briefing
When photographing interiors in available light, such as that from a window or doorway, you will need to load the camera with moderately fast film, such as ISO 400. Of course you may choose to use supplementary lighting, or to place the camera on a tripod so that a slow shutter speed is possible. In dimly-lit interiors, compact cameras produce a relatively bright viewfinder image, making focusing easier, which gives them an edge over SLR cameras.

See also:
Projects 52, 53 and 54

The approach you adopt will probably largely be governed by circumstances – if available light is sufficient, giving both quantity and quality, then you will not need to supplement it. Bear in mind, however, that light from doors and windows, especially if small in relation to the size of rooms, tends to be contrasty and directional, highlighting some areas of the room while casting others into deep and featureless shadow.

You should be able to use your own home to produce a set of pictures of simple interiors for this project. Even if some rooms do not immediately appear suitable, part of your task is to use the inherent contrast of directional light in order to select and simplify. For example, if you take a highlight reading inside on a bright day, the shadowy areas will be lost into darkness in the photograph, adding drama and mystery to the setting.

Framing In this picture (right) the framing is entirely in keeping with the simplicity of the passageway and furniture. Notice how the blocks of shadow act as visual full stops.

Mixed lighting This gracefully curving stairway (above) was lit by daylight and artificial light, making a colour cast inevitable.

Contrast Directional top-lighting illuminating only the treads of the stairs (above right) has produced a simple, abstract composition of light and shade.

Large window area Note how a window large in relation to the room produces a more even type of lighting in this simple bathroom interior (above). I was initially drawn to the taps, which are reminiscent of the curving necks of some exotic water bird.

Lifestyle The simple lifestyle of the people of the Outer Hebrides (right) is reflected in this picture of a kitchen/ sitting/living room.

Complex interiors

Technical Briefing
To record detail in an elaborate setting you will need a generous depth of field (see pp. 28–9) and a small aperture. The problem that may arise, however, is that shutter speeds may be too slow for hand holding the camera, making a tripod essential for this project. If you are using mixed daylight and tungsten, then colour casts may result, no matter which type of colour film you decide to use.

See also:
Projects 51, 53 and 54

Whereas with simple interiors a contrasty type of light can work heavily in your favour, as became evident in the previous project, when you are dealing with more complex settings, such as those illustrated on these pages, you will generally require a more even, detail-revealing quality of illumination.

This does not mean that the source of the light need be different – you can still use available window light, but you will be looking for ways of reducing contrast. You could, for example, use off-camera flash (see pp. 36–7) to lighten unwanted deep shadow areas, or use matt-white cardboard or a sheet as a reflector for flash or natural light, to bounce some light into slightly shadowy corners.

For this project you could, again, use your own home. You will need to produce pictures where you have reduced contrast to the point where the details can be clearly recorded. The advantage with both the contrast-reducing methods above is that they do not produce colour casts with colour film.

Strong patterns A profusion of pattern (above right) has made a complex interior. For this shot I used a tripod and a shutter speed of 1/15 sec, with reflectors on the left.

Mogul room Decoration here (right) could not have been more ornate, but plenty of light from a large window and reflected from mirrors allowed use of a hand-held camera.

Bric-à-brac Strong tropical sunlight and a large picture window (above) meant that there was plenty of light . Every item of the literally thousands in this general store can be seen in full detail. The little girl peeping shyly over the edge of the counter seems to be almost submerged under an avalanche of stock.

Mixed lighting This picture (right) was taken toward dusk as light levels were rapidly falling and the corners of the room becoming lost in shadow. To produce the highlight on the figure camera-mounted flash was used to supplement the natural illumination.

Conserving an atmosphere It is important not to lose the atmosphere of a room (above) so use additional lighting with care. In this conservatory I wanted to give the feeling of jungle, so I just used natural lighting and filled the frame with luxuriant foliage.

Large-scale interiors

Photographing large-scale interiors does not differ fundamentally in approach from the two previous projects. The only new factors that may have to be taken into account are selectivity of subject matter, what to include and what to leave out; and lens type – a wide-angle is generally more useful than a standard.

W hen planning your project on large-scale interiors, I cannot emphasize enough the importance of preparation and pre-planning. Visit the site you intend to photograph beforehand – probably the day before – in order to see how much light there is to work in, what lenses and accessories (such as a tripod) will be most useful, and what likely camera positions will give you the best results. Also, note any interesting features that you may wish to include.

Many important buildings have been photographed by professionals, and their work printed in books or brochures, or as postcards. If you are overseas, the local tourist office will almost certainly have illustrated pamphlets to give away. It is always worthwhile researching this material to see what vantage points have been chosen and if you could benefit from their work.

Tonal contrast This view of an interior courtyard in the Alhambra, Granada, shows well the delicate stonework of the Moorish building. Tonal contrast draws the eye deep into the frame.

Pattern and texture A beam of sunlight spotlights this statue (above) standing in a courtyard of the school of art in Venice. Sufficient light has spilled over to provide a wealth of valuable pattern and texture on the surrounding walls.

Church interior In this interior (right), I used ISO 400 film and hand held the camera at 1/30 sec. I positioned myself in the middle of the central aisle and used a 28 mm lens to include as much as possible of the splendour of the church's floor, walls and ceiling. Light levels were not perfect, but the clerestory windows provided useful downlighting.

Detail For this shot (far right) I set focus to infinity and placed the camera on the floor pointing up at this wondrous ceiling in a church in Rome. I then had to use the self-timer to trigger the shutter.

Multiflash To capture the colonnaded magnificence of the Grande Mosque of Cordoba, Spain (bottom right), I set the camera on a tripod with the shutter locked open, and then fired a flash at least half a dozen times to lighten the building's dark interior.

People and interiors

One of the difficulties that may have been experienced during the three previous projects was finding the best time of day or selecting the most appropriate viewpoint to show the chosen interiors largely free of people. Shooting interiors with people not only removes these problems but can make more interesting pictures.

Just as the inclusion of a person can add warmth and purpose to a room setting, so too can the setting add understanding and context to that person. For this project the correct balance of elements must be determined, using lighting, camera position, lens type, and aperture to produce a photograph that tells the viewer something of the person and, through that person, something of the setting. Remember, photographs are a frozen instant, and timing can be vital when photographing people.

Viewpoint By shooting from the front of the judging table at this village flower and produce show (below) the beans, onions etc. give context to the seemingly bizarre appearance of the judge holding up a cabbage.

Lens and aperture Another photograph at the same show (above) used a similar shooting angle, but a much lower position. An aperture of f4 on a 50mm lens took the immediate foreground out of focus.

Technical Briefing

If this project is undertaken using black and white film, bear in mind that faster films tend to show a more pronounced pattern of grain – a factor that can, of course, be used to advantage with the right type of subject. Grain, however, lessens the appearance of fine detail, and this will be most noticeable in the shadow areas of photographs.

See also:
Projects 20, 51, 52 and 53

Low-key Suitably filtered by the doorway, the intense tropical sun of Sri Lanka paints a low-key scene of delicate and subtle tones (above). Even a casual glance tells us that this room is central to the life of its owner, who sits in the half-shade gazing into the light of a new day, and surrounded by objects from the past. The camera position gives a viewpoint from the deepest shadows of the room, implying that the presence of the photographer is unknown to the subject.

High-key Although as sparse as the room above, high-key lighting has reached into every corner and removed the last vestige of intimacy from this scene (right), giving the room a much more open atmosphere.

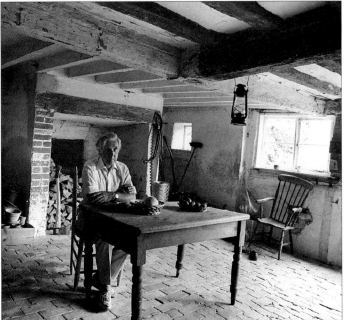

STILL-LIFE

Whereas many areas of photography rely
on quick reflexes and being in the right place at the right time,
shooting still-lifes is more a matter of patient observation
and having an eye for a pleasing arrangement.
Projects in this chapter deal with both 'found' still-life subjects
and those arranged specifically for the camera. Because of the
nature of the subject matter, lighting is
more than critical: the play of shadow against highlight,
the colour of natural daylight at different times of the day,
or the quality of studio lighting are all
of the utmost importance.

A restricted palette The essence of good still-life composition is refinement – of shape, colour, tone and form. Here all the essential qualities that convey the reality of these simple objects are described by light from a single window and the use of a limited palette of colours.

Using found still-lifes

A still-life is any object or group of objects arranged, either intentionally or by change, in such a way as to make a pleasing composition. In this introductory project on still-lifes, we will be concentrating on 'found' still-lifes — in other words, objects not primarily arranged for the camera.

Technical Briefing
This type of project is immediately accessible to all camera owners, since it is not dependent on any particular camera or lens type. The most important thing is to be observant – you will find subjects in the most unlikely places, if you are alert to them. Because still-life photography implies a very considered, almost leisurely approach, you will find a tripod a most useful accessory.

See also:
Projects 56, 57, 58, 59 and 60

How many times have you caught yourself in an idle moment reaching out your hand and making some minor adjustment to the position of an ornament around the home – perhaps a table lamp or ashtray, a family photograph or vase of flowers. If you work at a desk, you probably have a preferred position for the tools of your trade – the telephone in relation to your typewriter, or the contents of your book shelf. Whether you realize it or not, these preferred arrangements of inanimate object are, in themselves, found still-lifes, and the world abounds with them.

For this project you will need to take the time to look and *see* these uintentional arrangements. In many instances, though, found still-lifes are entirely natural: a wind-built mound of autumn leaves piled against the trunk of a tree; a piece of bleached and twisted driftwood cast up above the high-tide line; the still-glistening, salt-encrusted fingers of seaweed exposed by low tide; or the discarded objects in the garden shed. All are legitimate subjects.

Isolated element With this figure (left), what first attracted me was the colour contrast still visible in his battered appearance; then I was taken with how uncharacteristic he was of the over-animated, always-shouting genuine article.

Themes Close colour harmony (right) and a common theme of ornamentation link all the elements in this shot to make a very pleasing image.

Public display This amusing still-life (below), on both sides of the window, presents to all passers-by a wonderful contrast between the past, the present and the future.

Shooting around a subject

Once you are satisfied with photographing found still-lifes, you can create your own. By choosing one simple object and using different camera positions and lighting effects, you can create a series of very different pictures. And the choice of subjects for still-lifes is endless.

For this first project on arranged still-life subjects you will need to come to terms with how subtle changes of camera position and lighting can have a dramatic effect on your finished pictures. The best way to do this is first to place the camera on a tripod, and then arrange the subject where you can move freely around it, giving plenty of

room to move your lights or reflectors. This positioning will also allow you to view and shoot the subjects from different heights, producing the series of pictures that is required for this project.

When arranging any still-life subject it is vital that you keep monitoring it through the camera's viewfinder as you move or add to it. There is no point in viewing the

elements of the composition, and seeing that the direction of the illumination is satisfactory, while standing next to the still-life, if the camera is in a different position and at a different height. A difference of an inch can change the apparent relationship of one object to another, so arrange, view, light and check the composition from the camera position only.

Changes in camera position In this first shot of the exercise (left) I moved in close to the vase of sunflowers using a 28mm lens. By coming in this close I have changed the apparent size of the flowers in relation to the room. Next (centre), I moved in a little closer and to the right, allowing space for the two figures, who act as stepping stones taking the eye through the frame. For the final shot (right), still using a wide-angle, I pulled right back to reveal the sunflowers in their relationship to the table, and the table to the room.

Changes in light It is hard to believe, but both these photographs are of the same black glass jug. In the first picture (above), it is seen in its normal colour, positioned in a grey-coloured alcove I painted for the shot. The lighting here is noonday sunlight. For the next picture (right) I left the jug untouched until sunset to take the picture. The light at this time of day is so heavily filtered by its passage through the atmosphere that the golden light has transformed the jug.

Technical Briefing
For still-life work, you will find a tripod invaluable. With the camera set up securely, you can work on your composition and lighting, always going back to your reference point, represented by the fixed position of the camera, in order to check the position and effect of any changes you have made.

See also:
Projects 55, 57, 58 and 60

Themes in still-lifes

In this third project on still-lifes the emphasis is very much on selecting a particular theme. Perhaps the most difficult discipline in this type of photography is knowing when you have finished, in other words when to stop arranging elements of your composition — a task made considerably easier when you have a theme in mind.

Having worked on the previous two projects on still-lifes, you should now have a more developed idea of the type of subject matter you find interesting or appealing. In this project you will be dealing with multi-element compositions that you have chosen because of how the objects relate to reach other.

In the following pictures I have taken ordinary domestic items, typical of those found in most people's homes, as my source. These compositions work well largely because the items of each photograph appear logically to belong in close association with each other — thus relieving the composition of the need to justify or explain the selection made. The objects could be linked by their shapes, forms, colours or materials as well as by their functions. This is perhaps the key issue in putting together still-life pictures: choosing and arranging objects that work together as a whole, in a sympathetic lighting scheme and in a relevant and appropriate setting.

Keep it simple A mistake beginners often make is in trying to cram too many objects into the frame. In this image (below) I have used just three items, allowing the tonal contrast of the objects themselves against the plain background to add strength to the overall effect.

High-key This composition (below) contains objects made of a variety of different materials and with different surface characteristics, heights and colourings. By arranging them in full sunlight and overexposing slightly, they blend well into an appealing high-key image.

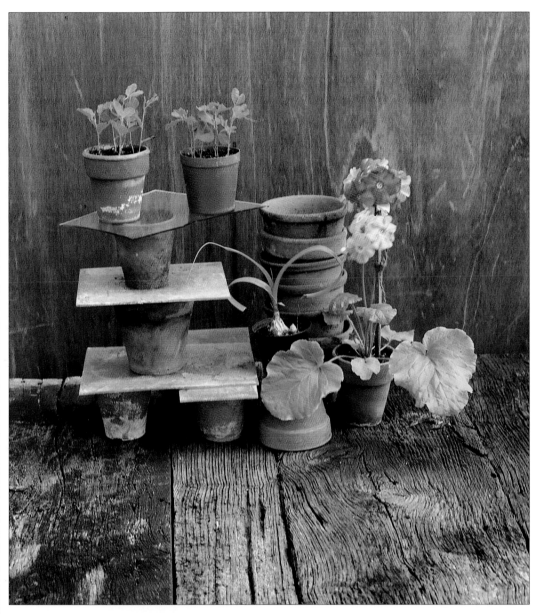

Minor intervention Apart from adding the flowering plant (above) to balance the stack of pots on the left, this composition is exactly as I found it on a greenhouse shelf.

Sympathetic shapes This entire composition (left) has as its theme simple rounded shapes – the eggs themselves, contained in their dark wire baskets, and the enamelled jug.

Technical Briefing
Remember to place the camera on a tripod and to monitor the composition as you build it by looking through the camera's view-finder. Lighting and a logical association between the objects you select are vital ingredients of successful photographs.

See also:
Projects 55, 56, 58, 59 and 60

Variations on a theme

Small changes make big differences. Bear this fact in mind and you may avoid some of the more obvious mistakes often made in still-life photoghraphy. The colour and style of your background, as well as lighting, exposure and film are all part of the way you interpret the shot.

Technical Briefing
A good way to learn how exposure affects the various components of still-life composition is to bracket shots. This could mean exposing at an average light reading and also at a setting both above and below the one you determine to be correct. Alternatively, you could take a highlight reading and a shadow reading and make exposures at these two extremes. Compare the results and decide which exposure works best.

See also:
Projects 55, 56, 57 and 60

Background colour can set the mood and atmosphere in photographs. Dark colours tend to limit the spatial quality, giving a confined, intimate or even brooding feel. In stark contrast, light or pastel colours impart a sense of space and freedom. This is the essence of this project. It will help if you can organize a space, within which to arrange your still-life, that can easily be changed in terms of its colouring and lighting. In the pictures below, for example, the little alcove in my studio has been used many times and it has been many colours.

Colour variations For the first shot (above left) I experimented with different paints before finding this warm brown colour, entirely suitable for the pastels and beige of the dried flower arrangement. For the next picture (above right) I painted over the brown with a coat of lemon yellow. Immediately the image seems to have far more space, though framing is practically identical. Overexposing half a stop has increased the feeling of heat and light.

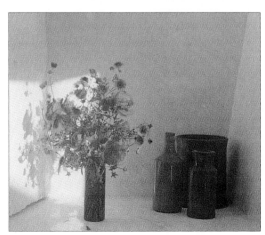

Soft and sharp These four images of an identical set-up were all taken within five minutes of each other using subdued daylight. The alcove itself is constructed from painted plywood.

In the first version (above) I used light from the side and from the alcove's open top to produce a well-balanced, straightforward shot with plenty of contrast. For the next (left), I simply added a diffusing filter to the lens.

The last two images are so different because firstly I changed from ISO 64 to ISO 1000 film and, secondly, I used a mirror to direct illumination into the alcove. In the third version (below left) contrast is more obvious (a feature of fast film) but colours are less distinct, muddier. In the fourth (below right) I again used a diffusing filter to make the lighting more even throughout the image.

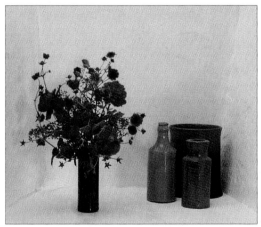

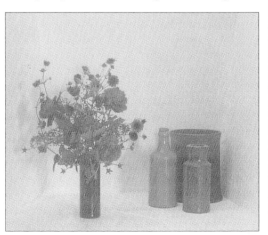

Difficult materials

Certain materials encountered when photographing still-life subjects present particular problems. Examples of these include clear glass objects, especially when you want to show both form and transparency; silverware or any highly polished material; glazed ceramics; and, most difficult of all, a mixture of these in one shot.

For this project two still-lifes using difficult materials are required. The first one should contain objects with shiny and highly reflective surfaces. The second shot should contain objects made of glass.

Glass and glazed or polished surfaces can act as mirrors, reflecting back light in the form of intense high-lights, or 'hot spots'. Also, just like a mirror, they can produce recognizable reflections of anything in front of them, thus confusing the image generally and the object in particular. One way to avoid this is to use diffused, indirect lighting, such as that from a photographic umbrella, or daylight through netted curtains. This, however, can give a dull and lifeless appearance. To avoid this, include some controlled reflections. A square of white or black card (whichever is appropriate) could be held in front of an object so that it is reflected in its shiny surface. This simple device can add that all-important element of form and thus help to define shape.

'Window light' The lighting for this picture (above) was a special photographic 'window light', which stimulates the effect of natural daylight. It gave me the overall illumination I wanted, but I also reflected a piece of black card in the tines of the fork and allowed the knife handle to reflect the white tablecloth.

Photographic umbrella Initially, when this plate and spoon (above) were lit with photo-floods, the reflections were such that nearly all colour was desaturated and thoroughly unsatisfactory. The solution was to use floods directed into special photographic umbrellas, which give a very even, diffused illumination.

Mixed objects For this picture (above), to avoid too many confusing reflections a studio window light was used, but it could just as easily have been lit with diffused daylight. The theme of the shot is early photographic memorabilia – the objects were placed on curved background paper so that no joint between the horizontal and vertical planes would be seen in the photograph.

Technical Briefing
A useful piece of equipment if you are shooting small objects with difficult surface characteristics, such as a porcelain figure, a piece of jewellery, a watch or a single glass, is a 'ring flash'. This is a circular flash tube that fits around the front of the lens and produces near shadowless illumination. You can easily buy or hire one from photographic stores.

See also:
Projects 55, 56, 57, 58 and 60

Food as still-life

As well as being a pleasure to eat, food also makes an excellent subject for still-life photography. Meat, fish, bread and fruits, as well as cakes and pastries all have such a wide variety of textures, shapes, colours, patterns and forms. Best of all, you can often find them displayed to perfection in shops and restaurants.

Technical Briefing

If you are arranging food as a still-life, you should (in most instances) confine yourself to one type of produce – be it fruit, fish, meat or bread – as is shown in the pictures on these pages. The finished composition will then have a clear theme and an inherent unity. As with most still-life arrangements, it is easier if you start by positioning the largest object in the composition first and then build the smaller elements around it.

See also:
Projects 55, 56, 57 and 59

For this project you have to produce a set of pictures featuring food as the main subject. The shots can be 'found' still-lifes, in as much as they were not created specifically for the camera, or pictures of food that you have arranged yourself at home.

Shop window displays are often a good souce of found still-life subjects. The shopkeeper will have tried to make the food appear as appetizing as possible and there is nothing to prevent you from taking advantage of the opportunity. If reflections from the glass are a problem, a polarizing filter should help (see pp. 204–5); also make sure you look at the surface of the glass properly for dirt or condensation and do not overlook the fact that your own reflection may be plainly visible.

If, however, you want to photograph a food display inside a restaurant, where you will often find some very appetizing arrangements, then you must request permission. In all my experience, I have never yet been refused. In fact, my request has usually been taken as a compliment, but you must ensure that you do not cause a nuisance, either to the staff or to other diners.

Eye-catching display The shopkeeper of this establishment (above) has obviously decided that every square inch should be covered with sausages, smoked hams and prepared meats of all descriptions. From a photgraphic viewpoint, fewer elements would have been better.

Advancing colour This is another found still-life (above) created by a gardener to use as a table display. Light was from a bright, open sky, but not in direct sunlight. It is interesting how strongly the red strawberries advance against the cooler green of the leaves.

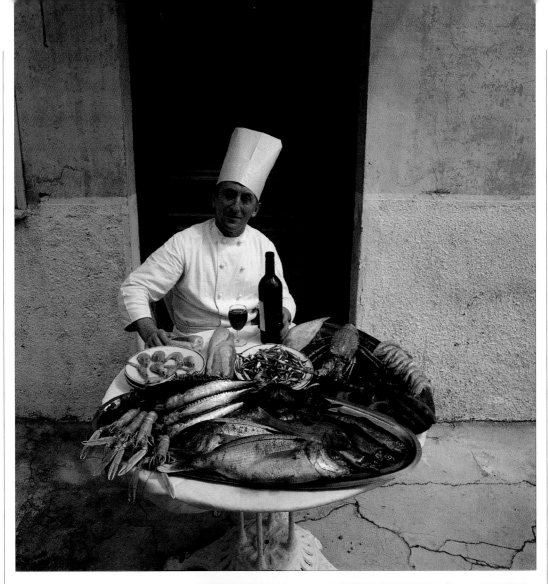

Compliments to the chef
After having had the most marvellous fish meal in a restaurant, I asked the chef if I could take his picture (above). He was more than pleased and, it being toward the end of lunchtime, he even had his kitchen staff refill the rather depleted display of fish from which we had chosen our food. The shot was taken in bright and overcast conditions.

Sweet tooth
Compositions that fill the frame, such as this sweet table (right), are often worth shooting. Luckily since I arrived soon after the restaurant opened for lunch, all the cakes were still intact, producing a compositional theme not only of food but also of very similar shapes.

THE NATURAL WORLD

This chapter is largely concerned with the photography of animals. Domestic animals and pets are relatively straightforward subjects, since they are usually very familiar and comfortable with people in close proximity. Wild animals, however, in zoos, wildlife parks and sanctuaries are altogether more challenging. Often many patient hours will have to be spent motionless in hides to obtain a good picture, or special flash set-ups used for nocturnal creatures.
With small or cautious subjects, the need for telephoto lenses is paramount.

A discerning eye There is so much beauty in nature that it is sometimes difficult to know how to go about recording it with the camera. The trick, well illustrated by these lily pads, is to arrange pictorial elements within the area of the viewfinder as an artist would within a canvas.

Animals around the home

Pictures of wild animals represent a special challenge for photographers. Animals that survive to maturity do so because of a highly developed sense of caution. Even the 'camp followers' that have learned to take advantage of our waste or generosity are innately shy and difficult subjects.

Although tragically there have been many casualties among animal species because of the activities of mankind, many others have learned to adapt and even flourish and can be approached sufficiently closely to make photography a rewarding pastime.

For this project you will need to take pictures of at least two different types of wild creature – say, a garden-feeding bird and a more testing subject such as the wild fox featured opposite. By necessity, subject matter must be governed by the types of animal you have in your particular locality.

You can make your task easier by providing local animal species with a ready source of food and drink, something that will be especially welcome during winter when birds and animals will venture nearer houses in search of scraps of food or ice-free water. Unless shooting bolder animals, a telephoto lens is invaluable for bringing subjects closer in and getting a good-sized image, and if you are trying for pictures of insects, the macro facility available on some lenses is essential.

Winter forage Pheasants (below), long bred for hunting, have lost some of their natural instincts and in country areas in early morning will approach very close to houses. This shot was taken from inside the house using a compact camera set on automatic.

Garden birds Although a common sight in many gardens, the thrush (bottom) is still well worth the effort of photographing. Its most noteworthy feature is its proud, speckled chest, so ensure that this is prominent in the shot or it could look rather dull.

Technical Briefing
For most pictures of animals around the home you will find a telephoto lens useful for hand-held shots. Alternatively, for very shy animals, set up the camera on a tripod and use a remote release to trigger the shutter. Fast film is essential if your intended subjects are likely to be most active either first thing in the morning or toward dusk – as is so often the case with wild animals.

See also:
Projects 62, 64, 65 and 66

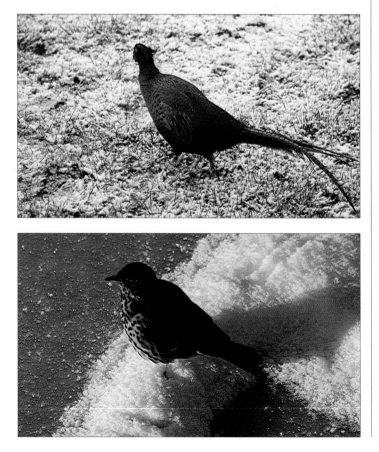

City foxes Many foxes (above), having been hunted out of country regions where they are considered vermin, have made a successful transition to city life. They can be seen at night in suburban gardens and, sometimes, even sunbathing on quiet roofs during the day. This picture was taken in late afternoon on a stretch of wasteground using a 135mm lens.

Friendly mouse This shot (top right) is a bit of a cheat, since the mouse was semi-tame and readily accepted food from the hand. I used a compact camera with built-in flash and set on automatic.

Anyone for cricket? For this picture (bottom right) the macro facility on the zoom lens was essential to obtain a good-sized image. Be careful not to put your own shadow over the subject when you are working very close-up.

A day at the farm

If you are photographing people doing their normal work, you need to adopt an easy-going good humour and be prepared to be flexible in your approach so as not to get in their way. This is especially true in an environment such as a farm, where everybody is usually occupied with specific things to do.

Technical Briefing

Because one moment you might be in bright sunshine, the next inside a barn working by window light, load your camera with a medium to fast film, such as ISO 400 (see pp. 32–5). This should give you the flexibility to cope with most situations. The most generally useful lens you can use is probably a moderate wide-angle (35mm) or a standard (50mm). Domestic animals are used to people, so you will have little call for a telephoto lens.

See also:
Projects 61, 64, 65 and 66

You can regard this project as a type of photoreportage, where the object is to capture on film as many aspects of the farm and the farming way of life as you can in a single session. If you don't know of a farm nearby, do not despair. The telephone book will give you the numbers of many farming associations which will give you some leads. Local schools often arrange annual visits to a farm, and you might be able to go along as a helper. Failing this, it is not uncommon to find city farms – small areas set aside and stocked with typical domestic livestock, where city kids can go to to get the feel of the countryside.

As for some general advice, wear old clothing and water-proof boots – farms are often muddy and you don't want to be worrying about where you put your feet. Deep pockets in a coat will be useful for spare lenses, extra film, filters, and so on, to save you carrying a camera bag. Arrive as early in the morning as possible: the farming day starts at sunrise and you will need to get in as much activity as you can.

High-steppers Early-morning light (above) casts long shadows from these chickens, which seem to be stepping daintily over the hard ground as if it is too rough for their liking.

Rotund sheep This shot (below) works well because it shows the sheep, so replete they cannot be bothered to graze, set against a wonderful old thatched barn.

Side issues Here (above) the farmer's wife carries home her small dog that had hurt itself on some wire. For complete coverage you need to show the daily routine of the people.

Reawakening appetites The cooler afternoon had rekindled the desire for food in these pigs (right). They were obviously very relaxed and content rooting in the grass.

Final chores The cows being brought in to the near paddock (below) provide the final photograph of the series.

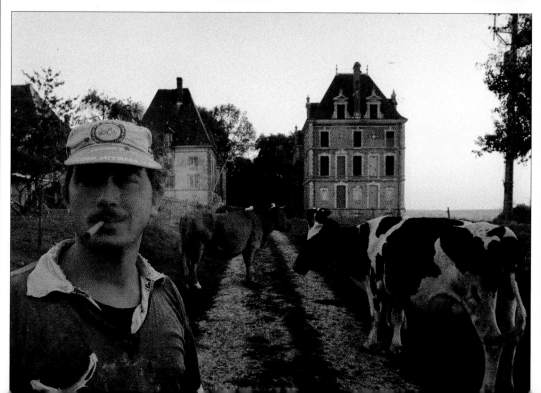

Flowers and flower gardens

Photographing flowers in a garden setting can present a problem — there is the danger that images may look like illustrations for a seed catalogue. Unless you require a straight record shot of a specimen, it is often best to include some other garden feature or perhaps a person.

Single-species planting The merit of this shot (above) lies in the quality of the lighting. The sky was quite dark and this produced wonderfully saturated colour.

Single bloom For this shot (left) I used diffused flash (see pp. 36–7). This was sufficient to allow me to select a much smaller aperture and throw the background into contrasting darkness, while keeping the light looking natural.

Mixed planting This shot (below) demonstrates that a mixed planting often makes for a much more interesting and lively picture.

Gardens are designed primarily for walking in, for breathing deeply the fresh fragrances of flowers or new-cut grass, for the sounds of birds or moving water – and not, unfortunately, for the sometimes dispassionate single eye of the camera. This is not to say that you cannot take evocative flower studies, only that it is no easy task.

Flower close-ups
One often effective method of introducing a little drama into flower pictures is to move in close and fill the frame with just a single, open bloom. Certainly, if you want to attempt this technique with a small flower then you will need somewhat specialist equipment and, preferably, an SLR. Close-up tubes or bellows are designed specifically for this task (see p. 203), but many zoom lenses for SLRs (see pp. 26–7) have a 'macro' setting to give near life-sized reproduction.

Larger flower specimens, however, are easier to deal with, comfortably filling the frame of a compact camera equipped with even a modest zoom lens. Just after rain is a

Naturalized planting It is easy to see from this photograph (right) the additional strength that is imparted to a composition once a feature other than the plants themselves is introduced. Use your hand to crop out the fallen tree and you will immediately notice the difference. This woodland setting was an extension of a formal park. The intensely bright sunlight in the formal area was considerably softened by the canopy of leaves.

Formal garden For a general view such as this (below) the roses would have appeared poor subjects for a photograph without the unifying structure of the box hedge to hold the composition together.

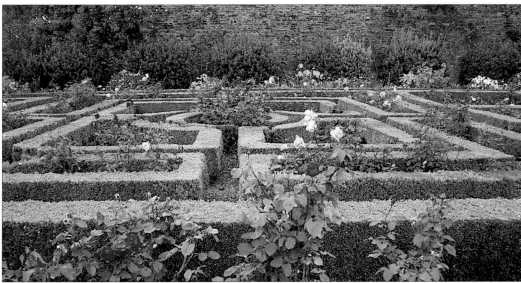

good time for such shots. Assuming the petals have not been distorted or damaged, the flower will be fresher and there may still be tiny water droplets within the bloom.

Flowers in situ
Broader views of single-species plantings, mixed plantings, formal gardens, or natural-history shots of naturalized flowers do not require any specialist equipment. With these, unless you can find some type of unifying structure to the composition or include in the shot some form of garden feature,

results could be dull and disappointing.

To accomplish this project you do not have to restrict yourself to any time span or location, although you may find that your own garden or a near-by park has all the elements needed. You should aim for a series of pictures that ranges in scope from single blooms, through mass-plantings and more traditional garden views, to a naturalized flower display. Each picture must stand on its own merits and not rely on the others in the series to give it purpose.

Technical Briefing
If you are using close-up equipment, bellows, tubes, or a zoom set to macro, a tripod is essential. Depth of field (see pp. 28–9) is extremely small and even the slightest focusing error will be evident. You might also need to erect a wind-shield around your specimen to prevent it swaying in and out of focus with every breeze.

See also:
Projects 35, 37 and 40

Zoos and wildlife parks

With zoos, wildlife parks and animal sanctuaries proliferating in most countries around the world, photographers have never had such easy access to exotic animals of all types. Nevertheless, to take good pictures of animals roaming with a reasonable degree of freedom still requires skill, patience and a fair share of luck.

T o produce a satisfactory set of photographs for this project, you will need to pay a visit to one of the animal institutions mentioned above. But more than simply snapping animal portraits, concentrate on revealing through your work something of the animals' habits or habitats.

Thankfully, the type of zoo with animals penned behind bars in sterile concrete bunkers is fast disappearing. However, very often there is still a wire safety fence separating you from the animals' enclosures. If the mesh of the wire is wide enough to push your camera lens through without danger, then there is no problem. With close-mesh barriers, however, you need to place the front element of the lens as near to the wire as possible and use the widest aperture you have available (taking into account film speed, light levels and shutter speed). This will render the wire so out of focus as to be invisible, although a slight softening of detail and contrast will be evident throughout the photograph. The longer the focal length the more effective the technique will be.

Technical Briefing
You need quick reflexes when working with wild animals, making a motor drive or autowind facility a valuable camera feature. A long focal-length or zoom is best to get a decent-sized image. Even when photographing in the tropics where light levels are high, animals tend to stay in the shade or become active only at dawn and dusk. This makes medium-fast (ISO 200–400) film essential.

See also:
Projects 61, 62 and 65

Depth of field Selecting f2.8 on a 135mm lens (left) gave a zone of focus that was just sufficient for this parrot.

Observation port This unusual view of seals (below) was provided by an armoured glass observation port.

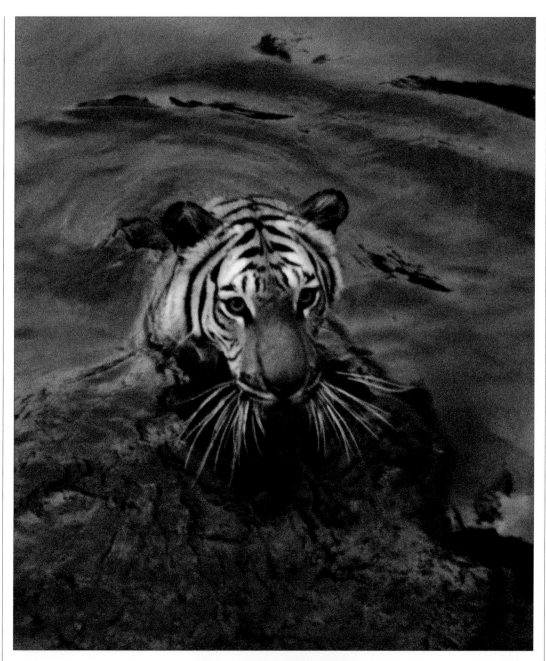

Tiger, tiger... It was late afternoon at Singapore Zoo (above) when I managed to take this picture of a tiger well out of his depth in the moat surrounding his enclosure. Unusually for cats, tigers are ready swimmers and he eagerly retrieved the meat thrown into the water, coming close enough for a good-sized shot.

Camouflage This picture was taken through a coach window at a wildlife park. I used a 135mm lens, but even so the lion blends superbly well into the dappled surroundings.

Domestic animals

Unlike the wild animals in the previous project, pets and domestic animals are relatively easy to deal with photographically. Used to being handled, approached, fed or pampered, many of these animals more readily identify with humans than they do with other creatures of their own species.

When photographing pets the chief things you need to bear in mind are: to work quickly but calmly; to have some food or play-things to keep the animal interested; and always to work with the camera as close as is possible to the animal's own eyeline. Use flash on fast film as the best shots are often of very quick moments and facial expressions that could otherwise be missed.

Technical Briefing
Although approachable and generally relaxed, animal behaviour is always unpredictable, so stay alert to the usual and unexpected. Compact cameras and autoexposure/autofocus SLRs are ideal cameras, allowing you to concentrate all your attention on the animal itself without worrying too much about the technical controls. Make sure, however, that aperture (for depth of field) and shutter speed (for action stopping power) are appropriate.

See also:
Projects 61, 62, and 64

Perspective Although small in the frame (top right), linear perspective fixes attention squarely on the subject.

Port in a storm A friend's pet goat (left) unhesitatingly took refuge from the elements in the back of my car, resulting in this comical image.

Eccentricity Not many people have both their pet pony and monkey in the drawing room (bottom right), but the opportunity provides amusing and unusual pictures.

Feline opposites These shots show how the same type of subject can be handled. The Outer Hebridean tom (above) looks pretty capable in any situation, while the pampered pedigree (right) seems more inclined toward the comfort of upholstered armchairs.

Birds in flight

With wildlife photography of this type, patience and a large measure of luck are your chief allies. Unless the subjects are caged birds, it is necessary to build up a complete picture of the subjects' movements and habits: where they feed, their favourite resting places, where they are nesting, and so on.

W hen photographing birds, you must take pains not to interfere with their routine in any way. If, for instance, you found birds with chicks, then an insensitive intrusion may cause the parents to abandon the nest and the young to die. A well camouflaged hide and, of course, a long lens will reduce the likelihood of this. Offerings of suitable food left along their flight path may well encourage birds to come closer to a concealed camera position, as well as improving the chances of survival of any chicks.

For this project it is not necessary to use wild birds, as in these pictures, but setting and background, as always, are vital components. If the subjects are caged or aviary birds, it is a good idea to construct a large, wired-in flight area, covered on the inside with a neutral-coloured background paper against which the birds will stand out in bold contrast. Inside this extended cage you can position the flash units and camera, and then trigger the shutter remotely from outside so that the cage is not seen in the photographs.

Bird sanctuary For these studies of a barn owl, I was very fortunate to have had the co-operation of a wild bird sanctuary, which had pairs of nesting birds. To take the shots two high-output flash units (one attached to a slave unit to fire synchronously) were placed on one side of the barn and a large matt-white reflector on the other. The lens was a 135mm. Flash output was so brief that the owl, captured in mid-flight, hardly even realized that they had been fired.

Technical Briefing
If there is a pre-determined flight area for the birds you are shooting then these types of pictures are possible with a compact camera and zoom lens. However, for serious work with wild birds, an SLR with at least a 135mm lens (the longer the better) is needed. Another pre-requisite is a tripod for the camera, clamps or stand for flash units, and a pair of binoculars for making initial observations.

See also:
Projects 62, 64 and 69

Using specialist equipment

For the vast majority of photographic situations, an ordinary compact camera (preferably fitted with a zoom lens) or SLR camera with zoom or wide angle, standard and moderate telephoto lenses will be adequate. When more unusual optics are required, an SLR is essential.

Macro lens For this close-up of an orchid a 100mm macro was used. Coloured cardboard gave a neutral background and acted as a windshield.

For this project, compact-camera owners will need to borrow or hire an SLR. Day-rate hire fees for cameras and lenses are not high.

The particular optics concentrated on here are macro lenses, perspective control (PC) lenses, and more extreme telephoto lenses.

Macro lenses are designed to give optimum results at extremely close focusing distances allowing, in some cases, 1 : 1 (or life-size) reproduction. This type of facility is available in two formats. First, some zoom lenses have a macro setting, which, once engaged, gives close focusing at a single, fixed focal length. Also available are true macro lenses, which look superficially like a normal lens.

Shift lenses allow some of the lens elements to be shifted off-centre, thus correcting the 'converging-vertical' effect noticeable when a wide-angle is tilted upward to include the top of a tall building.

Extreme telephoto lenses allow very distant subjects, such as timid wild animals, to be photographed at a good image size.

250mm lens Detailed studies of wild birds, such as this Eagle Owl, require a long lens. Here I used a 250mm lens and an aperture of 5.6 (the widest this lens had). The shallow depth of field has helped to isolate the bird from the background – useful when photographing subjects with subdued colouring.

PC lens For this picture (above) the camera was positioned well below the castle and to have included it all would have meant tilting the lens upward, causing vertical lines to appear to converge. Instead I held the camera straight and used the PC facility to 'slide' the top of the castle on to the frame.

500mm lens This photograph of a dramatically coloured bird (left) was taken using a 500mm lens from the position of a well-camouflaged hide.

Technical Briefing
When using close-up lenses, such as macro and telephoto, the depth of field is very shallow. Use the smallest aperture you can and a slow shutter speed to compensate, and support with a tripod. Extreme telephotos are also heavy and impossible to hold steady otherwise.

See also:
Projects 68, 69 and 70

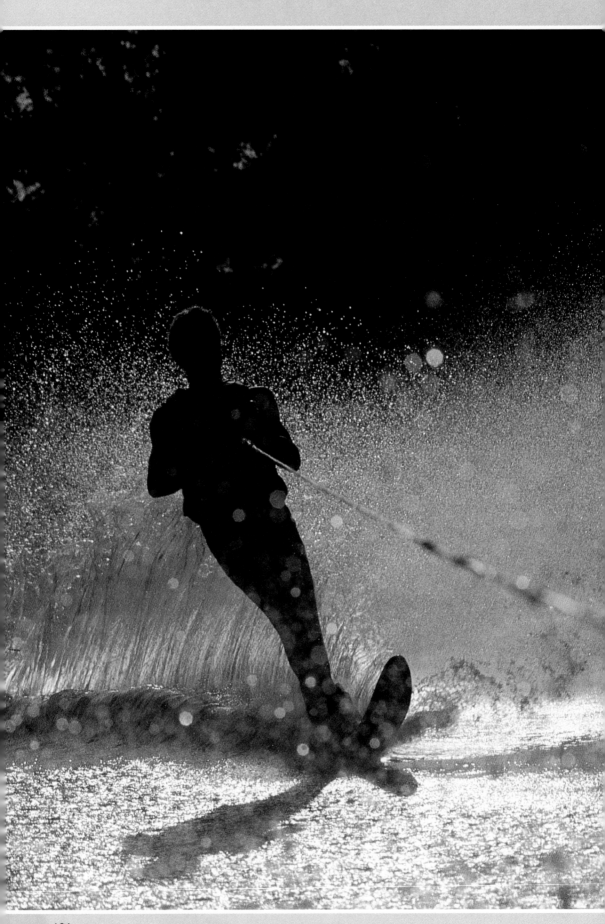

ACTION

Action can be real or illusory, as the projects
in this final chapter reveal. The way in which the various
camera controls are used is vitally important to the
appearance of action sequences on the final
image. Shutter speed, for example, is central to the recording
or 'freezing' of movement. In some situations, the actual
shutter speed might be rendered irrelevant because the
stopping power of flash is being used instead. In almost all
instances, the closer into the action you can get,
either through camera position or focal length, the more
impressive will be the results.

Timing Luck plays a major part in good
action photography. Back lighting catching the spray from
the trailing ski forms a glistening curtain, separating the figure
from the shadowed background.

Technique for action

This first project on action photography is all about interpreting fast-moving subjects — using shutter speed, camera position and (if available) choice of lens — in order to produce evocative and exciting images. Often, being able to anticipate the way the action is developing is the most important prerequisite.

It is a fallacy to think that fast-moving action pictures necessarily require fast shutter speeds. As often as not relatively slow shutter speeds will give far superior results. This is particularly true when the sense of action is best conveyed by a less-than-sharp image, either of the subject itself or of its background (as in panning).

Related to this are viewpoint and focal length, since these determine the size and disposition of other elements in the frame in relation to the main subject.

You will need to produce action pictures of at least two different activities. One picture should feature panning using slow shutter speeds, and the other should capture an instant of frozen action using the fastest shutter speeds available.

Slow pan I used a 1/15 sec pan (right) to capture the feeling of movement by blurring the background, and also to render the people and parked cars unreadable. Viewpoint was vital to position the wheels against the bright highlight.

Fast shutter It was important in this shot (above) to use a shutter speed that did not stop the motion of the rotor blades. I opted for 1/1000 sec.

Moving pan In this variation of panning (right) I was travelling at exactly the same speed as the motorcyclist and panned him at 1/30 sec.

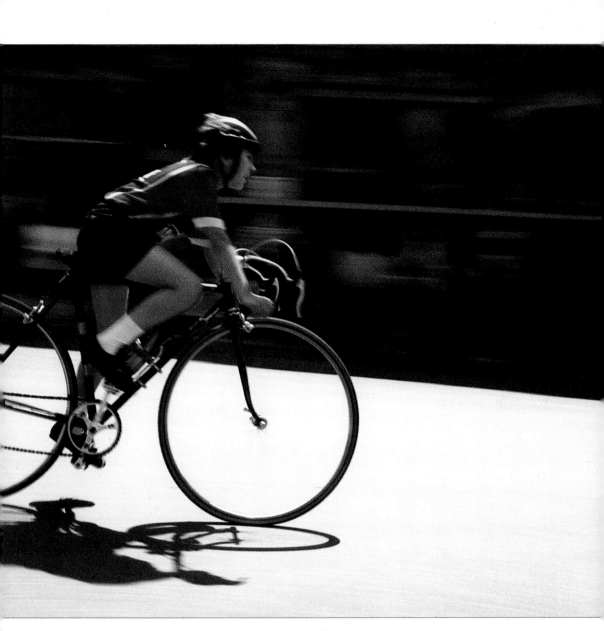

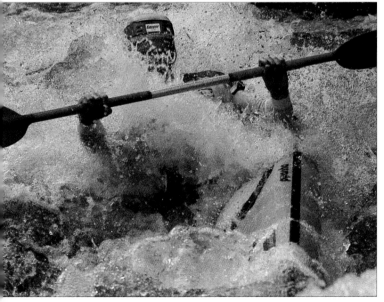

Technical Briefing
At action or sporting activities you can gain valuable tips by watching professional photographers. For your own part, pay close attention to the action and if possible use a motor-driven camera or one with automatic frame advance.

See also:
Projects 66, 69, 70 and 71

Viewpoint and lens To take this shot (left) I positioned myself on a bend that forced the canoeists toward the bank. I used a compact with zoom set at 90mm and 1/500 sec.

Capturing action with flash

Using flash to capture action presents the subject in a totally unrealistic way – a bird frozen in mid-flight, wine pouring from a bottle as if a solid crystal of liquid. All this 'trickery' is possible simply because electronic flash delivers its light in a single burst of illumination lasting a tiny fraction of a second.

All cameras have either a single flash synchronization speed or a range of shutter speeds up to a maximum (usually 1/60 sec, but sometimes 1/125 or 1/250 sec) that can be used with flash. With many modern cameras, activating the built-in flash or attaching a dedicated flash to the camera hot shoe (see pp. 36–7) puts the camera into flash mode.

Flash duration with modern units depends on the amount of light being reflected back by the subject – the more light picked up by the built-in flash sensor the shorter the burst of light,

and the greater the 'freezing' effect. Remember this aspect of flash when trying this project and arrange your subject in light-coloured, reflective surroundings so that less light output from the flash will be necessary for correct exposure, and flash duration will be shortened.

As you will probably be using a relatively long shutter speed of about 1/60 sec arrange your subject in subdued ambient lighting, otherwise light levels may be sufficiently high for a blurred image of your subject to be recorded while the shutter is open as well as the frozen flash image.

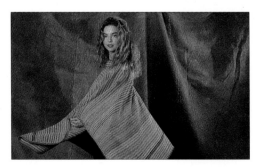 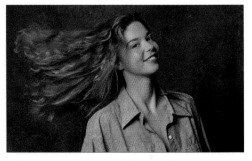

Twin flash For these two photographs of the same model (above and above right) I used two flash units, one attached to the camera and the other 'slaved' so that it fired in unison, to overcome the dark and non- reflective surroundings. To get the poncho to stand out rigid, the girl twirled round while staring directly at the camera. The second shot is similar: I pressed the shutter when her hair was at its fullest extent.

Frozen liquid This type of image is often used in advertising shots (above). It looks professional but is very easy. The bright surroundings ensure that any reasonably powerful flash unit should deliver a sufficiently brief burst of light to freeze the liquid. However, you cannot tell if the effect overall is right until the film is developed, so take a lot of exposures.

Femme fatale For this shot of wrestlers (right) in Madison Square Garden I used an amateur flash.

Creating a sense of action

As demonstrated in the two previous projects, shutter speed has a far more creative role to play in photography than simply being one of the factors determining correct exposure. Used with imagination, it can introduce you to a way of seeing movement and action that is impossible with the unaided eye.

U sing the knowledge that as long as the shutter is open the film will record whatever moves in front of the lens, this project is designed to manipulate reality to create some bizarre movement effects with the camera. It will be easier to accomplish with either a manual camera or an automatic one with a shutter-priority mode option. However, as you can see from the two waterfall pictures on the opposite page, a fully automatic camera can be made to co-operate with the help of some neutral density filters.

Another important point to remember is that only continuous light is to be used – from domestic bulbs or tubes, photofloods or natural daylight, for example – not the instantaneous burst of illumination delivered by flash units.

Finally, ensure that at all times during the exposures the camera is stationary, preferably mounted on a tripod, because slow shutter speeds are to be used. In all the examples on these pages, the effects are the result of light acting on the film for relatively long periods.

Moving and stationary elements The unreal effect created by these two images (below and right) is the result of blurred and sharply recorded detail in the same shot. For the picture below I set up lighting that required a 1/4-sec exposure for the foreground figure and, while she held still, I had the waiter jerk quickly backward. The snooker shot is similar in principle – the model held still while the balls streaked across the frame, recording as multiple images at 1/2-sec exposure.

Technical Briefing

In preference you should use a manual camera or one with a shutter-priority mode. The shutter speed needed to record blur depends entirely on the speed of the moving elements in the picture, but sufficiently slow speeds to warrant the use of a tripod are likely. Use extremely low light levels or neutral density filters to force slow shutter speeds on a fully automatic camera.

See also:
Projects 66, 68, 69 and 71

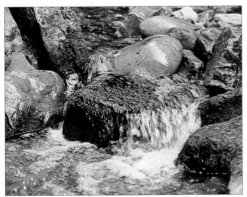

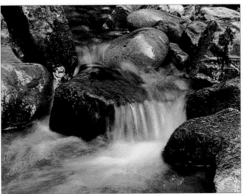

Degrees of blur For this first shot of the waterfall (above left) I was using a fully automatic camera which set a shutter speed of 1/125 sec. This produced an image roughly corresponding to the way the water would have appeared in reality, with just minimal blurring. For the second shot (above right) I placed a neutral density filter over the lens.

This cut down dramatically the amount of light entering the lens and forced the camera, still on automatic, to select a shutter speed of about a full second. This gives a much higher degree of blurring to the moving water, an effect which can be very useful in action photography for creating a feeling of fast movement.

Sporting events and activities

With nearly all sporting events and activities, the better you know your subject, the better your chances of capturing those telling shots. If, for example, at a track meeting or a basketball match you want to secure a position near the final bend or under one of the baskets, then make sure you get there early.

To produce a good portfolio of shots, arrange to attend at least two very different types of activity – perhaps a straight individual sport and a contact team sport. It is important to remember that this is an action project, so the emphasis is on the participants and not the audience reactions.

The equipment needed in terms of camera, lenses and accessories depends on how close you are to the field and the ebb and flow of the action. For most events, however, a moderate telephoto will be adequate.

One very effective technique is timing a shot so that you catch a figure at the very peak of an action. Movement is 'frozen' as a footballer

straining his body upward to reach the ball, for example, seems to hang suspended in mid-air for an instant. For shots like this you will find that a fast shutter speed is not necessary.

> ### Technical Briefing
> Sometimes taking the eye away from the viewfinder to wind on, even for an instant, can mean a lost opportunity. Therefore, a camera offering automatic frame advance or a motor-drive facility will be of immense help. A rifle grip can be more convenient at sporting events than a tripod.
>
> ### See also:
> Projects 68, 69 and 70

Silhouettes The action of this alpine hockey game just after sunset (above) is captured effectively by these near-silhouettes, despite the low light levels.

Image size To include the whole of the speeding land yacht (below left) would have given a very small image size. Panning at 1/60 sec produced the streaked background.

Peak of action Movement is suspended for an instant (right) so a fast shutter speed is not necessary.

Amateur meet At amateur events like this high jump (far right) you can usually get in close to the action.

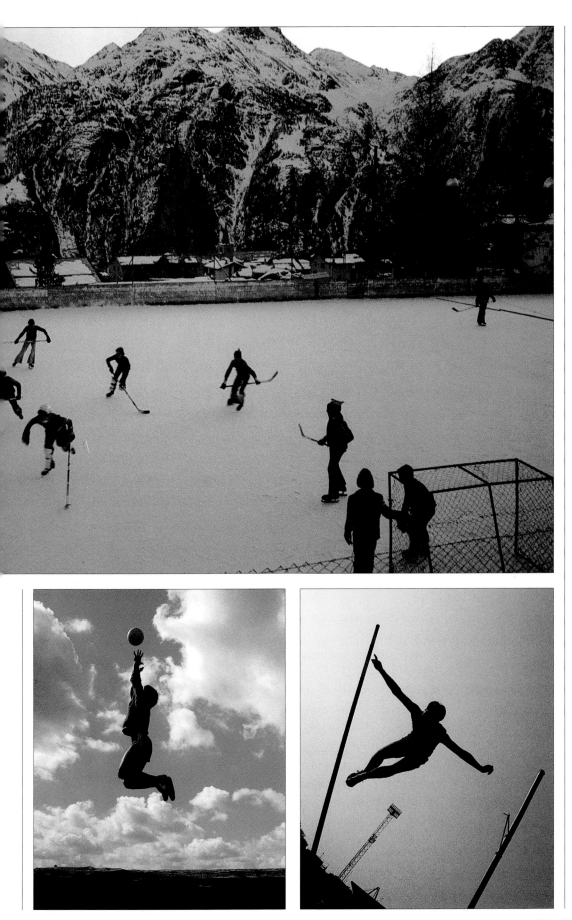

The Projects Summary

Once you have worked your way through all of the projects, perhaps over a period of several months, you will have built up an invaluable store of photographic experience, as well as an impressive portfolio of different types of pictures.

It will now be clear that there are many aspects to consider before taking a picture. Basic rules concerning exposure, aperture, composition and so on will enable you to produce an acceptable image of any type of subject. However, it is possible to 'bend the rules' and to use your imagination to give originality to your photographs, for example by using such techniques as overexposure to create silhouettes. Photographs should be interpretations rather than just records of what is in front of the camera, and it is this that makes photography into an art.

Almost any subject is suitable, including those usually considered 'unphotogenic' and it is essential to be observant of your surroundings, perhaps noticing unusual architectural features or industrial landscapes that would make dramatic shots. Photographic opportunities can present themselves at any time and may be fleeting, so always be alert and ready to catch that glimpse of sunlight through heavy clouds, for instance, or a telling facial expression.

Photography, like any craft, can become a source of great pleasure and enthusiasm once the basic techniques have been mastered and applied. The next section of this book will help you to acquire skills other than just using your camera; it covers specialist equipment, developing and printing, and how to present your pictures to their intended audience in the most impressive way.

Broadening
Your Scope

Choosing the right equipment

There is no single camera/lens/accessory combination suitable for all photographic situations. Think clearly about where you will be working, what you want to achieve and how you intend to accomplish your objective. Choosing the right equipment for a project is, of course, vital when working on location. Even in the studio, especially with live subjects, pre-planning is all important.

The advice presented on the next few pages gives some idea of typical kits for various projects, but can be adapted in the light of your own experience.

Architecture
The basic kit for this type of subject should consist of a single camera body and two to three lenses: a wide-angle; a standard, preferably with shift movements to prevent unwanted perspective distortion (although this is very expensive and is normally wide-angle); and a telephoto for architectural details. A wide-angle lens will be

CAMERA CASE

It is best to have two different-sized camera cases. One needs to be large enough for a single camera, perhaps two lenses and a selection of small accessories. The other, larger case can be reserved for trips out on location and should be able to accommodate two camera bodies, three fixed focal length lenses (or two zoom lenses) and all the necessary accessories. If you were out after shots of athletes in a cross-country race, for example, you might include a motor drive; for natural history close-ups of a rare orchid you would need a set of extension bellows (or close-up filters), a tripod and maybe a fold-up umbrella.

Camera bag A camera bag should be just large enough to take your particular selection of equipment: too large and things will rattle around; too small and you will be cramming things in.

The main reason for using a case, or carry-all, is to protect your equipment so it needs to be robustly built and have a rigid frame. Professionals often have a case strong enough to stand on. It might be a bit heavier to carry, but that extra bit of height can sometimes give you the winning slant.

To prevent the cameras, lenses and other accessories from rattling around inside the case, it should have plenty of compartments and retaining straps. Many 'suitcase' types come with a solid foam interior, out of which you cut shapes that exactly fit your equipment. These offer maximum protection.

useful inside a building, especially if space is a little cramped, the area to be shot is extensive, or a generous depth of field is called for. The standard lens will probably be the fastest lens you own and its extra speed might come in useful if light conditions are low and flash is prohibited. If flash is not allowed and lengthy exposures are necessary, take along a tripod and a cable release to avoid jarring the camera as you release the shutter, alternatively, use the self-timer. The telephoto lens is ideal for those little out-of-the-way features. For black and white shots, include in your kit yellow, green, and orange filters for controlling the tonal values of the sky and stonework. For colour shots of the exterior, a polarizing filter may be useful.

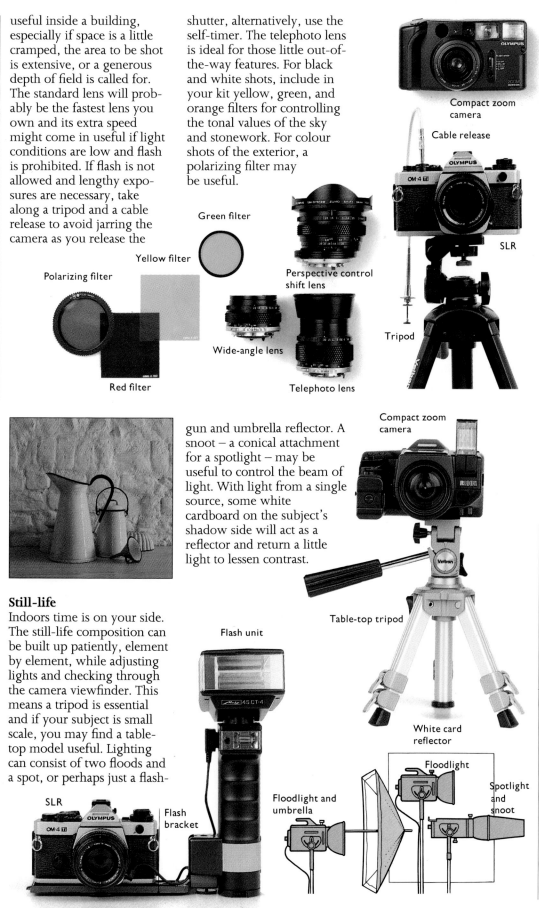

Compact zoom camera

Cable release

Green filter

Yellow filter

Polarizing filter

Perspective control shift lens

SLR

Wide-angle lens

Red filter

Telephoto lens

Tripod

gun and umbrella reflector. A snoot – a conical attachment for a spotlight – may be useful to control the beam of light. With light from a single source, some white cardboard on the subject's shadow side will act as a reflector and return a little light to lessen contrast.

Compact zoom camera

Table-top tripod

Flash unit

Still-life

Indoors time is on your side. The still-life composition can be built up patiently, element by element, while adjusting lights and checking through the camera viewfinder. This means a tripod is essential and if your subject is small scale, you may find a table-top model useful. Lighting can consist of two floods and a spot, or perhaps just a flash-

White card reflector

Floodlight

SLR

Flash bracket

Floodlight and umbrella

Spotlight and snoot

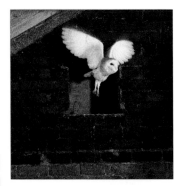

Wildlife

Animal subjects can be the most elusive as well as the most challenging. Of almost universal help will be some form of remote triggering device for the camera. This could be a long air tube and bulb, which allows the shutter to be tripped from many feet away. More expensive is a radio-controlled shutter release. This enables you to remain in radio contact with your camera, observing the

scene with a pair of binoculars. Then, at precisely the right moment, a radio signal can be transmitted to trip the shutter. Yet other forms of remote release rely on the subject itself tripping the shutter by interrupting an infrared beam. The use of all these devices will require a sturdy tripod with the camera pointing at a likely spot. Also essential is an automatic frame advance for the camera (or a motor drive set to single frame), otherwise you will have to break cover after every frame to wind the film on. Many animals come out only at night, so a flash is essential, either mounted on the camera itself or clamped to a convenient branch and cabled to the camera. For shots of fast-moving animals and birds in flight, use rapid-fire stroboscopic flash. This device produces intense

pulses of light lasting a mere millionth of a second or less – often too brief for the subject even to register. The lens required depends very much on the scale of the subject and its distance from the camera – in fact, anything from a modest wide-angle to a long telephoto. As a precaution against rain or heavy dew, the camera can be enclosed in a plastic bag, leaving a hole for the front of the lens to poke through.

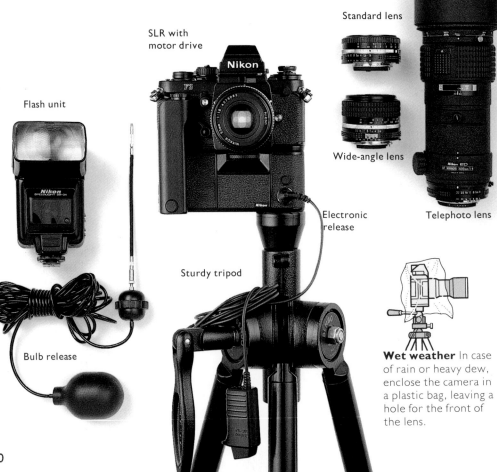

Flash unit

SLR with motor drive

Standard lens

Wide-angle lens

Telephoto lens

Electronic release

Sturdy tripod

Bulb release

Wet weather In case of rain or heavy dew, enclose the camera in a plastic bag, leaving a hole for the front of the lens.

Action projects

For sport and action sequences, avoid being burdened with excessive equipment, so you can respond instantaneously, quickly bringing your camera to your eye, squeezing off a shot, and then being ready for the next opportunity. With professional, organized sport, you won't be able to get to the press photographers' enclosure and so, except for wide-angle shots of the venue and an overview of the crowds, your main needs will be for a long lens (90mm minimum) and a motor drive (or a camera with a built-in frame advance) You won't be able to use a tripod if you are in the stands, but a pistol or rifle grip will make supporting the camera and long lens much easier and should minimize camera shake. Amateur sports events can be better hunting grounds, since you will usually be able to stand on the sidelines and a compact camera with built-in zoom up to about 90mm should produce some excellent shots.

Compact zoom camera

Zoom lens SLR with motor drive

Landscape

To capture scope and breadth wide-angles, such as those fitted as standard on many compacts, are certainly vital and their extensive depth of field is also important, but in no way can they encompass the scene as viewed stereoscopically with the eyes.

Using a long lens to concentrate on just a portion of the scene can often evoke more atmosphere. Telephoto lenses are also useful for pulling in distant aspects that would be missed entirely with a wide-angle. Skies can be another problem area and a polarizing filter or an ultraviolet filter (sometimes called a haze filter) can prevent them from appearing over exposed. For a series of shots of the same scene throughout the day, take along a tripod and cable release, and leave your camera set up as long as is necessary. Don't forget an umbrella. Many a sunny morning has turned into a sodden afternoon.

Compact camera with
fixed wide-angle

SLR

Tripod

Yellow filter Starburst filter

Polarizing filter

UV filter

Telephoto lens Wide-angle lens

Portraits

Pictures of people can be effective both in the controlled environment of the studio and outdoors in a more informal setting. For portraits indoors, natural daylight might be sufficient. Direct sunlight streaming into the room, however, might be too intense and contrasty. In this case filter and soften it by using a length of curtain netting or even tracing paper stuck to the glass. Other light sources could include two floods for general illumination and maybe a spotlight for rim-lighting your subject's hair or for adding catchlights to the eyes. Flash is also suitable, either angled off a wall or ceiling or directed into an umbrella reflector. Have a sheet of white cardboard handy to use as a reflector in case you need to throw some light into too dense a shadow area.

For the 35mm camera format, the most popular lens for portraiture, indoors or out, is a short telephoto – anywhere between 85mm and 135mm. This will allow you to fill the frame with a head-and-shoulders composition without coming up too close to your subject. If you will need to adjust your lighting indoors, set up the camera on a tripod. Outdoors, you will probably favour hand-holding the camera as you walk round finding the best angle and lighting effect.

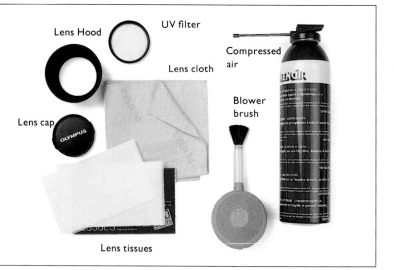

Flash unit

Moderate telephoto lens

SLR

Compact zoom camera

Tracing paper

Flood-lights

Tripod

Diffusing material

Spotlight and snoot

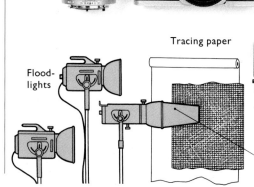

Lens care Normally lenses need only superficial care. As a precaution always keep a UV filter on the lens. If this becomes dirty, clean it with lens tissues or a lens cloth. A lens hood and cap also give good protection. The front element of the lens is very delicate, so only use a blower brush or compressed air (from the recommended distance) to dislodge dust and dirt.

Lens Hood

UV filter

Compressed air

Lens cloth

Blower brush

Lens cap

Lens tissues

Close-ups

In this area of photographic interest, the SLR has a definite advantage over the compact. With an SLR you can attach such specialist items as extension tubes or extension bellows between the camera body and lens. Also, many zoom lenses have a 'macro' setting, which gives near life-sized reproduction. For even more specialized work,

SLRs can be attached via special adaptors to microscopes or telescopes. The main problems encountered are extremely shallow depth of field (an unavoidable feature of close-up equipment) and lighting – with the lens so close to the subject there is not much room for light to get in. To help to overcome the first problem the camera must be mounted

on a sturdy tripod so that minutely fine adjustments can be made to focus control or to subject position. On location, it may be necessary to construct some form of windbreak (perhaps out of cardboard) around your subject to stop it swaying in and out of focus. For the second problem you will need to have a flash unit to illuminate and freeze the subject. The cardboard used as a windbreak can also act as a reflector to return some light to the shadow side of the subject. Another useful accessory is ring flash, a circular lighting tube that fits around the outside of your lens and delivers near shadowless illumination to your subject.

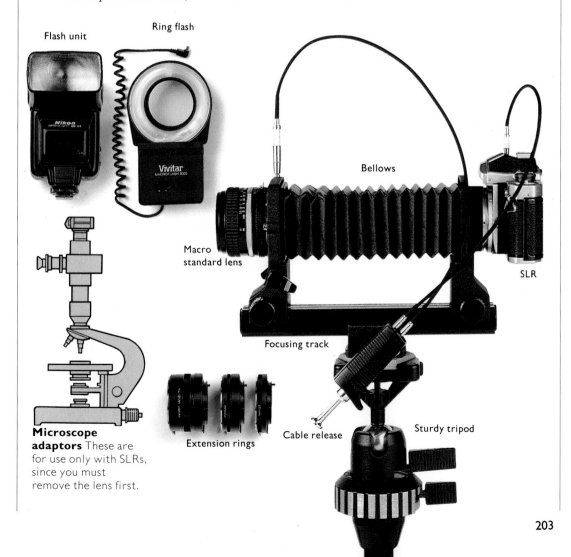

Flash unit

Ring flash

Bellows

Macro standard lens

SLR

Focusing track

Microscope adaptors These are for use only with SLRs, since you must remove the lens first.

Extension rings

Cable release

Sturdy tripod

Using camera filters

There are three main classes of filters. Those for use with black and white film manipulate the way the various tones are recorded. Filters for colour film may be grey, pale-coloured or colourless (such as a UV filter), or strongly-coloured to correct faults that occur if the wrong type of film is in the camera (see pp. 32–3). For both types of film there are dozens of special effects filters.

Home-made diffuser By smearing petroleum jelly unevenly on a plain-glass filter you can create the type of effect seen here (above).

A camera filter is a disc of optical-quality glass (or less-expensive and less-robust plastic) that screws into the threaded front mount of the camera lens. Ensure that the filters you buy are of the correct diameter for your lens thread (which may well vary between the different lenses of an SLR outfit). Square filters, which slot into an adjustable holder attached to the camera lens, are also available. The holder is adjustable.

Filter factors

With very few exceptions, all filters reduce the amount of light reaching the film. For SLRs this does not matter, since the TTL (through-the-lens) metering system will register the reduced light

Special effects filters
Typical filters include: prism, starburst, mist, graduated colour, and clear centre spot. Use these filters sparingly, however, or they soon become tiresome.

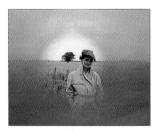

 Clear centre spot A coloured filter with a clear centre can produce a fun image.

 Prism Subjects with strong lines and bold colours are most suitable for a prism filter.

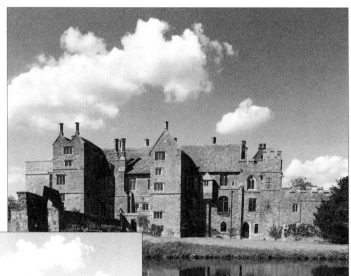

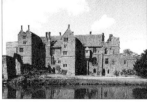

Yellow filter A yellow filter with black and white film will strengthen sky contrast, as in these before (left) and after (above) shots.

GENERAL-PURPOSE FILTERS

name/ factor	Exposure increase (in stops)	B & W or colour	Effects of use
Pale yellow ×2	1	B & W	Lightens yellow and darkens blue slightly.
Yellow ×2.5	1.3	B & W	Darkens blue sky. Lightens skin tones.
Yellow/Green ×4	2	B & W	Intensifies mist and haze. Lightens green, such as in foliage.
Orange ×4	2	B & W	Produces dramatic, dark sky effects. Reduces appearance of freckles on body.
Red ×8	3	B & W	Lightens cyan. Blue skies appear in extreme contrast. Shadow detail eliminated
Deep red ×20	4.3	B & W	Daylight scenes appear as if shot in moonlight.
Skylight	—	Colour	Extremely pale reddish filter used to 'warm-up' colour films.
UV/Haze	—	Both	Filters excessive UV light and improves colour/tone rendition.
Polarizing varies	—	Both	Darkens blue skies making clouds more prominent. Reduces or eliminates reflections from non-metallic surfaces.
85B ×1.5–2.75	.5–1.5	Colour	For daylight shots with tungsten-balanced film.
80A ×1.5–2.75	.5–1.5	Colour	For shots in tungsten light using daylight-balanced film.

level and increase exposure to compensate. Compact cameras, however, sample the light via a window on the outside of the camera and, unless the filter also completely covers this window, you may find that your shots will be underexposed by varying degrees, depending on the strength of the filter. Manufacturers indicate on the filter rim the amount of additional exposure required to compensate for this – it is known as the filter factor.

Other uses of filters

The filters in this chart are the more usual ones used in general photography. But there are many, many more in different colours and strengths. You can use coloured filters with colour film, but then you will create a colour cast corresponding to the colour of the filter used.

You can use filters in combination to correct for more than one element in a scene. In this case, if you don't have TTL metering you must multiply filter factors together to work out the necessary exposure increase in stops.

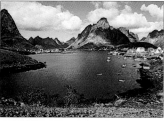

UV filter In mountain areas there is typically a lot of UV light, making a UV filter very important.

Neutral density filters

This chart of neutral density (ND) filters is only a selection of those available. All ND filters are grey in colour and are suitable for use with both colour and black and white films. Their primary use is in situations where you what to select a very wide aperture (see pp. 28–9), or a very slow shutter speed (see pp. 30–1) without overexposing the film. They will not in any way affect the way that tones or hues are recorded.

Filter name	Filter factor	Exposure increase (in stops)
0.3	×2	1
0.5	×3	1.5
0.6	×4	2
0.7	×5	2.3
0.8	×6	2.5
0.9	×8	3

Polarizing filter This is an ideal filter for strengthening sky colour or tone, as you can see here.

The home studio

A home photographic studio is the ideal place to explore the finer points of lighting technique. If you are lucky enough to have a spare bedroom, an unused garage or a converted attic then you are well on the way. Even if one of these options for a permanent studio is not available, you should still be able to make part-time use of another room in the house.

The size of room needed for a photographic studio depends on what you want to shoot. For example, if your main interest is in small natural history subjects and still-lifes, then a room of about 9 to 10 sq m (100 to 110 sq ft) should be sufficient. If, on the other hand, you are likely to be taking full-length portraits, then your space requirements will be very much greater – perhaps in the region of 18 to 20 sq m (200 to 220 sq ft).

For preference, a flexible studio should be squarish in shape, as opposed to long and thin. Working in a comfortable rectangle or square shape, you will be able to position lighting units to the sides of your subject and not just in an arc covering the front or the rear.

Also, to increase flexibility, a high ceiling is desirable – something taller than 2.75m (9ft). This will allow lights or reflector boards to be placed well above the subject, and will also permit the use of tall backdrops.

Although you would normally use artificial lighting – flash or tungsten – in a home studio, natural daylight via a large window area is a worthwhile bonus. If daylight-balanced colour film and flash are used they can be mixed with light from the window, since all have the same colour temperature. However, for those occasions when the exclusive use of artificial light is called for shutters or lightproof blinds will be indispensable.

Storage You always need more space than you think for small accessories, props, etc., so include as many shelves and cupboards as possible.

Make-up area This is by no means essential in a home studio, but if space and finances allow then models will find it extremely useful.

The colour of the walls and ceiling is particularly important. White-toned surfaces reflect most light and so, from the point of view of general illumination, are the best choice. Moreover, with white walls and ceiling you will have the freedom to bounce light on to your subject without worrying about unwanted colour casts. Never use a gloss finish paint, however, since this will produce glare spots.

Other general points you should consider are: a good, firm floor so that vibrations are not transmitted to a tripod-mounted camera; shelves and storage space; a well-lit make-up area for models; and a generous number of power points for lighting units. Alternatively, buy a power distribution box and run lights from this.

Floodlights Two or three flood-lights have highly variable general lighting options. Soft boxes, as shown, will diffuse the light and spots intensify it.

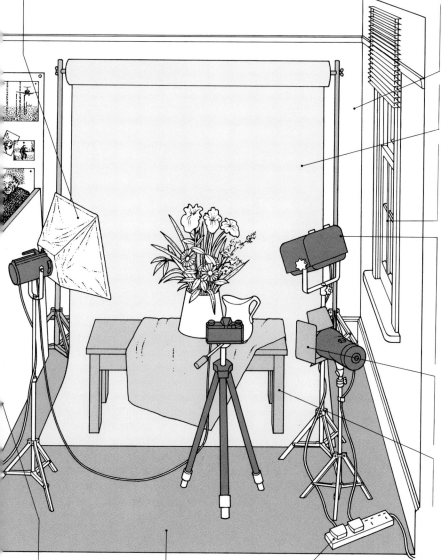

Matt-white walls and ceiling This finish does not produce glare or colour casts when used as a surface off which light bounces.

Backdrops Have a variety of different-coloured background papers and materials.

Window This allows natural daylight into your studio but shutters and/or blinds can be closed when artificial lighting alone is wanted.

Studio flash There is a good choice of relatively inexpensive amateur studio flash units available. They can be operated with their own power packs or from mains supply and have the same colour temperature as ordinary flash.

Lighting reflectors Different sizes and shapes of lighting reflectors can be fitted to flood-lights to produce different effects.

Table A solidly made table is essential for small natural history subjects and still-lifes.

Reflectors These can be simple sheets of matt-white cardboard, or board covered with kitchen foil for a brighter, sharper reflected light.

Floor A solid, non-slip floor ensures a steady surface for your tripod-mounted camera and floor-standing lights.

Distribution box This plugs into the mains power and should have sufficient sockets for all your expected lighting needs.

The home darkroom

Processing and printing your own film gives you the ultimate control over results. All too often, meticulously framed, lit and exposed shots are sent off to commercial processing laboratories where they receive standardized treatment, which in no way brings out the full potential of the image.

Virtually any room in the house can be used as a temporary home darkroom. Of course, it is very much more convenient if a permanent area can be set aside since there will then be no need for you to pack away all the equipment after each session.

Safety in the darkroom
Because you will be working with a combination of chemical liquids (some dangerous in themselves), water and electricity in a dimly lit or totally blacked-out area, you should pay particular attention to safety. Separating your darkroom into a dry side and a wet side will help prevent many potential mishaps since electrical equipment should never be handled with wet hands. All chemicals, when not in use, should be in properly sealed containers and out of reach of children. Because you will often be working in dim lighting or darkness, always keep the floor area free from clutter, and develop the habit of putting your equipment, paper, trays and so on in exactly the same position.

Film processing
You don't even need a darkroom for film processing – just a black, lightproof changing bag available from most photographic stores. Inside the bag place your film processing tank and spiral, your intact cassette of exposed film and a bottle opener for removing the top of the cassette. Two special light-trapped openings in the bag allow you to insert your hands and forearms. Once your hands are in the bag, all you need do is open the cassette, remove the film and load it on to the inner spiral of the film tank. Then once the lid is securely fitted on the tank, remove the loaded film tank from the bag and start the processing sequence. All this is done in normal room lighting.

The exact sequence of processing steps depends on the type of film being handled but complete chemical kits are available for all types of black and white and colour negative films, as well as for most colour slide films. These kits come with full instructions.

For each chemical or wash stage of film processing, simply pour the correctly

Lightproof changing bag The film processing tank and spiral, cassette of exposed film, bottle opener, and scissors for trimming off waste film are placed inside the bag for lightproof film processing.

diluted liquid at the appropriate temperature into the top of the tank lid, follow the directions concerning agitation and timing, and then pour the liquid out again through the top of the lid.

Printing
For printing you do need a completely lightproof room that has access to water and power. Because certain chemicals used in the process give off potentially hazardous fumes, the room should also be ventilated.

The first stage of printing involves using an enlarger to expose your processed film image on to a sheet of specially sensitive printing paper. It is at this stage that you determine how much exposure the paper requires and, for colour, how much filtration it needs. Because colour paper is sensitive to all light, this step is carried out in total darkness (except for the light from the enlarger). Black and white paper,

however, is insensitive to red, and can therefore be handled in the very dim illumination given off by special 'safelights'.

The next stage with colour printing is processing. The exposed paper has to be loaded into what looks like an elongated film processing tank. With the paper inside the paper drum and the lid secure, turn on the ordinary room lights and start the processing sequence.

Traditionally, black and white paper is processed in open trays of chemicals, the sheets being transferred from one to the other at the end of each stage. There are, however, fewer processing stages in black and white than in colour. You must remain under safelighting throughout the entire sequence.

Dry side/wet side Good darkroom design separates all the processes involving water or chemicals (the wet side) from the exposure and print finishing processes (the dry side).

Home darkroom design The diagram below shows a typical design for a home darkroom, and includes all the equipment necessary for processing black and white or colour negative films, and most colour slide films.

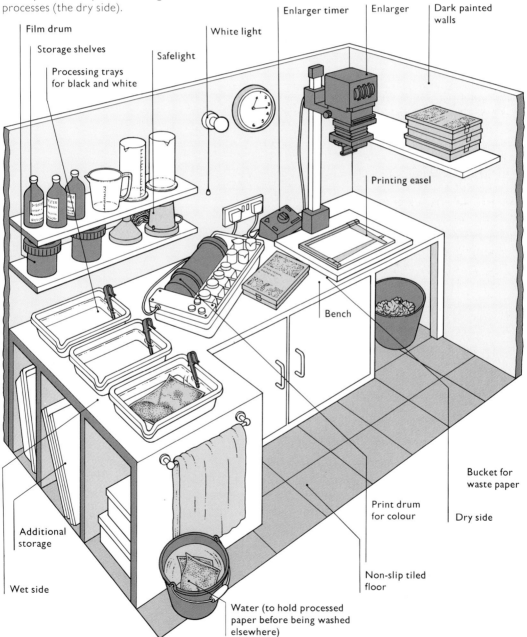

Film drum

Storage shelves

Processing trays for black and white

Safelight

White light

Enlarger timer

Enlarger

Dark painted walls

Printing easel

Bench

Additional storage

Wet side

Water (to hold processed paper before being washed elsewhere)

Print drum for colour

Non-slip tiled floor

Bucket for waste paper

Dry side

Photographic montage

If you want to get away from the conventional recording aspects of photography, then photographic montage is certainly worth trying. This fascinating technique combines portions of different prints to build up a composite image which can have either a realistic or fantasy theme.

All forms of montage work best if they are planned beforehand. If you intend to produce a realistic montage of, say, a single structure or location, as in the example here of Mont St Michel, off the Normandy coast, it is best to mount your camera on a tripod, so that the perspective of each element of the final composite image will be exactly the same.

Mont Mosaic You can see from this montage of Mont St Michel (below) that it would have been impossible to include the foreground, island, and buildings on a single frame without moving much farther back, and then the impact and scale would have been much reduced. Instead, I used elements of eight different shots taken from exactly the same position for the final mosaic effect. This uniform perspective gives the work continuity and minor variations in tone or colour provide texture. The diagram (right) shows the first stage of the assembly process. The overall design of the composition has been worked out, and the eight individual photographs have been positioned and then roughly taped in place.

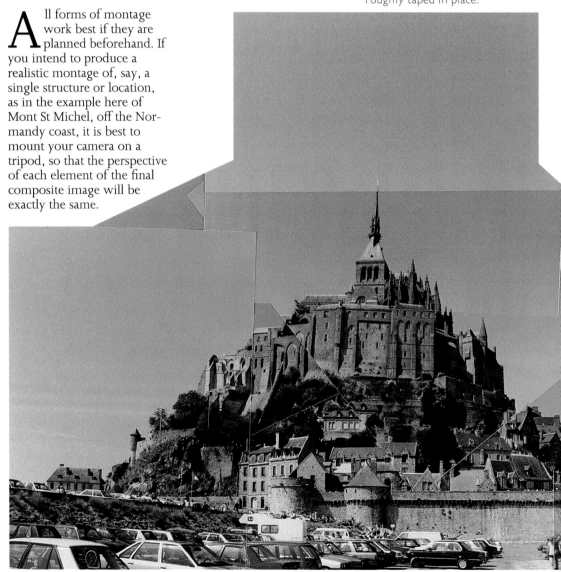

Assembly

1 If prints have white borders, trim these off.
2 Position the prints roughly so that they overlap.
3 With a knife remove any excess, leaving some spare for taping.
4 Apply double-sided tape to the back of each print and assemble the montage.
5 Use pencils, pens or dyes to hide any joins, add shadows, etc.
6 When dry, use double-sided tape to stick the montage to the backing board. Trim off any excess board.

Basic technique

Look carefully at all four corners and edges of the viewfinder, taking special note of how much of the scene you are including with each framing. After the first shot, pan the camera on its tripod so that the next shot overlaps with the first. Continue to pan either across, or up and down. Remember, though, that if you want the final montage to appear realistically continuous you must allow for plenty of overlap between shots.

Fantasy montage

If you want to produce an image of an impossible subject, then your approach can be far more relaxed. Look through your stock of prints, perhaps discards from some of the projects – you will probably find plenty of material to work with. You might decide to cut out the doorway of a house and mount behind it a print of somebody's face or some incongruous scene.

This type of trickery will have more impact if you ensure that the tonal or colour quality of the different elements are similar and that lighting and perspective appear to 'marry up'.

After treatment

After assembly (see pp. 212–13) the montage can be framed and displayed as it is. You could also take a photograph of the finished work. If so, make the prints smaller than the original so that any mistakes or crude joins will be invisible.

Equipment

A tripod is essential, but any type of camera is suitable for this technique. For the 35mm format, choose a 35 to 55mm lens. Longer lenses have a restricted angle of view so you will need to take more shots to include all of a largish subject; shorter lenses might distort the edges, which is not uncommon with cheaper wide-angles.

If you have a compact with a fixed wide-angle that distorts, increase the overlap between frames and use only the central area of each shot in the montage.

Copying your montage

When copying any print, document, artwork, and so on you must ensure that the original is parallel to the camera back (where the film is positioned). In this way *all* of the original is the same distance from the film and will be recorded in focus.

To copy your montage, lay it flat and position the camera directly over the centre, with the lens looking down. Special copy stands are available for this. These have built in lamp holders and a vertically adjustable camera mount. However with many photographic enlargers you can remove the head and attach the camera by the tripod mounting thread.

Mounting and presentation

Photopurists may argue that the whole film image as captured by the camera should always be seen in its entirety. Most of us, though, are more concerned with presenting our photographic efforts to the viewer in the best possible light and therefore find nothing objectionable in enlarging part of a negative to remove a distracting figure, or masking the bottom of a slide to obscure a parked car marking the foregound of a magnificent old building.

Slide storage The plastic boxes supplied by processors make ideal containers for slides. Larger-volume plastic filing cases are also available.

The emulsion surface of a photographic image (slide or print) is very delicate. It can be adversely affected by rough handling, excessive heat, humidity, damp or fumes. Pictures that you want to display, or slides in a portfolio for possible sale to book or magazine producers, are greatly at risk.

Slide presentation
The best way to present a lot of slides for possible sale is in either an artists' portfolio case fitted with special black card mount inserts or in a series of transparent plastic viewpacks (see right). Place individual slides in purpose-made, acid-free acetate sleeves before mounting them. Never use glass-fronted mounts – the glass is very

fragile and if it breaks will almost certainly scratch the film surface.

Slide show
The most impressive form of presentation is with a slide projector. Just as with a film, a slide show should have a beginning (establishing shots), a middle (development of the theme) and an end (shots that summarize whatever you want to convey). Run through the slides first to ensure that all are correctly orientated in the

projector and jot down some brief notes so that you can tell your audience what each shot is about – usually five or six seconds projection time per image is sufficient.

A more sophisticated version of this is an audiovisual presentation. The principles of image selection and sequence remain the same, but the commentary is

Creative cropping The film image is not necessarily the *final* image. The inset version (right) is the complete frame. In the cropped version much distracting woodwork of the balcony has been removed, helping to concentrate attention on the magnificent Tudor exterior.

recorded and, on the same tape a control track is laid down that allows a computer to trigger the slide changes. An audiovisual presentation can use any number of projectors to create fades, overlaps, dissolves and other special effects.

Print presentation

Prints look very effective in plastic sleeves (backed with an appropriate coloured paper) inside an artists' portfolio case. A sleeve could show a single enlargement or four or five related smaller images. Use small tags of double-sided tape to secure prints to the backing paper.

Another obvious form of print presentation is as a framed image on a wall. In this case, careful positioning of the picture is vital, since colour prints, in particular, are subject to damage from strong, direct sunlight. Also, unless special glass is used, direct light will cause reflections that make the print difficult to see.

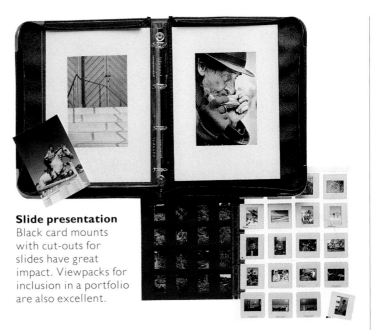

Slide presentation
Black card mounts with cut-outs for slides have great impact. Viewpacks for inclusion in a portfolio are also excellent.

Frames A selection of framing kits available from many large stores (right). To adapt the frames to fit your mounted print you may need a simple mitre cutter to finish the corners neatly.

Mounting prints with double-sided tape

1 Place the print face-down on a clean surface and cover the back with double-sided tape.

2 Using a metal rule and a sharp craft knife, carefully trim off the excess tape.

3 Peel off the tape's backing paper, leaving the exposed gum ready to receive the mounting board.

4 Turn the print over, and position it on the mounting board, using a straight-edge as a guide.

Fault finding

Picture faults can occur in two distinct areas of the image-making process: in the camera, and during film processing or printing. This chapter concentrates only on common problems that are likely to be encountered at the picture-taking stage.

STATIC

Appearance This fault mainly occurs in very cold conditions when the film is wound on too quickly. Quite literally, static electricity can build up on the film and discharge, causing blue, streak-like flashes to appear on the developed film.

Remedy If possible, switch the automatic film advance off and slowly wind the film on manually after each exposure. If frame advance is automatic and there is no manual option, keep the camera and film as warm as possible when not actually in use. 📷 📷

Appearance Only part of the image is visible at the beginning or end of the film.

Remedy Do not try to squeeze in extra pictures. 📷

Half frame

Stray light / mid film

Appearance If bands of stray light are causing the film to fog in strips like these, it probably means that the camera is not completely light tight.

Remedy Consult a qualified camera repairer. 📷 📷

Appearance This is caused by too slow a shutter speed or too wide an aperture. Images have featureless highlights and detail only in shadow areas.

Remedy Select a smaller aperture or a faster shutter speed, or (if it occurs often) have your camera professionally assessed. 📷 📷

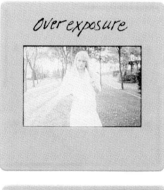

Over exposure

Stray light / end film

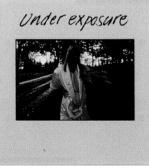

Under exposure

Appearance This is caused by too fast a shutter speed or too small an aperture. Images are dark with detail only in highlight areas.

Remedy Select a slower shutter speed or a wider aperture. 📷 📷

📷 Common with SLRs
📷 Common with compacts

Appearance Bright featureless highlight or a series of bright shapes caused by intense light shining off the aperture blades.

Remedy Use a lens hood and don't include overbright highlights in the frame. 📷 📷

Appearance This problem is confined to compacts. It occurs because with close subjects, the viewfinder image does not exactly correspond to the lens image. Its most common form is objects or figures with their tops cropped off.

Remedy Pay attention to the parallax correction marks inside the viewfinder. Also, keep subject distances beyond the minimum recommended in the camera manual to ensure that there is some space around the subject in the frame to allow for this type of error. 📷

Appearance Much the same as ordinary over-exposure, except that the overbrightness might only be local. With autoflash, you might have set the wrong ISO number, stood closer to the subject than recommended, or there might have been a highly reflective surface included in the shot. With manual flash, you may have set the wrong aperture.

Remedy Check the ISO film setting, subject distance, and any problem surfaces. Recalculate your aperture setting. 📷 📷

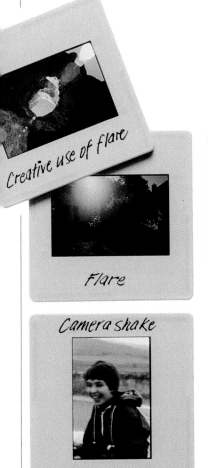

Creative use of flare

Flare

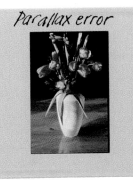

Parallax error

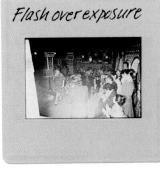

Flash over exposure

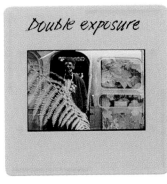

Camera shake

Double exposure

Unsynchronised flash

Appearance This is probably the most common fault, caused by moving the camera while the shutter is open. It is different from subject movement, since even static elements are blurred.

Remedy Use a faster shutter speed. If this is not possible, use a faster film. Always adopt a good posture for picture taking – a relaxed stance with legs slightly apart and elbows tucked in – or use a convenient support, such as a wall or a tripod. 📷 📷

Appearance This is caused when the film does not advance between shots, so that images are superimposed on the same frame. It is a film-loading error mostly associated with older, manual cameras.

Remedy If your camera has automatic film take-up, you will receive some form of warning that the film is not advancing properly. With a manual camera, make sure the rewind crank turns each time you wind on. 📷

Appearance Electronic flash must fire when the shutter is fully open to expose all the frame. With SLRs, you must select the shutter speed stated in the user's manual. If a faster speed is set, only part of the frame will be exposed. Compact cameras do not have this problem.

Remedy Unless automatic, make sure you select the shutter speed recommended for electronic flash. 📷

Glossary

A

Angle of view The amount of subject area encompassed by a lens. A *wide-angle lens* has a greater angle of view than a *standard* or *telephoto lens*.

Aperture A circular hole set in a solid disc inside the lens, that admits light to the film. The size of the aperture can be varied via the *diaphragm*.

Aperture priority Describes an autoexposure *mode* where the user sets the *aperture* size and the camera sets the *shutter speed* to give correct *exposure*.

ASA Abbreviation for the American Standards Association. A system of denoting film *speed*, now replaced by the *ISO* system.

Available light A general term describing the light naturally available for photography. This can be daylight or ordinary room lighting indoors, but not any additional light.

B

Back lighting Any type of lighting coming from behind the subject directly toward the camera. Used for silhouettes.

Barndoors Four flaps that fit around a photographic *floodlight* that can be adjusted to vary the spread of light.

Bounced light Any type of light (but usually from a flash) that reaches the subject via another surface, such as the ceiling or a wall. Bounced light gives a softer, more diffused effect.

Bracketing A series of photographs taken both above and below the settings recommended by the *exposure meter*.

B-setting A *shutter speed* setting that keeps the *shutter* open for as long as the shutter release is depressed.

C

Cable release A flexible cable that attaches to the shutter release. Allows the *shutter* to be fired without the camera being touched – usually when the camera is fixed on a tripod, to avoid vibration. Locking the cable plunger keeps the shutter open when the camera is on the *b-setting*.

Colour cast An inaccurate overall or local colour on a print or slide.

Colour contrast The apparent difference in intensity of two adjacent colours.

Colour saturation The purity of a colour resulting from the absence of white or black.

Colour temperature The assignment of a temperature rating – in °K (Kelvin) – to the colour quality of light. The more orange-red the colour, the lower its temperature; the more blue-white, the higher.

Compact camera A 35mm *format* camera featuring a separate viewfinder, a high degree of automation, and with a non-interchangeable lens of either *fixed focal length* or a moderate *zoom*.

D

Dedicated flash A flash designed to work with a particular model(s) of camera. Once fitted to the *hot shoe* it integrates with the camera's circuitry and cuts off light output from the flash when correct *exposure* is achieved.

Depth of field The zone of acceptably sharp focus both in front of and behind the point of true focus. Depth of field is dependent on the *aperture* set, the focal length of the lens, and the focusing distance. The smaller the aperture, the shorter the lens and the farther the focusing distance, the greater the depth of field.

Diaphragm An arrangement of overlapping 'leaves' that adjust to form an *aperture* of varying diameter.

Diffuser Any material used to scatter and thus soften the quality of illumination from a light source.

E

Emulsion An even mixture of light-sensitive crystals and gelatine coating a transparent, flexible base. It is the emulsion that carries the film image.

Expiry date A date printed on a film carton recommending the date by which the film should be used.

Exposure The amount of light received by the film. It is a product of the intensity of light (determined by the

aperture) and the length of time that intensity of light acts on the film (determined by the *shutter speed*).

Exposure latitude The range of brightnesses of light that a film can record with acceptable subject detail.

Exposure meter A device, usually inside the camera, that measures the amount of light falling on or reflected by the subject. The readings from an exposure meter are either converted into recommended *aperture* and *shutter speed* settings for correct *exposure* (on manual cameras), or they are directly set on the camera (automatic cameras only). On *SLR* cameras, (through the lens — *TTL*) meters are now universal.

F

Fixed focal length lens A term used to describe a prime lens, or one with only a single focal length. The description is used to distinguish between an ordinary and a *zoom* lens.

Flash synchronization The precise instant when the *shutter* is fully open and the flash fires. The *shutter speed* required for flash synchronization varies, depending on camera type, but it is usually $1/125$ sec or slower. On *compact cameras* with built-in flash, and often when using *dedicated flash* with an *SLR*, the correct shutter speed is automatically set.

Floodlight A *tungsten lamp*, used almost exclusively in the studio, with a wide dish-like *reflector* that produces a broad beam of relatively soft illumination. See also *Spotlight*.

F numbers Also known as f stops. A series of numbers on the outside of the lens barrel denoting the sizes of *aperture* available. The higher the f number the smaller the aperture. Changing from one f number to the next – either opening or closing the aperture – doubles or halves the amount of light passing through.

Focal plane The plane at which light from the lens is brought into focus. This plane coincides with the position of the film at the back of the camera.

Format The size and shape of a particular type of film or camera. The 35mm format, for example, refers both to the film and to the camera that accepts it.

Frame A single *exposure* on a roll of film, or a compositional element that surrounds or otherwise sets off the main subject.

Frame advance On most *compact cameras* and many *SLRs*, an automatic feature that advances the film one *frame* after each *exposure*.

F stops See *F numbers*.

G

GN See *Guide number*.

Graininess The appearance of the clumps of light-sensitive silver halide crystals contained within the film *emulsion*. These crystals are more noticeable the higher the *speed* of the film and/or the bigger the enlargement of the original film image. Excessive graininess destroys the resolution of fine image detail.

Guide number Often referred to by the abbreviation GN. A figure that denotes the power (or light output) of a light source (most commonly flash). This figure is usually quoted in both feet and meters. Dividing the guide number by the subject distance gives the *aperture* to use for correct *exposure* (assuming the use of *ISO* 100 film). Guide numbers are now not commonly used for determining exposure, since most modern flash units do this automatically.

H

High-key Refers to an image composed predominantly of light *tones* or colours. This type of effect can be accentuated by slight *overexposure*.

Highlight The brightest part of an image.

Hot shoe A holder on top of a camera shaped to accept the 'foot' of a flash unit, and containing electrical contacts that fire the flash when the *shutter* is released.

Hue The name of a colour, such as red, blue, green, yellow, and so on.

I

ISO Abbreviation for the International Standards Organization. A numbering system denoting the light sensitivity, or *speed*, of a film. The numbers of the ISO system are identical to those of the now redundant *ASA* system.

L

Latitude See *Exposure latitude*.

LCD panel Liquid crystal display giving complete status via shifting display of all camera systems and functions.

Light trail A streak of light visible on the film image caused by a moving light source during *exposure*.

Low-key Refers to an image composed predominantly of dark *tones* or colours. This type of effect can be accentuated by slight *underexposure*.

M

Macro lens A type of lens that is especially designed to give optimum results when used close up to the subject. Many types of *zoom lens* have a macro switch, that can be engaged when the lens is at its maximum focal length setting.

Maximum aperture Refers to the widest *aperture* (represented by the lowest f *number*) available on a particular lens.

Minimum aperture Refers to

the smallest *aperture* (represented by the highest *f number*) available on a particular lens.

Mode Any of a number of automatic *exposure* programs that may be available on a camera. *Aperture-priority* and *shutter-priority* modes are just two common examples.

Motor drive A motorized wind-on system built in to, or bought as a separate accessory for, a camera that winds the film on after each *exposure* while the shutter release button is depressed. The number of *frames* that can be exposed in any given length of time depends on the speed of the motor and the *shutter speed* setting.

N

Negative Developed photographic image showing (with black and white film) subject highlights as dark *tones* and shadows as light tones, or (with colour film) subject colours as their complementaries.

Neutral density filter A grey-coloured filter that reduces the level of light entering the lens without affecting its colour content. Particularly useful in bright conditions when *aperture* cannot be *stopped down* further and *shutter speed* cannot be shortened.

Normal lens See *Standard lens*.

O

Open flash Firing a flash unit manually without releasing the *shutter*, or with the shutter set on a timer.

Orthochromatic film A type of film that is sensitive to all colours of the *visible spectrum* with the exception of orange and red.

Opening up Increasing the size of the *aperture* (by selecting a smaller f number) in order to allow more light into the lens or to reduce *depth of field*.

OTF Abbreviation for off the film. A light measurement system where sensors detect the amount of light reflecting back from the film surface.

Overexposure Allowing photographic material to receive too much light, either by using too large an *aperture* or too long a *shutter speed*.

P

Panchromatic film A type of film that is sensitive to all the colours covered by the *visible spectrum*.

Panning Moving the camera to follow the direction of travel of a subject while the *shutter* is open. This produces a relatively sharp image of the subject while blurring all stationary objects in the field of view.

Parallax error A problem occurring with many *compact cameras* because they have a separate *viewfinder* and taking lens. It is brought about by the slightly different amounts of subject that are encompassed by each.

PC lens Abbreviation for *perspective* control lens. A type of lens containing some elements that can be shifted off-centre in order to correct the type of perspective problems noted when a camera is tilted upwards. Thus the tops of tall structures, trees, etc. can be photographed without distortion.

Perspective A way of representing the depth and distance of the real world on the two-dimensional surface of a print or slide.

Pinhole camera A basic type of photographic recording device that uses a pinhole instead of a lens to collect and focus light from the subject, to give a soft image.

Positive Developed photographic image showing (with black and white film) subject highlights as light *tones* and shadows as dark tones, or

(with colour film) colours corresponding to those of the original subject.

Primary colours Of light: red, blue, and green. Of dyes: red, blue and yellow.

R

Red eye An optical effect where the pupils of the eyes appear red instead of black. Occurs when the flash is too close to the lens and illuminates the subject directly.

Reflector Any material or surface that reflects light. Reflectors are often used in photography to soften the effect of the main light or to bounce illumination into subject shadows.

S

Sharpness Term used to describe the amount of fine subject detail that can be seen in the photographic image.

Shutter A light-tight barrier that can be opened for a range of timed intervals to allow light from the lens to act on the film. In an *SLR* the shutter is situated just in front of the *focal plane*; in a *compact camera* the shutter is more usually situated inside the lens.

Shutter priority Describes an autoexposure *mode* where the user sets the *shutter speed* and the camera sets the *aperture* to give correct *exposure*.

Shutter speed Any of a series of timed intervals, often ranging from 1 sec to 1/2000 sec, during which the *shutter* is open and light from the lens can act on the film.

Single lens reflex A type of camera, most commonly available in the 35mm format, featuring an angled mirror behind the lens and a top-mounted pentaprism. With this system, the *viewfinder* image is always exactly the same as the image seen by the lens, no matter what optic is used.

Slave unit An electronic unit with a mounting shoe for a flash-gun, and a photo-sensitive cell. This cell reacts to light from a first flash by triggering a second, attached to the slave unit, virtually instantaneously.

SLR See *Single lens reflex*.

Speed 1. Film: refers to the light sensitivity of the *emulsion* – the faster the film speed the higher its *ISO* number and the less light it requires for correct *exposure*; 2. Lens: refers to the *maximum aperture* available on that lens – a fast lens has a wide *aperture* (from f1.4 to 2.8), which makes it more flexible in low-light conditions.

Spotlight A *tungsten lamp*, used almost exclusively in the studio, with a *reflector*, lens, and simple focusing system, producing an intense, adjustable beam of light. See also *Floodlight*.

Standard lens This has a fixed focal length (which varies according to the *format* of the camera) that produces an image encompassing approximately the same amount of a scene as the unaided eye. For the 35mm format, this a 50–55mm lens. Also known as a normal lens.

Stopping down Decreasing the size of the *aperture* (by selecting a larger f *number*) to allow less light into the lens or increase *depth of field*.

T

Telephoto lens A fixed focal length lens with a narrow *angle of view*. It enlarges distant objects and is ideal for such subjects as head-and-shoulders portraits and natural history. *Depth of field* at any given *aperture* is restricted, making accurate focusing critical.

Tone A uniform and distinct shade of grey anywhere between pure white and featureless black. Black and white images are composed entirely of different tones.

TTL Abbreviation for through the lens. A type of metering system that utilizes sensors inside the camera body, which measure only the light coming in through the lens. This system is now universal on *SLR* cameras, since it produces accurate results no matter what lens is attached to the camera.

Tungsten lamp A type of artificial light source (domestic and photographic) that uses a tungsten filament heated by an electrical current. The light given off has a different spectrum (and thus *colour temperature*) from that of daylight.

Tungsten light film A type of colour film with an *emulsion* designed to reproduce accurately the colours of subjects illuminated by *tungsten lamps*. Tungsten light is deficient in the blue end of the *visible spectrum* and so this film has increased sensitivity to these wave-lengths. Usually tungsten light film is for slides, for which there is no printing stage when any *colour cast* can be corrected, as with colour print film.

U

Underexposure Allowing photographic material to receive too little light, by using either too small an *aperture* or too brief a *shutter speed*.

V

Viewfinder An optical sighting device that allows the camera user to see the scene encompassed by the lens. *Exposure* settings may be displayed alongside the viewfinder in many cameras.

Visible spectrum That part of electromagnetic radiation (light) that is visible to the unaided eye. When separated out into its different wavelengths, the visible spectrum forms the familiar colours of the rainbow; when added together again, these form white light.

W

Wide-angle lens A fixed focal length lens with a wide *angle of view*. It makes all middle and far distant objects seem small and far away and very close-up objects appear enlarged and distinct. It is useful for panoramas, or in very confined spaces. *Depth of field* at any given *aperture* is extensive, making accurate focusing less critical.

Z

Zoom lens A lens whose focal length can be continuously varied within its design limitations.

Index

ACKNOWLEDGEMENTS

The author would like to thank Jonathan Hilton for all his help with the writing of this book; Roger Bristow for art direction; Bob Gordon, Ruth Hope and Steve Wooster for design; Sarah Bloxham, Jennifer Chilvers and Susan George for their editorial help; Kate McPhee and Rupert Wheeler for production; and Paterson, Olympus, Pentax and Courtenay Flash.

The publishers are grateful to Tecno Cameras, of London EC2, for the loan of photographic equipment.

Photographic credits
Equipment photography in the first and third sections of the book by Geoff Dann; all other photographs by John Hedgecoe

Artwork credits
All diagrams by Trevor Hill and David Ashby